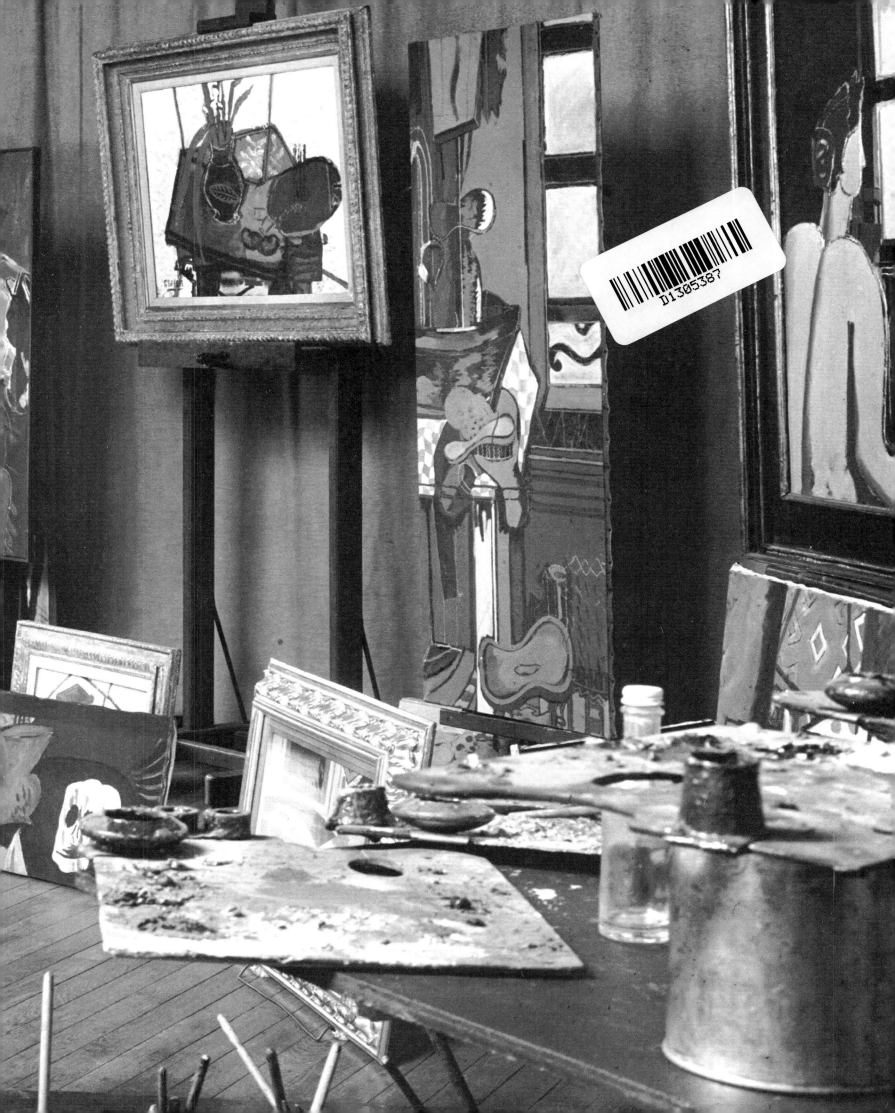

Georges Braque

PIONEER OF MODERNISM

Georges Braque

PIONEER OF MODERNISM

WITH ESSAYS BY

Dieter Buchhart

Isabelle Monod-Fontaine

Richard Shiff

ACQUAVELLA

This publication accompanies the exhibition

Georges Braque
Pioneer of Modernism

DIETER BUCHHART, CURATOR

On view
OCTOBER 12 – NOVEMBER 30, 2011

Acquavella Galleries
18 East 79th Street
New York, NY 10075

Library of Congress Control Number
2011910694

ISBN 9780982688601

COVER
Georges Braque
Still Life with Guitar I (Red Tablecloth), 1936
Oil on canvas
38 ¼ x 51 inches (97 x 129.5 cm)
Gift of R. H. Norton, 47.46
The Norton Museum of Art, West Palm Beach, Florida

ENDPAPERS
Georges Braque's studio, Paris, September 1944.
Photograph by Pierre Jahan

FRONTISPIECE
Georges Braque
The Pantry (detail)
1920
Oil on canvas
31 ⅞ x 39 ⅜ inches (81 x 100 cm)
Albertina, Vienna – Batliner Collection, Inv. GE18DL

Designed by Henk van Assen
HvADESIGN, NY

Printed by PhoenixLitho
Philadelphia, PA

TABLE OF CONTENTS

Foreword

THE MOST RECENT MAJOR RETROSPECTIVE OF PAINTINGS BY GEORGES BRAQUE in the United States was over twenty years ago. Thousands flock to see his work when, as the co-founder of Cubism, he is exhibited alongside Picasso, but for many people his importance starts and ends with that collaboration. In fact, as we seek to demonstrate with this exhibition, he was not only one of the first and most daring of the Fauve painters at the dawn of the twentieth century but he also continued to break new ground with profound insight and experimentation until his death in 1963. We believe a new look at the entire career of this creative genius is long overdue and with the help of our distinguished guest curator Dieter Buchhart we have selected works of the highest quality from all periods of Braque's development.

I am indebted to the many museum directors and curators in the United States, Europe and Australia who have generously lent us their outstanding treasures as I am to the private collectors who have been willing to share their paintings with the public, some of which will be seen for the first time in decades.

I would like to thank Dieter Buchhart and his assistant curator Verena Gamper as well as our distinguished essayists Isabelle Monod-Fontaine and Richard Shiff.

Our gallery staff worked long and hard on this exhibition including Michael Findlay, Esperanza Sobrino, Emily Salas, Jean Edmonson, Kathleen Flynn, Maeve Connell, Devon Vogt, Garth Szwed, and Eric Theriault as well as Nicholas Acquavella, Eleanor Acquavella Dejoux and Alexander Acquavella.

William R. Acquavella

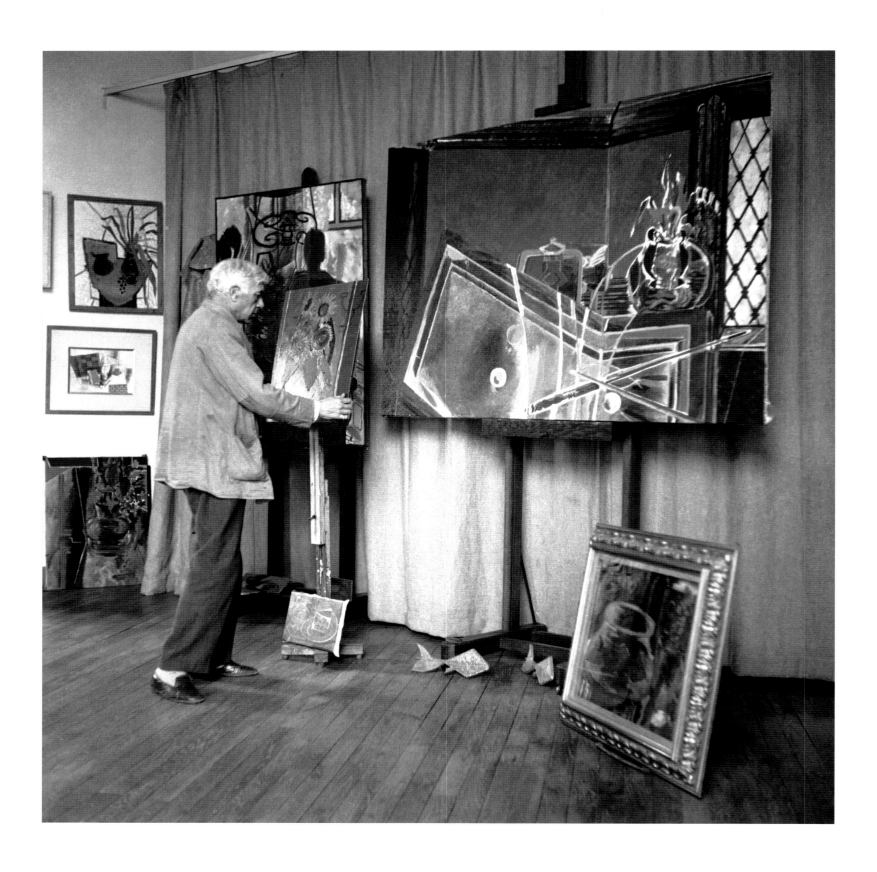

Introduction

GEORGES BRAQUE WAS ONE OF THE GREATEST INNOVATORS OF TWENTIETH CENTURY ART. The explosive beginnings of this creative artist's work lie in the colorful, expressive landscapes that can be considered pinnacles of Fauvism and led to a break with classical perspective and the traditional conception of space by way of his exploration of the work of Paul Cézanne. His later collaboration with Pablo Picasso and their shared development of Cubism would radically change the history of art. Both their new formal language as well as the introduction of materials such as paper, newspapers, and sand to painting and drawing revolutionized art history. Not only was Braque the inventor of *papiers collés*, but he was also a co-"inventor" of Cubism, equal in stature to Picasso. And yet this master of the modern still life is usually placed in the latter's shadows. Important exhibitions such as the 1989 exhibition, "Picasso and Braque: Pioneering Cubism," shown at the Museum of Modern Art in New York and Basel's Kunstmuseum, explored the collaboration of the two artists in Cubism. A show at New York's Pace Gallery in 2007 investigated the extent to which early film might have influenced Braque and Picasso's Cubism, and this year the Kimbell Art Museum is presenting the exhibition, "Picasso and Braque: The Cubist Experiment 1910–1912." It is rather rare for exhibitions to concentrate solely on Braque's work. This is the first Georges Braque retrospective in the United States in over twenty years.

The fact that the entire oeuvre of this pioneer of modernism has not been given more attention despite the artist's undeniable achievements and his significance for art history strengthened a desire long shared by Bill Acquavella and myself to dedicate a retrospective to this exceptional artist. Here we placed a special emphasis on tracing Braque's artistic development with an exquisite selection of the artist's most important masterworks.

Not only is Braque presented as a Fauve and as decisive in the development of Cubism, but the exhibition also focuses on how the artist moved from the landscape to the world as still life. In so doing, we explore his intense engagement with the still life and the interior from before and after the First World War—after recovering from his serious war injury during a long period of convalescence. After the war, he transformed objects to a collage-like two-dimensionality, and continued his intense exploration of the materiality of paint and rough foundations. Braque, who always saw poetry as the foundation of his work, created a world of metamorphosis in which each and every thing and living being could take on any possible form. Impressive examples from the important series of billiard tables and studios, which he created in the 1940s and 1950s, form a final apex in the artist's oeuvre. In these paintings, Braque lyrically constructed and deconstructed impressive spatial metamorphoses against the limitations of shape and space between being and non-existence. By refusing to accept the apparently recognized criteria for reality and by breaking with classical perspective and the traditional use of materials, Georges Braque advanced to

become a pioneer of modernism. These very signs of Braque's modernism are also the focus of the contributions made to this catalog by Braque expert Isabelle Monod-Fontaine, the important art historian Richard Shiff, and myself.

Already during his lifetime, Braque enjoyed great renown in the United States. After his New York exhibitions at the Valentine Gallery in 1934 and the Buchholz Gallery in 1938, a retrospective of his work was shown at the Arts Club of Chicago, the Phillips Memorial Gallery, Washington, and San Francisco's Museum of Art in 1939. His exhibition at Baltimore's Museum of Art in 1942 was followed by a significant retrospective in 1949 at the Museum of Modern Art in New York and the Cleveland Museum of Art. In 1962 and 1963, further exhibitions were held during his lifetime: "Homage to Georges Braque" was on view at Cincinnati's Contemporary Art Center, the Arts Club of Chicago, and Minneapolis' Walker Art Center. After Braque's death in 1963, the Saidenberg Gallery paid tribute to Braque with a retrospective exhibition, and the Guggenheim Museum held the last United States retrospective of the artist's work in 1988.

This exhibition at Acquavella Galleries brings together more than forty masterworks from museum and private collections from the United States, Europe, and Australia, and shows for the first time loans of previously inaccessible works of great significance. All of the artist's key creative periods are included, and justice is done to the significance of Braque as a decisive pioneer of modernism.

I would like to thank all the lenders for their generous support of our exhibition project, and for lending us these masterpieces despite the fragility of some of them and their great importance to their collections. My special thanks go to Bill Acquavella not only for the initiative he took, but also for his enthusiastic support of this fascinating project. Working together with Bill, Eleanor, Nicholas, and Alexander Acquavella was a great pleasure for me. I would like to thank Michael Findlay and the team at Acquavella Galleries, who contributed eagerly to the success of this exhibition, and Verena Gamper, who supported the project with great commitment as assistant curator. Among the many others who have supported us in our efforts, allow me to single out Isabelle Monod-Fontaine and Richard Shiff for their important contributions to the catalog, and also thank Quentin Laurens for his support of the exhibition. They brought a great deal of goodwill to the project, and thus contributed decisively to its success. My heartfelt thanks go to all supporters of this project.

We hope that the visitors to the exhibition enjoy exploring and rediscovering the work of this unique artist. We hope that this exhibition can do justice to the importance of Georges Braque as a pioneer of modernism and open new perspectives for the American and the international audience.

Dieter Buchhart
NEW YORK, JULY 2011

LENDERS TO THE EXHIBITION

ALBERTINA, VIENNA

THE ART INSTITUTE OF CHICAGO

BAYERISCHE STAATSGEMÄLDESAMMLUNGEN, MUNICH –
PINAKOTHEK DER MODERNE

BERGEN ART MUSEUM, NORWAY

FONDATION BEYELER, RIEHEN/BASEL

KRÖLLER-MÜLLER MUSEUM, OTTERLO, THE NETHERLANDS

KUNSTHAUS ZÜRICH

MERZBACHER KUNSTSTIFTUNG

THE METROPOLITAN MUSEUM OF ART, NEW YORK

MUSÉE D'ART MODERNE DE LA VILLE DE PARIS

MUSÉE NATIONAL D'ART MODERNE–CENTRE DE CRÉATION INDUSTRIELLE,
CENTRE POMPIDOU, PARIS

THE MUSEUM OF MODERN ART, NEW YORK

NATIONAL GALLERY OF ART, WASHINGTON, D.C.

THE NORTON MUSEUM OF ART, WEST PALM BEACH, FLORIDA

THE PHILLIPS COLLECTION, WASHINGTON, D.C.

SAN FRANCISCO MUSEUM OF MODERN ART

SOLOMON R. GUGGENHEIM MUSEUM, NEW YORK

STAATLICHE MUSEEN ZU BERLIN, NATIONALGALERIE, MUSEUM BERGGRUEN

TATE

AND PRIVATE COLLECTORS WHO WISH TO REMAIN ANONYMOUS

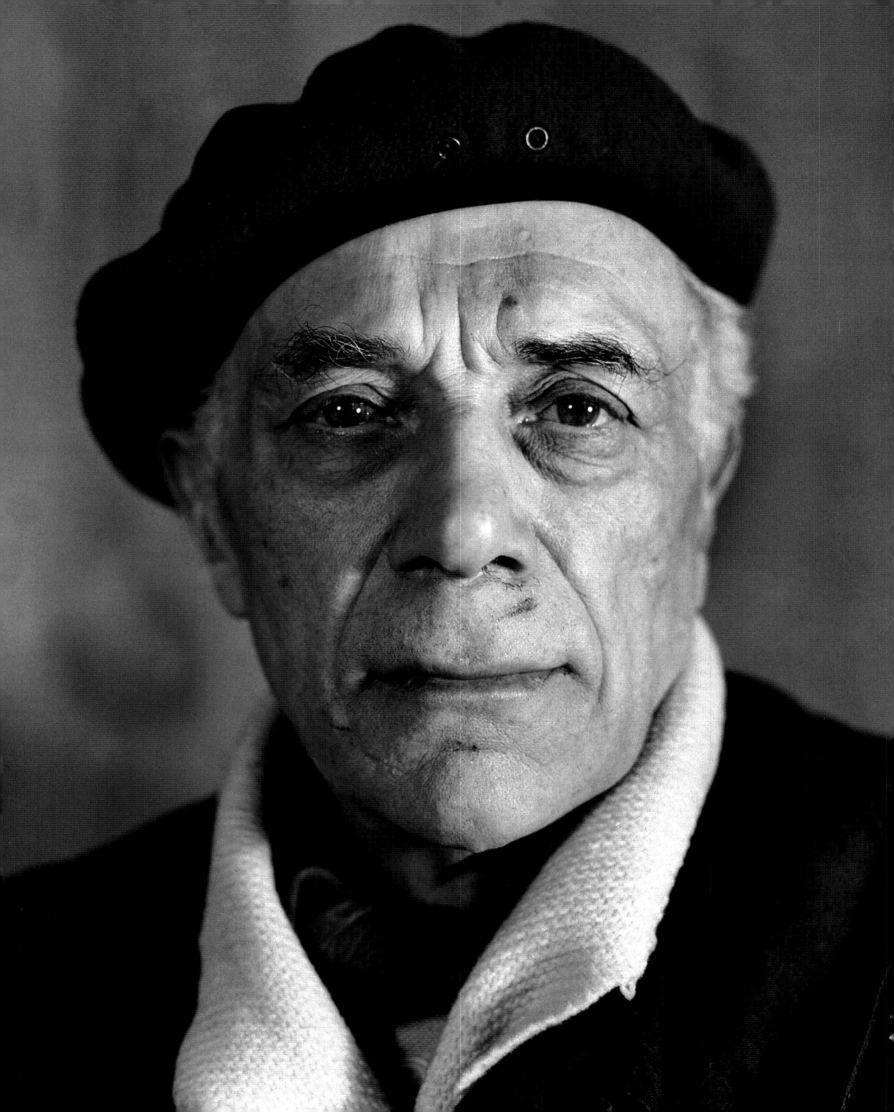

"...I have no idea what I will be doing tomorrow

never mind in a year.

Ideas conceived beforehand

do not exist for me...."

—GEORGES BRAQUE

Essays

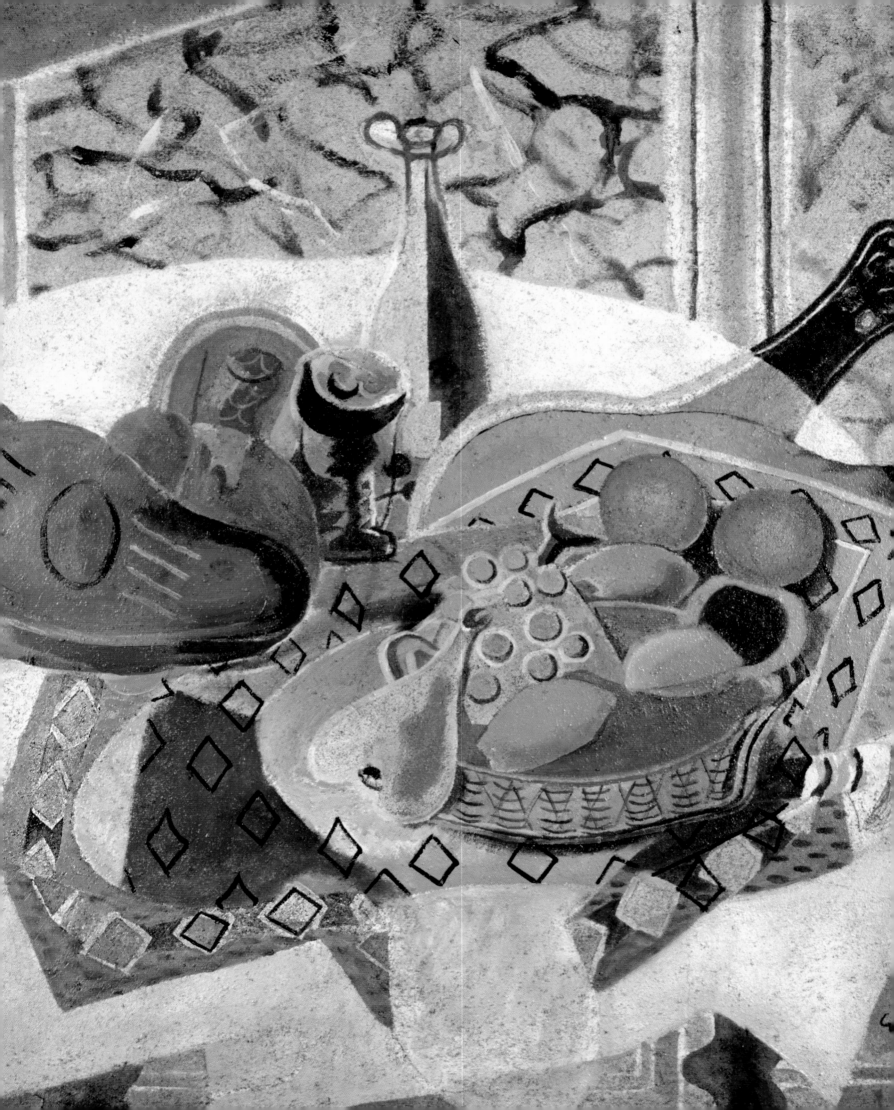

Isabelle Monod-Fontaine

From One Space into the Other

THE FEELING OF SPACE IN GEORGES BRAQUE'S WORK IS VERY UNIQUE: the interior and exterior are not really separated. One may move from the interior towards the exterior of objects without difficulty, as if the painter did not establish a clear boundary between his mental space and the limited circle of objects that make up his surrounding environment. This is perhaps the reason for which the "still life," as it is called, is his preferred subject throughout the years, from the Cubist period through the final *Studio* series. On several occasions, and at length, he expressed himself on this point: "This is what guided me toward the still life: I found in it an element of greater objectivity than in landscapes. The discovery of the tactile space that got my arm moving across a landscape invited me to seek an even closer sensory contact. If a still life is not within my hand's reach, it seems that it no longer stirs me."[1] It is clear that far from being "still" or without life, Braque's compositions of objects create constellations as changing and as surprising as the descriptions of the Norman skies which he basked beneath at the end of his life. Braque invests so deeply in "the nature of things," to borrow a title from Francis Ponge, that he identifies with them, enters into them, and uses them to express all of the nuances of his own mental landscape, with visions as familiar, undulating, meteorological, and as open to metaphors and metamorphosis as those described by Proust in *Remembrances of Things Past...*

In general, one searches the post-Cubist works of Braque—those completed after 1917 and his difficult return to life and to work (after recovering from the serious injury he suffered in May 1915)— for the telling traces of a return to order, for a regression towards the sensible clarity of a French-style classicism far from the incomprehensible pre-1914 boldness. What is not noticed often enough is that these canvases, frequently invaded by black, present on the contrary the most common objects in a ghostly, or visionary, light. From a background of darkness, hazy figures emerge, mixed with dust and sand: shadows lightly outlined with white rings, fruit of implausible color, and drooping guitars. These nocturnal backgrounds shroud the post-war compositions with a mysterious depth, and the color black would henceforth haunt the future paintings of Braque. The material itself visually presents a heavy texture, at once dark and

PLATE 32 [DETAIL]
Georges Braque
The Mauve Tablecloth
1936
Oil on canvas
33 ½ x 51 ½ inches
(85 x 131 cm)
Private Collection

Fig. 1 [LEFT]
Georges Braque
Gueridon
1939
Oil on canvas
70 ⅞ x 28 ¾ inches (180 x 73 cm)
Musée National d'Art Moderne,
Centre Georges Pompidou, Paris
Inv. AM4303P

PLATE 31 [RIGHT]
Georges Braque
Gueridon
1935
Oil and sand on canvas
71 x 29 inches (180.5 cm x 73.5 cm)
San Francisco Museum of
Modern Art, Purchase with the
aid of funds from W. W. Crocker

granular, but it also evokes the metaphor of life-giving soil and of sensory memory that pre-serves familiar objects to better restore them—intact, and yet disembodied. In this way, clusters of grapes, apples or pears painted by Braque in the 1920s powerfully evoke to me similar fruits preserved whole, and as if crystallized, in certain phrases of Proust: "…plums of bluish-green, luminous and spherical as the roundness of the summer sea, grapes hung from wooden beams, drying and transparent like a clear day in autumn, pears the color of a celestial lake." Several hours later, the plums had become purple, and in the celestial lake of the pears' skin, "some traces of pink clouds" were now floating, as the narrator describes in this passage of *In the Shadow of Young Girls in Flower* (1919).[2] The compositions of fruit Braque invented also incorporate oth-erworldly colors and the elongated forms that he preferred at that time. Of course, the pears of Braque are not the blue of a celestial lake, but are an equally implausible emerald green, and float in the space of the fruit bowl as if in a liquid universe. In this *Brown Still Life* dated 1926 (**Plate 29**), the pears, grape cluster, fruit bowl, glass and pitcher intertwine; their curves repeat and re-spond to one another in visual echoes spread across the entire oval surface of the gueridon. The gueridon—a type of pedestal table with an oval top, a sort of microcosm of the work—encloses without creating boundaries, and provides Braque with an indispensable form for the represen-tation of tactile space that preoccupied him almost exclusively since 1909/1910. An overview of Braque's paintings through the single lens of the gueridon still life motif offers a succession of visual poems from the years 1911 to 1939, culminating in the nearly baroque compositions of the mid-1930s, before the final masterpieces of the *Studio* period (1949-1956). The *Studio* paintings work in a different space, one which is resized, enlarged and unfolded to infinity.

It is precisely this series from the 1930s on which I would first like to focus. This series is with-out a doubt less well known, less exhibited than other periods of his work, and it remains very intriguing. Let us consider for example two canvases entitled *Gueridon* (1935, **Plate 31**; 1939, **Fig. 1**). These two variations of the same composition share the same vertical format and are both characterized by a masterful piling up of motifs whose apparent disorder is in fact struc-tured by a meticulous system of symmetry. The background is divided into three registers of unequal size: parquet floor, molded wood paneling, and wallpaper with an aggressive deco-rative pattern. In the San Francisco version, it is a zigzag pattern. In the foreground the still life flourishes, placed on a tablecloth whose folds are star-shaped and which is displayed as a ruffle around a bouquet, the stems of which are represented by the extended legs of the gueri-don. It is a strange still life that brings together indeterminate elements (in the first version, the painting in San Francisco, it appears that one of the zigzag patterns from the wallpaper has landed in the fruit bowl, as if it were an exotic fruit; in the second, the version in Paris, a drooping guitar curves with indolence over the tablecloth where it has little reason to be), and others drawn with a crazed precision (the lemons in the foreground, or the faceted crystal glass). What appears to be a transparent light fixture hangs from above, drawn as between the lines

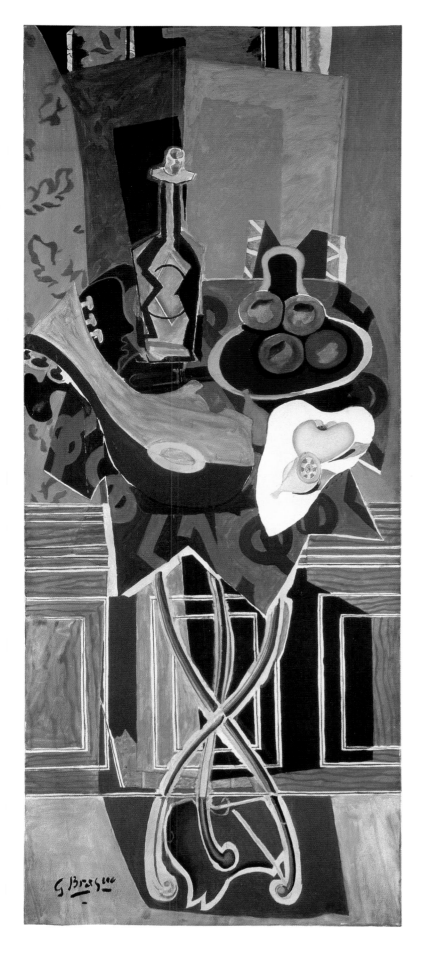
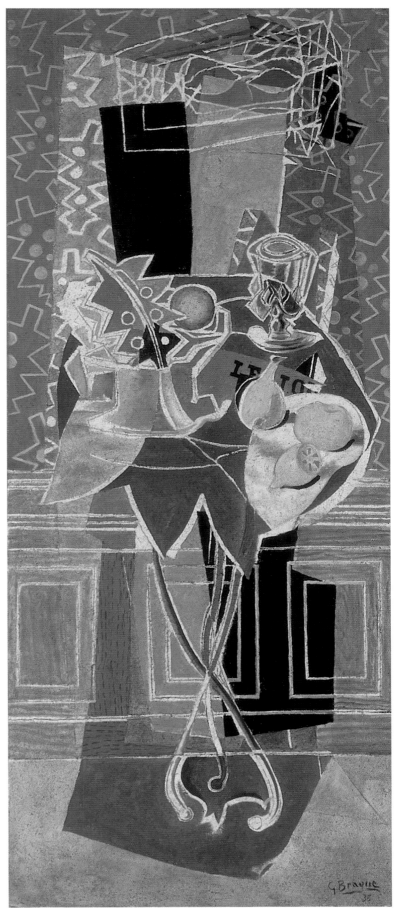

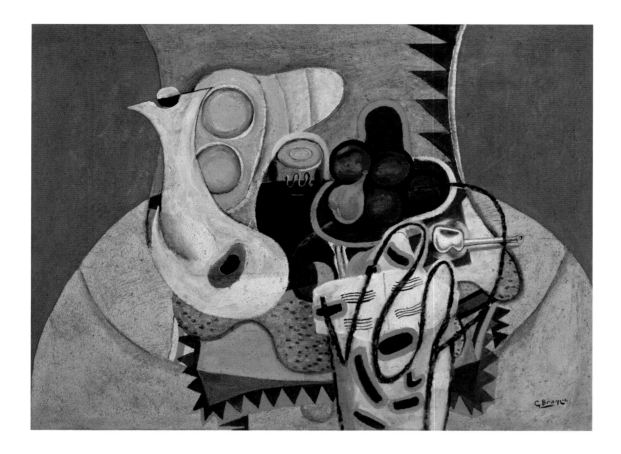

Fig. 2 [LEFT]
Georges Braque
The Pink Tablecloth
1933
Oil and sand on canvas
38 ¼ x 51 ¼ inches (97 x 130 cm)
Chrysler Museum of Art, Norfolk, VA.
Gift of Walter P. Chrysler, Jr.
Chrysler Museum of Art, Norfolk, VA.
71.624

Fig. 3 [BELOW]
Georges Braque
Still Life with Sheets of Music
1936–38
Oil on canvas
45 x 58 inches (114.5 x 145.5 cm)
Gift of Mary and Leigh Block,
1988.141.6
The Art Institute of Chicago

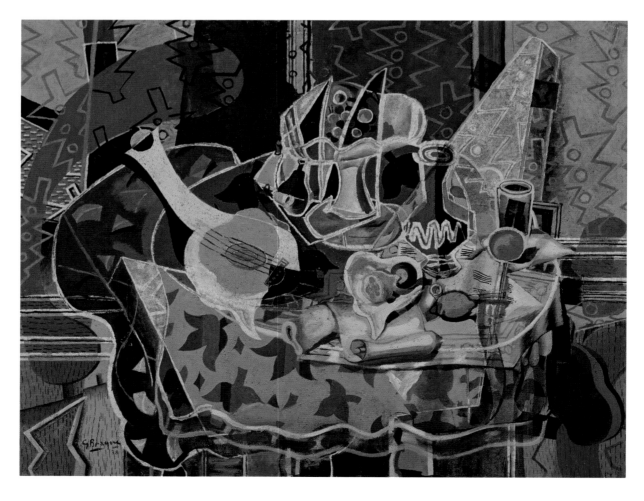

(absent in the second version), casting light and symmetrical shadows that contrast strongly with each other. Although the second version is a bit simplified compared to the first, these two paintings read with a great deal of complexity. The fundamentals of traditional still life are overturned by the intrusion of heterogeneous elements and by the nearly baroque inventions which Braque had not yet begun to explore extensively. Furthermore the entire *Tablecloth* series (*The Yellow Tablecloth* (1935, **Plate 30**), *The Mauve Cloth* (1936, **Plate 32**), but also *The Pink Tablecloth* (1933, **Fig. 2**), *Still Life with Guitar I (Red Tablecloth),* (1936, **Plate 33**) or *Still Life with Fruits and Stringed Instruments* (1936-1938, **Fig. 3**) combine unrestrained decorative motifs, changing shapes, and increasingly bold if not aggressive color associations in the same way (see for example *The Pink Tablecloth,* **Fig. 2**). A new spirit seems to take hold in Braque's painting, a baroque fantasy that animates the little theater of objects set up by the painter on tables that are themselves fantastically colored. It must however be underscored that the backgrounds in front of which the tables, or gueridons, supporting the still life arrangements are placed, remain compartmentalized and geometrically organized—even if the compartments in question are filled with colors and rich patterns, the compositions still always rely on a solid linear structure.

During the same years, Braque debated with Tériade the role chance and the unconscious played in his creative process. Published in the third edition of the review *Minotaure*, traditionally more of a Surrealist publication, the following astonishing words were accompanied by an image of *The Pink Tablecloth*: "Impregnation is everything that enters into us unconsciously, everything that develops and preserves itself through obsession, and that releases itself one day through creative hallucination. Hallucination is the definitive realization of a long process of impregnation whose beginnings date back to our youth," declared Braque.[3] Is this to say that objects, effectively always the same since he began to paint —fruit, guitars and mandolins, newspapers, glasses and bottles—have endured this slow transformation, have passed through the deepest layers of the unconscious, through voluntary and involuntary memory (in which we see a Proustian notion), to access at last the liberating form of "hallucination?" This notion of "hallucination" (a word that Braque borrows from his friend Carl Einstein[4]) allows for a better understanding of the profoundly disturbing nature of these very beautiful and very strange paintings. They utilize the methods of apparition, of visions and of metamorphosis, without losing anything of their time-honored pictorial technique and traditional simplicity, or their "artisanal" quality, in the best sense of the term.

In 1949, Braque began work on a series of exceptional paintings that all bear the title *Studio*. In these works, the very nature of still life finds itself transported to a level of density and of complexity never before seen and never equaled since. He presents a total view of the most intimate space, the space of development and accumulation, where his works are born. As always, Braque does not focus solely on an inventory of objects, but attaches himself to their relationship with

space, fixating on their ultimate interconnectivity. In *Studio V* (1949-1950, **Plate 40**), or in *Studio IX* (1952-1956, **Plate 41**), which concludes the series, he gathers together not only the easily recognizable elements with which he is ordinarily surrounded—his tools (easel, palette, brushes), his common subjects (jars, stools, sculptures), his furniture (lamps, chairs, tables)—but also the hidden figures of his mental universe. Is the bird that crosses *Studio IX* a painted figure (in an unfinished work) or is its presence a dream, a hallucinatory image? The implausible course of this bird splinters the measured space of the piece (on a square canvas) into vivid splashes of yellow, and magically enlarges it. As he did in the previous series, the painter translates his entire experience in this work through the different degrees of material presence of the objects, their palpable and granulated qualities, and through the contradictory sensations they evoke (empty and full, opaque and transparent, apparition and disappearance, night and day). Before this field that is open to meditation, the viewer loses the habitual and reassuring points of reference: one may only ascertain the malleability of a painting that can express, absorb and communicate everything, that has the power to expand space and to unfold the most hidden mental convolutions; or to withdraw into the simplest, most raw depiction. In the *Studio* series, by means of division, dislocation, superimposition, and suggested transparency, space seems to increase in successive layers, beneath the surface of the canvas as well as in front of it, toward the viewer. It is as if the painter was inviting the viewer to enter into his space literally: into his studio, into his mind, and into his vision.

With the exception of several splashes of color (a tint of exquisite rose on the palette, yellow fragments around the bird like a shattered stained glass window, or the red lettering of his signature), browns and grays dominate this final *Studio* piece, as they do in the majority of Braque's work after 1919. These shades of color, somber without being opaque, embody the vague and metamorphic substance that is memory, and they help give body to the thinking space that is for Braque the space of the painting. More than other painters, Braque knew how to make the surface of a painting "a pictorial fact" as he referred to it[5], the place for a thought in motion. This thought is still in motion for those who look upon these works and who take them in, at length, in their entirety.

Translation by Sara Ansari

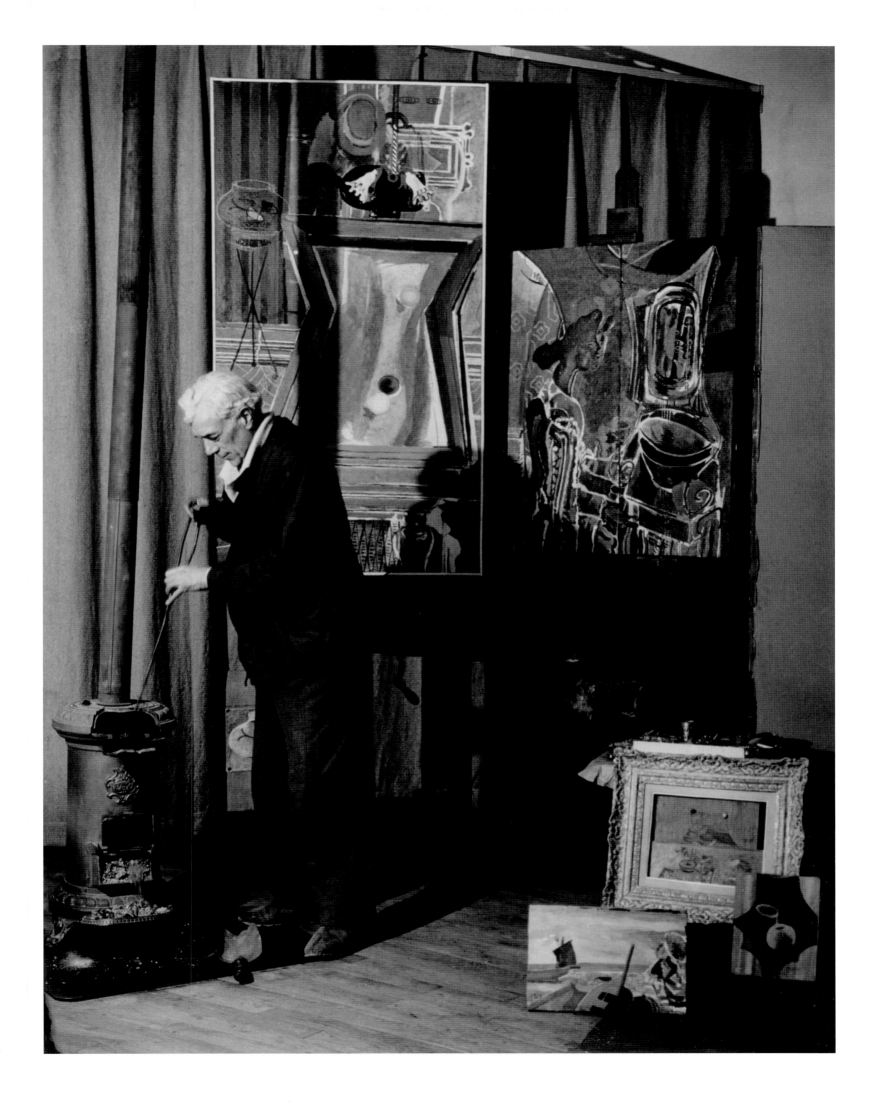

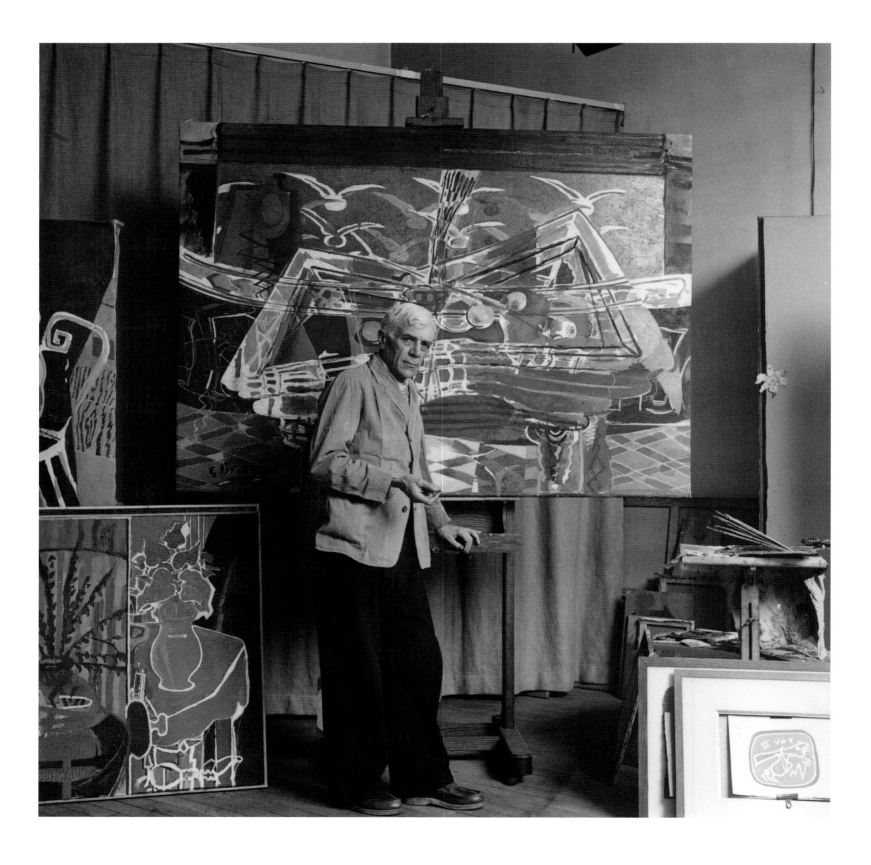

1

Words of Braque from a 1961 interview with Jacques Lassaigne, and reprinted in "Un entretien avec Georges Braque," *XXème Siècle*, vol.XXXV, n°41, 1973

2

Marcel Proust, "A l'ombre des jeunes filles en fleur," from the second volume of *A la recherche du temps perdu* Gallimard, Bibliothèque de la Pléiade, tome 1, Paris, édition de 1962

3

The words of Braque as recorded by Tériade in, "Emancipation de la peinture," *Minotaure*, n°3-4, 12 décembre 1933

4

See the monograph published by Carl Einstein in 1934, "Georges Braque," Paris, Editions des Chroniques du Jour. A member of the group "Documents," this German writer and art historian was a friend and admirer of Braque's work. He would organize the first retrospective of Braque's work in 1933, at Basel's Kunsthalle.

5

"The purpose of painting is not to reproduce an anecdotal fact, but to produce a pictorial fact" in "Pensées et réflexions sur la peinture" *Nord-Sud*, décembre 1917. The original French citation is the following: "Le but de la peinture n'est pas de reconstituer un fait anecdotique, mais de constituer un fait pictural"

Georges Braque in his Paris studio, with *The Billiard Table* and *The Double Bouquet,* 1948.
Photograph by Willy Maywald

Richard Shiff

Infinition

To render indefinite

In December 1917, Georges Braque published twenty aphorisms as a presentation of his thoughts on aesthetic practice. A brief editorial statement introduced the Braque doctrine as "a beacon for those who follow with interest the evolution of contemporary art." A closely linked sequence of three among Braque's twenty illuminations captures the core of his attitude toward painting:

> The subject is not the {represented} object; it is the new unity, the lyricism that derives wholly from the means.
>
> The painter thinks in forms and colors.
>
> The aim is not to take care to *reconstitute* an anecdotal fact but to *constitute* a pictorial fact.[1]

Each of these notes establishes more or less the same principle of encounter and interaction: a painter at work with a material means of picturing is already constituting art. Braque brings to the sense of a "fact" the connotation of something dynamically produced rather than merely existing. (In French, the noun *fait*, fact, corresponds to the adjective *fait*, made, done; in English the same connection appears through the Latin etymology of *fact*.) Nothing more than the artist and the means is needed for the fact of art—no studio model or *plein air* view, no academic plan or program, no philosophical concept or theory, no advance definitions to guide the process. With Braque, the represented object, the traditional "subject" and aim of painting—whether portrait, landscape, or still life—takes second place to "lyricism," a subject more immediate and intimate, yet indeterminate. In the art that Braque proposes, the topical aspect of the subject (what we usually mean by "subject matter" or "content") remains as an arbitrary feature, while the essential subject lies elsewhere: in feeling. "The Renaissance painters painted what they saw, but ... one must paint what one feels."[2]

PLATE 15 [DETAIL]
Georges Braque
Glass, Bottle and Newspaper
1912
Charcoal and faux-bois wallpaper on paper
18 7/8 x 24 3/8 inches
(48 x 62 cm)
Fondation Beyeler, Riehen/Basel

To work in a lyric mode is to feature personal sensation, emotion, and reflection, leaving to others the cultural themes of a more generalized epic mode. It was not every artist of the early twentieth century who translated his or her modernity into lyrical form, but Braque did. No cultural or political imperative dictated his particular use of the means.[3] He was a painter left to his paints, one on one; this situation was stimulating enough. Braque recalled that from a relatively early stage in his aesthetic development whatever third element he might once have believed essential in motivating his art had slipped away—whether a phenomenon of nature, or a cultural force, or the pressures of the historical context, or any such "anecdotal fact"—the items interpreters use to explain particular plays of aesthetic imagination. "I no longer needed sunlight," Braque realized; "I brought my light with me."[4] He had himself, and he had his material means.

By 1917, the year of his notes, this lyrical Braque had lived through a cultural catastrophe on an epic scale. The Great War had terminated a period of particularly intense artistic invention. Braque suffered grave wounds at the front in 1915 and slowly recovered while remaining in military service. After two years, he was released and able to return to the privacy of a studio to paint. The period preceding the long war had already become mythologized in memory. During subsequent decades, interviewers often asked Braque to reflect on what had happened—how the succession of innovations between 1906 and 1914 had occurred and what it all signified. With regard to the strategy of his early Cubist constructions around 1908, Braque spoke of following an intuition to organize landscape scenes and still life arrangements "from the background planes forward, bringing [the space and material of the picture] closer to me piece by piece."[5] This method of planar projection—a kind of perspective in reverse—satisfied his desire "to touch the thing and not only to see it," to reach across what he often called "tactile" or "manual" space, a physical space of active manipulation. Throughout his career, Braque opposed tactile space to the dematerialized space of visuality, whether philosophical and scientific (as in the past with Renaissance masters) or oneiric and automatistic (as with the painter's Surrealist contemporaries of the 1930s and 1940s).[6]

In the several years after 1908, Braque intensified his pursuit of the reality of "tactile space." Radical innovation continued as he painted surfaces that evoked the angular shifts of faceted planes, made a number of three-dimensional constructions in paper, and then in 1912 reached deeper into materiality by way of *papiers collés*—all fields of experimentation he shared with Pablo Picasso. Braque's heavy, blunt parallel strokes in the painted figures of these years—as in *Man with a Mandolin* (1911-12, **Fig. 1**)—asserted his physical involvement with the material process. The method demonstrated that a painting resonates with the painter's tactile contact while it sets the elements of its representation into visual order. Braque's insistent mark signifies light, shadow, surface, and space, all given equally frank material presence, as if antonymic qualities, such as light and shadow, were opposed in name only and might be exchanged in graphic form:

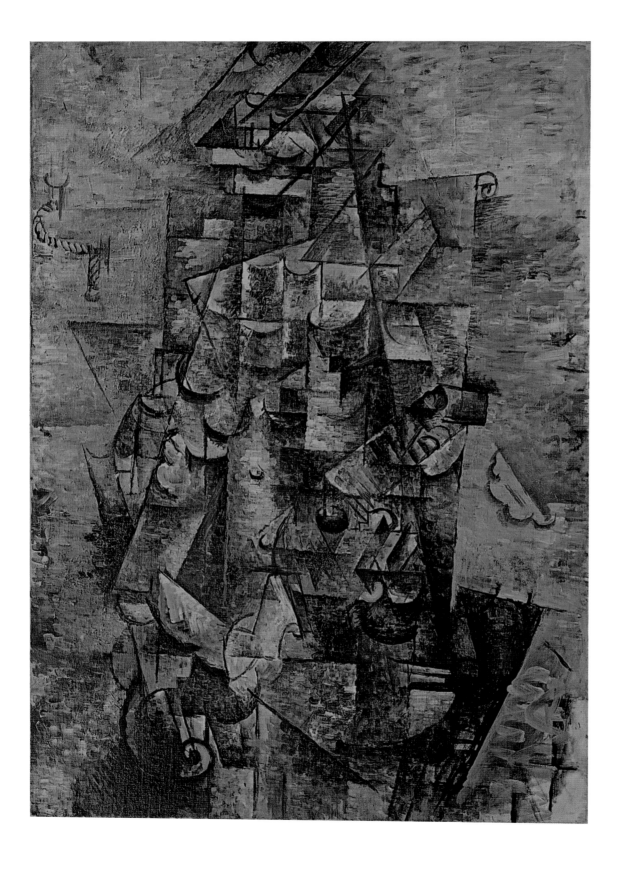

Fig. 1
Georges Braque
Man with a Mandolin
1911–1912
Oil on canvas
45 ¾ x 31 ⅞ inches
(116 x 81 cm)
The Museum of
Modern Art, New York.
Acquired through the
Lillie P. Bliss Bequest

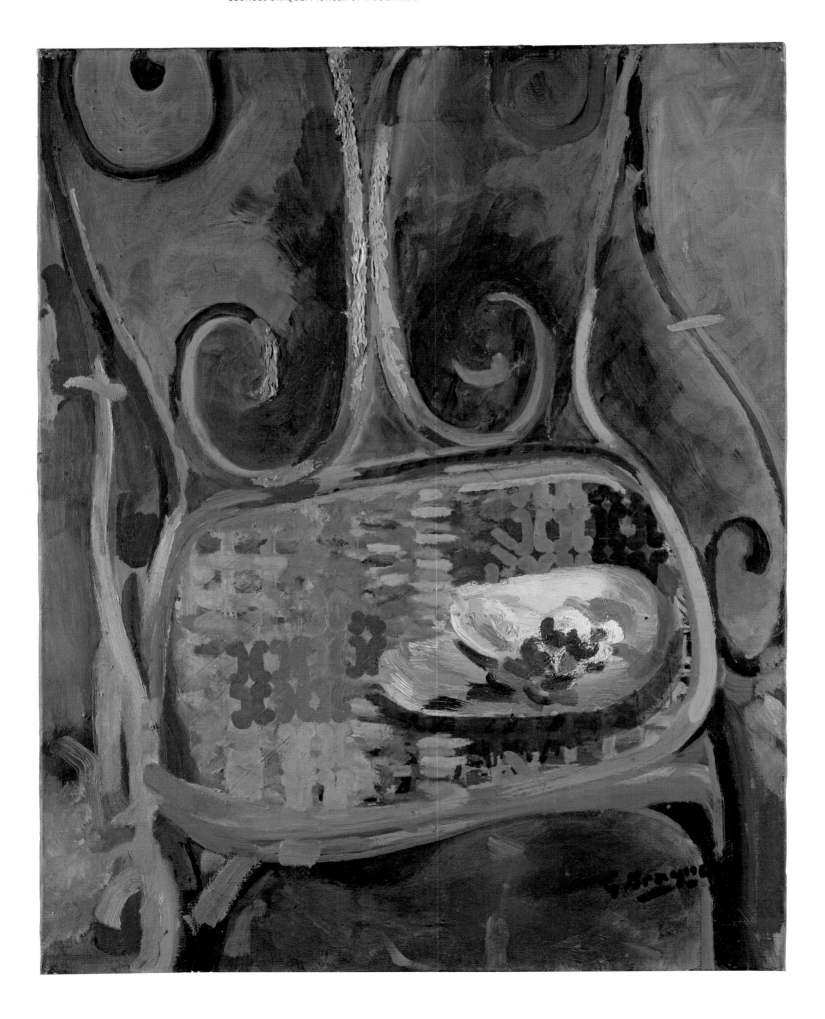

the antonymic becomes the metonymic. The painter's mark is as evident in the representational voids (the spaces of a background that refuses to stay back) as it is in the solids of a central figure. Certain details of Braque's marking seem like tests or trials of his hand, a cataloguing of its touch. At the lower left corner of *Man with a Mandolin* he applied thick, broken diagonal strokes, a kind of hatching that appears arbitrarily placed, neither part of the figure nor part of the ground—an accent that accents nothing in particular. At the lower right corner we find its fluid counterpart, a curling, wavy flourish of the brush; this mark or gesture seems just as anomalous, probably even more so, than the hatching. Braque was exercising his paint and his touch, allowing each to resist the other and to correspond to the other—he undermined such analytical differences, even such dynamic ones.

In terms of the legibility of the image, many of Braque's late paintings are less problematic than the so-called Cubist works, but the same concern for the directness and complications of touch remains in play. When rendering a common garden chair (1947-60, **Fig. 2**), Braque articulated the structure clearly but configured its voids or background areas with such tactile energy that he needed to reassert the linear frame of the foreground object, gradually thickening and brightening it with yellow and orange-red, in tension not only with the violets of the ground but also with a pale, acidic green, the primary descriptive color of the chair itself. Each element seems destined to outdo another in an adjustable, even reversible, hierarchy. From the ground, to the chair frame, to the patterned chair seat, to the palette resting on it, to the paint deposits on the palette: each level seems a little more aggressive in color or texture than the last, so that together all push forward—"closer to me piece by piece," as Braque had explained, indicating his past experience but also projecting a future. This was the effect in 1960 as much as in 1910. And to this end, "to make of touch a form of materiality," Braque often "introduced sand, sawdust, iron filings," and other common byproducts of craft into his fine-art paint, extending its substance as well as the range of its color.[7] Optical color plus tactile texture amounted to more color than color alone.

Regarding the *papiers collés*, Braque declared, "I brought sculpture into the canvas."[8] His constructed image was acquiring substance; it was substance. The *papiers collés* achieved representation by setting pieces of material in mutual contact. Here, touch itself was represented, one thing touching another. In this respect, a work in *papiers collés* is hardly a representation at all—more a material "constitution" than an optical "reconstitution" (to invoke Braque's terminology of 1917). When the tactile sense becomes the focus of representation, to cause pieces of material to make contact amounts to a presentation, not a representation; or, at the least, the artist's pictorial action confuses this distinction. Touch or materiality is the location of Braque's primary "lyricism," the personal experience embodied in his art. In *Bottle, Glass and Pipe* (1914, **Plate 22**), the configuration of objects on a table is a secondary optical effect; ahead of it is a more concrete sense of the touch of things and of the capacity of a body (of the artist or of a thing) to move

Fig. 2
Georges Braque
A Garden Chair
1947–1960
Oil on canvas
25 ⅝ x 19 ¾ inches
(65 x 50 cm)
The Metropolitan
Museum of Art, New York.
Jacques and Natasha
Gelman Collection, 1998
(1999.363.10)

through and displace space, as any object does. In a related work of *papiers collés* from after the hiatus of the war, *Bottle and Musical Instruments* (1918, **Plate 24**), the corrugations that characterize a cut piece of cardboard remain emphatically tactile within a group of pasted papers perceived as variations on visual tone and texture. Here, Braque established a range of touch from rough to smooth as well as a range of tone from dark to light. The two senses intersect without fully corresponding; nor do they follow a recognizable natural order. "I brought my light with me," Braque said; his new objects, creations of the studio, would retain their material force under high or low illumination and even in darkness. His works were not illusions but things like other things. He would sometimes take a work outdoors to compare its qualities to the things of the world seen in natural light.[9] This was the test of a painter's tactile space.

The physicality of Braque's early Cubist methods crystallized his aesthetic thinking; he was an artist who derived his intellectual notions from experience, from practice, rather than deriving his practice from a theory. He even argued in principle against all theorization, despite being good at it himself. Like Nietzsche, another non-theoretical theorist, he adopted a rhetoric of aphorism. Alluding to a Nietzschean sense of self-liberation, Braque stated late in his career that setting a goal for painting—whether for an artist's cumulative professional accomplishment or merely for the work immediately at hand—was to enslave oneself to a preconceived end, eliminating the opportunity to discover anything other than what one could already imagine.[10] This was the core of his objection to Surrealism: despite having the capacity to touch on the unconscious, the Surrealists' automatistic practice was a preformed notion that dictated behavior. As such, it "ended in enslavement."[11] Paradoxically, the Surrealist method, as open as it was, restricted the possible range of surrealist results. Braque preferred a limited method with open results.

For analogous reasons, Braque resisted the heritage of Renaissance art and its scientific perspective. As with Surrealism, the flaw in Renaissance method appeared with its predictable outcome; it fixed its representational object all too securely. Braque explained his position by coining a word: "For me, it's never a matter of rendering things absolute. ... I never try to give things definition, I'm always being led to a kind of 'infinition.'"[12] Braque's French neologism *infinition* plays on the infinite as unbounded or unending and also involves the negation of a painter's finish (*le fini*). *L'infinition* serves as the negative of *la définition*. If to give an object a definition is to limit its sensation to a fixed concept, to contain it, then to apply a process of infinition is to remove all restrictions, allowing the object to be now this, now that—so that it might *feel* now like this, now like that. Braque associated the condition of infinition with art that renders "the thing as lived," as opposed to "the thing as [merely] represented," that is to say, fixed. "The Renaissance masters represented things, they did not live them. ... If you try to define a thing, you replace the thing with the idea you have of it, which is generally false."[13] Why "false"? Things encountered in life are mutable. A fixed concept never captures the changing thing; the idea, completing itself in

definition (this X is a case of Y), is at best a reduction. Infinition un-fixes, un-finishes what would otherwise be defined and conceptualized rather than felt. A practice of infinition is consistent with the open flow of a lyrical art. Braque's friend, the critic Carl Einstein gave a related account of Cubist practice, arguing that its merit was to have undermined the false dichotomy of subject and object. Full aesthetic experience was "a process possible only through the intimate union of these two forces [subject and object] ... a process continually open to change [labile], involving no fixed state, no static equilibrium."[14] This describes Braque's lyricism—its exchange of material properties and sensory feelings.

Late in his career, in 1954, Braque referred to a Zen principle that had been guiding him for decades, long before he actually studied Zen (which offered confirmation): "I do not believe in things; I believe only in their relationship ... For things to exist, there must first come into being a relationship between you and the things, or between the things themselves."[15] Braque created some of the "things themselves," and to do so, he had to have contact with things, with material substances. He enjoyed the craft of it, which led him to sculptural objects and ceramics as well as to painting, printmaking, and collage. As I have stated, a model for representation was not essential to Braque's practice; he required only to choose a means of representation. He himself became an element of the means. "When I am making a sculpture of a horse," he said, "when I am working on the leg, I raise mine."[16] When subject and object or sensation and material converge, when an artist can feel clay or plaster within his hand just as he can feel his own leg, such an artist can do without the horse.

Between use and means

Braque recognized that conventional art either derived visual imagery from existing concepts and definitions or shaped its object with the aim of acquiring a definition. Both scenarios result in imagery with limited morphological reach. Braque opened a tactile path to an expanded range of imagery. To the extent that he then rationalized his position, it was a matter of hindsight, not projection. He avoided attributing his aesthetic trajectory to any single motivation; nor did he associate his result with an end or purpose achieved. Perhaps he had always had a goal but had attained it so early in his career that all activity afterward amounted to a way of life, his way of life; and he needed no goal. He made his art as naturally as a person breathes. Breathing requires no concept.

Despite the fact that Braque's public identified his achievement with Cubism, the principles he announced in 1917 had already been realized and exemplified in the work of his Fauvist interlude of 1906-07. When he discussed the history of his involvement with material touch—his various ways of developing a physically enhanced surface, whether with manipulated paint or by introducing other materials for the sake of their color and texture—he referred to "precedents in

certain Fauve canvases."[17] Fauves such as Henri Matisse and André Derain, as well as Braque himself, applied paint with extraordinary directness, treating the viscous material as a substance as well as an assertive line or a saturated color. It may have been Braque who was the most conscious of this constellation of associated features: substance, materiality, touch.

In 1906, Braque depicted the Mediterranean light of L'Estaque and, shortly before this, the Atlantic light of Antwerp. His *Seascape, L'Estaque* (1906, **Fig. 3**) displays virtually the same chromatic range as analogous Northern views. It was as if the painter were demonstrating that "the subject is not the object," for the object was changing while the lyrical subject did not. Braque's various canvases of 1906 feature direct juxtapositions of red and green, violet and yellow, applied with the most evident materiality. Freely arranged, his colors "constitute a pictorial fact" and become, only in their secondary function, the description of a limited number of characteristics of the locality. Whether L'Estaque or Antwerp, the given configuration of land, water, and sky remains no more than summarily translated. A sense of height and a distinctive form of vegetation distinguish the southern location from the northern one. In March 1906, as if to speak for Braque as well, Derain wrote to Matisse that their generation of artists was fortunate in being the first at liberty to capitalize on a newly acknowledged condition: whatever material an artist chose to use would assume "a life of its own, independent of what one makes it represent."[18] The means would come first, followed by its object, so that the "subject" of art would be the means and not the representation. This is much of what Braque meant by "lyricism" in his notes of 1917.

As we know, a lyrical expression—lyric poetry, for example—derives from the sensations felt by an individual in a specific situation or encounter. Lyricism projects individual agency beyond any generalized cultural principle. Braque invented his artistic representations according to the experience of his means, the colors and textures he felt through his involvement with the tactile space of painting. To say, as he did, that "the painter thinks in forms and colors," was to transfer this body of "manual" sensation, the painter's craft, to the traditional seat of invention, the mind or intellect. For Braque, thinking and feeling, concept and craft, were one. Accordingly, he issued a warning: "Be satisfied with discovery; take care not to explain."[19] The danger in explanation was that it strives for analytical closure; it divides thinking from feeling. The beauty of Braque's aphoristic mode of "explaining" himself was that the meaning conveyed would remain on an intuitive level—part thought, part feeling, open to additional thought and feeling. The analytical component of an intuition is never devoid of emotion.

With respect to morphological flexibility and unfailing pictorial openness, Braque took encouragement from the example of Paul Cézanne, a predecessor whose means entailed a similar stress on the tactile. Cézanne's characteristically blunt, coarse markings tracked his touch across a canvas surface, with the painter inventing the pictorial image as he moved along, discovering

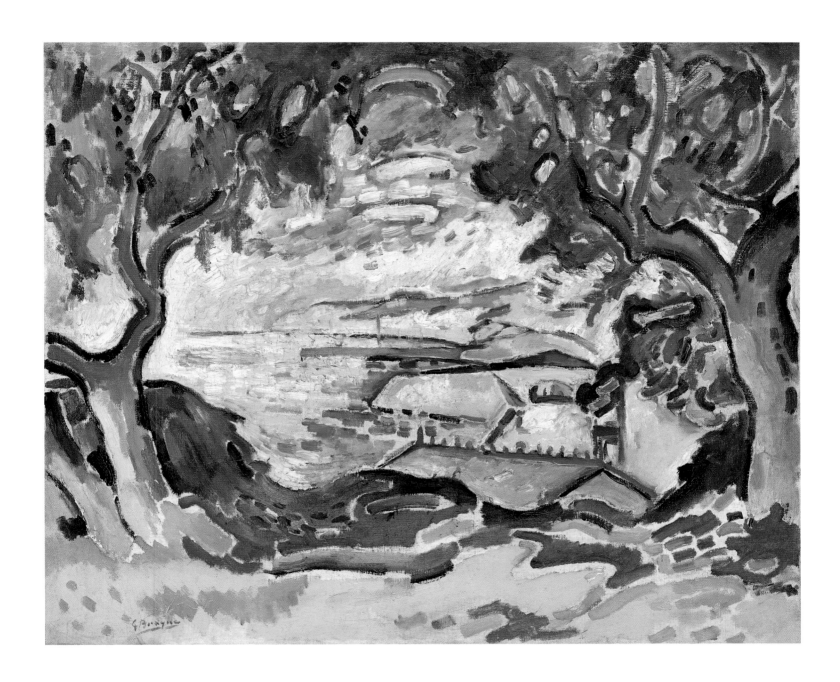

Fig. 3
Georges Braque
Seascape, L'Estaque
1906
Oil on canvas
23 ¼ x 28 ½ inches (59 x 72.5 cm)
Carmen Thyssen-Bornemisza
Collection, on loan at the
Thyssen-Bornemisza Museum

Fig. 4 [ABOVE]
Paul Cézanne
The Sea at L'Estaque
1878–1879
Oil on canvas
28 ¾ x 36 ¼ inches
(73 x 92 cm)
Musée Picasso, Paris

Fig. 5 [BELOW]
Paul Cézanne
L'Estaque
1879–83
Oil on canvas
31 ½ x 39 inches
(80.5 x 99.5 cm)
The Museum of Modern Art,
New York. The William
S. Paley Collection.

his motif rather than recording it. Braque liked to contrast Cézanne to Édouard Manet: Cézanne lacked the talent and finesse of Manet, which led the latter's paintings into agreeable, familiar patterns. Manet had technical mastery, but Cézanne was the more imaginative and inventive of the two. Manet's skill amounted to a science, as opposed to Cézanne's art: "The scientific fact is the repeated fact. The artistic fact is the invented fact."[20] Here Braque, speaking to an interviewer around 1950, could have made the same point with his language of 1917: "The aim is not to take care to *reconstitute* an anecdotal fact [a repeated fact] but to *constitute* a pictorial fact [an invented fact]." Each of Cézanne's paintings—each of his marks, actually—became a new "pictorial fact," a thing made (*fait*) on the spot rather than a representation of some other thing or phenomenon. Cézanne's new fact had a profound effect on Braque's Fauvist and Cubist generation, especially around 1904 to 1910.[21] More than any other artist, Cézanne had made it possible for Derain to say that now (in 1906) the painter's means could assume "a life of its own." Cézanne "cleansed painting of the idea of mastery," Braque stated years later; "he bound his life into his art, his art into his life."[22] Art was a product of the artist engaged with the means as if without any guidance whatever—no concept, no external conditions. Such art was something to be lived through. Cézanne, Braque said, "took risks."[23] To work with a means, but without the security of mastery, was risky.

Given the pictorial facts of Braque's own art, what might he have been noticing in Cézanne? What constituted Cézanne's risk? By conventional standards, Cézanne's facts, his marks of paint, the "little sensations" he rendered, appeared to have been arbitrarily positioned with respect to the representational scene that served as his model.[24] The marks failed to respect the logic of a naturalistic spatial order. They responded instead to emergent rhythms played out across the surface of the canvas. With Cézanne's technique, it might appear that elements of the nominal foreground and background became interchangeable. In *The Sea at L'Estaque* (1878-79, **Fig. 4**), strokes of blue and green representing the Mediterranean turn in various directions so that segments of the depicted water relate to directions implied by other, more linear features of the view, such as the trunks and foliated branches of trees, a tall industrial chimney, and the contours of architectural structures. The represented sea loses its integrity for the sake of the material facts of the surface of marks. What ought to appear as a conceptual unit—whether we perceive it as the sign of water or an abstracted blueness—becomes as fragmented as every other part of the image. All has been experienced in and felt through the painter's touch-by-touch process of discovery. In Cézanne's related landscape *L'Estaque* (1879-83, **Fig. 5**), various representational features appear to have been infected by the properties of their neighbors. In the area just below the center of the composition, patches of green foliage acquire an architectonic feel, while the planar structures of the depicted architecture (if this is what it is) sometimes appear more like foliage and sometimes more like rock. Colors and contours conventionally associated with one representational feature or another reappear where they should not be.[25]

We might plausibly argue that Braque learned Cézanne's morphological lesson (whether or not this was Cézanne's conscious teaching): one thing relates to another thing; the reality an artist *feels* is in the relations. I have already quoted Braque's statement, "I do not believe in things; I believe only in their relationship."[26] He also put it this way: "What lies *between* the apple and the plate is also painted. ... It's precisely the relation of these objects between one another and of the object with the 'in-between' that constitutes the subject. How can I say what the picture 'represents' when the relationships are always different things?"[27] The relationships remain unstable; they change. Then how did Braque paint the in-between? In his earlier years, when the connections to Cézanne are most evident in Braque's own pictures of L'Estaque, he allowed the represented properties of architecture, trees, and grassy or rocky ground to intermingle. A color or contour line would pass into an alien area, as in the immediate central foreground area of *Houses at L'Estaque* (1908, **Fig. 6**), or, even more obviously, in the analogous area of the smaller study of the same subject (1908, **Fig. 7**). In the bottom right corner of the smaller composition, there is a green plane that evokes vegetation because of its color, while it also suggests architecture because a segment of this plane is ochre and the whole assumes a rectilinear form. Its diagonal edge passes into the base of a central tree, where it changes color in an ambiguous way, to suggest all three representational features: tree, architecture, ground vegetation. The painter has rendered the in-between.

While visiting L'Estaque, Braque seems to have generated his pictures at their site, or at least in its inspirational vicinity; shortly afterward, he produced a closely related *Houses, La Roche-Guyon* in Paris during the winter of 1908-09 (**Fig. 8**). Its details of geometric architecture, organic trees, and the irregular passages of the surrounding land are generic pictorial features, like the elements of a traditional still life. As in the works from L'Estaque, *Houses, La Roche-Guyon* pictures the in-between as it appears in the working of the specific pictorial motif. This is perhaps most obvious where bands of green and gray extend to the right of the central tree, as if infected by the geometric character of the architectural planes still farther to the right. The interior markings of these bands sometimes follow the direction of hatchings in the architecture or in the tree and yet are sometimes opposed to both (a situation to be observed in Cézanne's paintings). This area of *Houses, La Roche-Guyon* is independent and yet not: its status is in-between. Facets of ochre, green, and gray to the left of the same central tree comprise still another instance of the in-between. Here, a succession of planes mimics the organic bends of the adjacent tree. Like Cézanne, with his otherwise unarticulated voids that occupy areas of surface beside represented objects (bits of table, wall, water, sky), Braque made the in-between into a thing. His insistent markings materialized it.

In the paintings of his later years, Braque's layered tracings of schematically representational forms imply a state of superposition and transparency. We might see both a palette and the

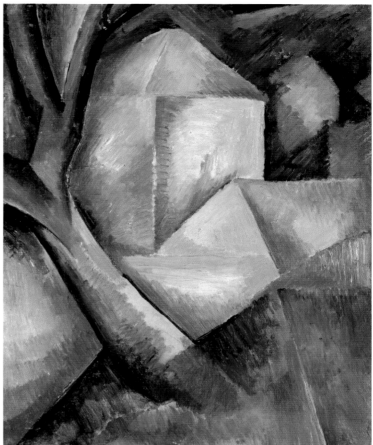

nominally hidden part of the chair it rests on, or both an easel and the furnishings and wall it stands in front of: the entirety of the enclosed volume of Braque's studio has become an in-between (see *The Billiard Table* [1944-52, **Plate 38**]; *Studio V* [1949-50, **Plate 40**]). In *Woman at an Easel (Yellow Screen)* (1936, **Plate 34**), picture framing combines with the ruffled dress of a female model as Braque imposes one motif on another. The decorative curve of an easel morphs to its left into a succession of units of wallpaper pattern that lead back to the irregular curve of the model's dress. One thing becomes another. Braque, as always, demonstrates that reality lies in the relationships.

The Billiard Table (1944-52, **Plate 38**), is one of many paintings to which Braque applied sand as a way of stressing the tactile materiality of the roughened surface. He rubbed some areas of sandy paint with charcoal, producing a gritty quality—a textured and darkened variation on the color of the paint. The grainy surface scatters ambient light, muting its effect, like a film or vaporous cloud that passes between the viewer and the object. There are also vertical streaks of muted, sandy white, most evident where they seem to lie not on, but in front of the billiard table with its recessive central fold. The streaks assert a mirror-like surface plane, but without occupying a logically specific position; the fold suggests perspective into depth, but no perspective in particular. Braque said of his painting during the 1940s: "I work from the picture plane and take myself as much forward as back."[28] With its enhanced tactile presence and its intriguing optical

Fig. 6 [ABOVE, LEFT]
Georges Braque
Houses at L'Estaque
1908
Oil on canvas
28 ¾ x 23 ⅜ inches (73 x 59.5 cm)
Hermann und Margrit Rupf
Stiftung, Kunstmuseum Bern

Fig. 7 [ABOVE, RIGHT]
Georges Braque
Houses and Tree (Maisons et arbre)
Summer 1908
Oil on canvas
16 x 12 ¾ inches (40.5 x 32.5 cm)
Gift of Geneviève and
Jean Masurel (Paris), 1979
LaM, Lille métropole musée
d'art moderne, d'art
contemporain et d'art brut
Inv: 979.4.16

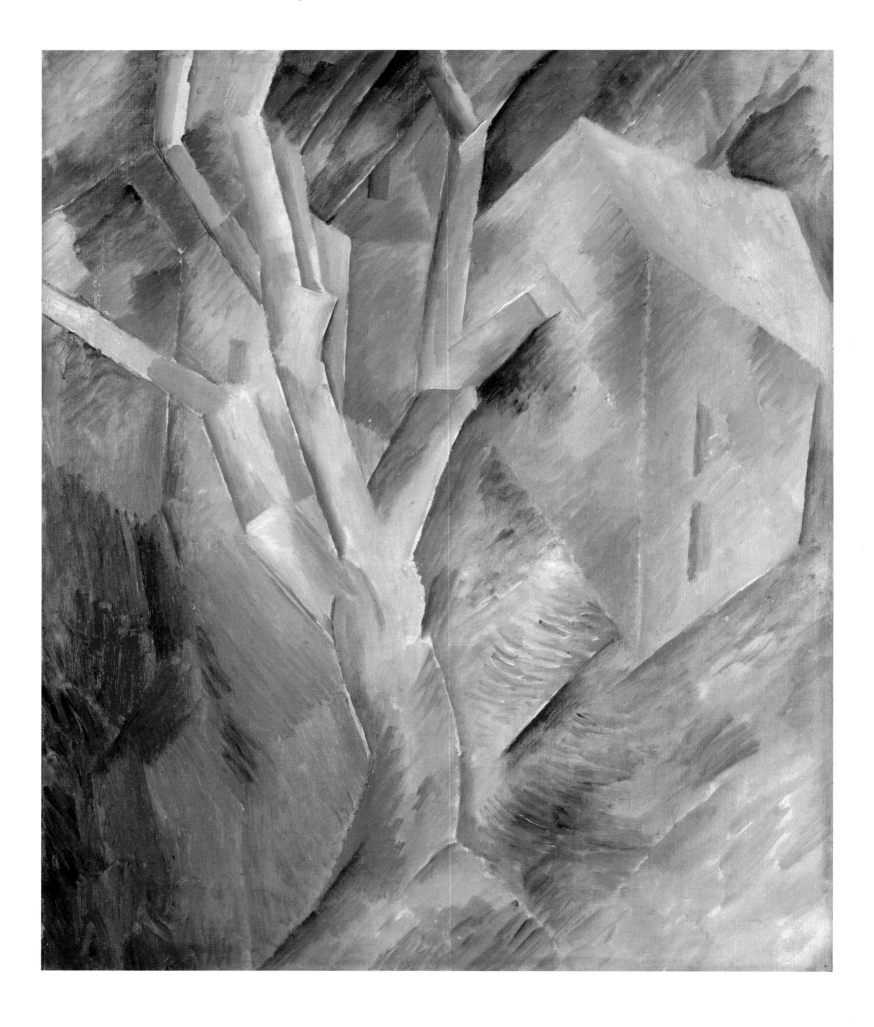

order, *The Billiard Table* is an impressive object. Beyond listing either its elements of representation (billiard table, lamp, and so forth) or its perspective ambiguities, it would be very hard to define what this painting shows. In any case, according to Braque, definition should not be the concern: "To define a thing is to substitute the definition for the thing."[29] Braque would argue instead that *The Billiard Table* manifests the course of a thought or a feeling that disappears, exhausting itself as the work proceeds, "to rejoin a state of intellectual nothingness."[30] The painting achieves endless mutability; it attains infinition.

Braque sometimes indicated his position to interviewers by introducing anecdotal accounts of the exchange of means and use. An object with a fixed use is an object limited, defined by its utilitarian purpose. To discover an unexpected use for an object is to have converted the object to a means, and a true means has no limit. Here are two of Braque's examples: a cyclist finds the handle of an umbrella in a trash can and uses it as the handle for his air pump; Braque himself, worried about the brakes on his car, uses a roadside stone as a wheel block, calling his action a "poetic transformation" of the stone. He added that, once returned to the roadside, the stone "does not exist any more. It becomes whatever someone else will make of it."[31] As a stone un-used, it loses its status as a means, as a dynamic fact in Braque's hands; in this respect, it no longer exists. When someone else finds—makes—another use for the stone, when someone converts it to a means, it will again exist as a fact.

A fact is something transformed, something made. A means of transformation has no defini-tion because its relations are endlessly subject to change: any means is a means to infinition. "At a certain temperature iron becomes malleable; it loses its sense of iron," Braque said; "that's the kind of temperature I'm seeking."[32] It was the temperature at which a material substance escapes definition and becomes a means, available to change, ready to be molded into any form and to serve any use of the moment. Change in the way of seeing things, including seeing paint-ings, "is what makes art living"—a means, a living fact.[33] Braque's practice kept the painter's means alive.

Fig. 8
Georges Braque,
Houses, La Roche-Guyon
1909
Oil on canvas
25 ½ x 21 ¼ inches (65 x 54 cm)
Art Gallery of New South
Wales, Sydney

1

Georges Braque, "Pensées et réflexions sur la peinture," *Nord-Sud,* December 1917, 3-4 (original emphasis). Variations and paraphrases of Braque's three statements exist in his notebooks and in recorded interviews both early and late in his career. The opposition between the anecdotal and the pictorial (as in the third of Braque's notes) had appeared in Maurcie Denis, "Définition du Néo traditionnisme" (1890), *Théories 1890-1910: Du Symbolisme et de Gauguin vers un nouvel ordre classique* (Paris: Rouart et Watelin, 1920), 1. All translations from French are the author's. I thank Jason A. Goldstein, Jessamine Batario, and Roja Najafi for essential aid in research.

2

Braque (1954), quoted in Alexander Liberman, *The Artist in His Studio* (New York: Viking, 1960), 40.

3

This is not to dispute the type of interpretive observation that would link Braque's images of muscular female nudes during the 1920s to the need perceived in France for postwar social regeneration. Rather, in the case of Braque, such thematic issues took second place to his continuing engagement with the means of painting, not always in harmony with a legible theme. He was not the best index of his social and political times. For the possibility of political echoes in Braque's imagery, see Romy Golan, *Modernity and Nostalgia: Art and Politics in France Between the Wars* (New Haven: Yale University Press, 1995), 18; Kenneth E. Silver, *Esprit de Corps: The Art of the Parisian Avant-Garde and the First World War, 1914–1925* (Princeton: Princeton University Press, 1989), 293. We have inherited a certain prejudice against the lyrical mode in twentieth-century art, given compelling arguments to the effect that the position had already become politically and psychologically compromised, if not untenable, as a result of the nineteenth-century conditions of bourgeois modernity; see Walter Benjamin, "On Some Motifs in Baudelaire" (1939), *Illuminations,* ed., Hannah Arendt, trans. Harry Zohn (New York: Schocken, 1969), 194. The prejudice extends from lyrical art to expressionistic modes of all kinds and has often gone unquestioned, especially among late twentieth-century writers,

who readily accept ironic forms of art (putative products of a conflicted or divided self) but not non-ironic forms (putative products of an integrated self). Both sides of the potential debate have merit; but the issues quickly become over-theorized, and the arguments would have had limited appeal to Braque.

4

Braque, quoted in Jean Paulhan, "Georges Braque dans ses propos," *Comoedia,* 18 September 1943, 6.

5

Braque, in Paulhan, "Georges Braque dans ses propos," 6. John Richardson reports a later conversation (presumably 1950s) in which Braque gave an alternative description of the effect that interested him: "It's as if the artist were behind rather than in front of the canvas, pushing everything outwards" (John Richardson, *A Life of Picasso: The Cubist Rebel 1907–1916* [New York: Alfred A. Knopf, 2007], 55).

6

Braque, quoted in Dora Vallier, "Braque, la peinture et nous: propos de l'artiste recueillis," *Cahiers d'art* 29 (October 1954): 16. On "*l'espace tactile,*" see also Georges Braque, "Notebooks 1917-1947," *Illustrated Notebooks* 1917-1955, trans. Stanley Appelbaum (New York: Dover, 1971 [1948]), 78. For Braque's statements on Renaissance art and Surrealism, see Georges Charbonnier, "Entretien avec Georges Braque" (1950-51) *Le monologue du peintre,* (Paris: René Julliard, 1959), 8, 11.

7

Braque, in Vallier, "Braque, la peinture et nous: propos de l'artiste recueillis," 17.

8

Braque, in Paulhan, "Georges Braque dans ses propos," 6.

9

For the associated anecdotes, see Alex Danchev, *Georges Braque: A Life* (London: Hamish Hamilton, 2005), 136-38.

10

Braque, in Vallier, "Braque, la peinture et nous: propos de l'artiste recueillis," 14.

11

Braque, in Charbonnier, "Entretien avec Georges Braque," 11-12.

12

"*Je ne cherche jamais à définer les choses, étant toujours porté vers une sorte 'd'infinition'*": Braque, in Charbonnier, "Entretien avec Georges Braque," 9. See also Braque, "Notebooks 1947-1955," *Illustrated Notebooks 1917-1955,* 117: "*Je ne cherche pas la définition. Je tends vers l'Infinition.*" Jean-Claude Lebensztejn (email to author, 14 June 2011) recalls the related pun by the nineteenth-century sculptor Auguste Préault: "*Je ne suis pas pour le fini. Je suis pour l'infini.*"

13

Braque, in Liberman, *The Artist in His Studio,* 40. For this reason Braque would allow a bit of white in a painting to become a napkin in a still life; but he would avoid beginning with the concept of a napkin, only to feel compelled to use white: "I think that the white area is something conceived before you know what it will become [as a representation]. There is a ... poetic transformation of the [material] thing" (Braque, in Charbonnier, "Entretien avec Georges Braque," 10).

14

Carl Einstein, *Georges Braque,* trans. E. Zipruth (German to French) (Paris: Éditions des Chroniques du Jour, 1934), 44.

15

Braque, in Liberman, *The Artist in His Studio,* 39. On Braque and Zen, see Danchev, Georges Braque: A Life, 100-03.

16

Braque, in Liberman, *The Artist in His Studio,* 40.

17

Braque, in Vallier, "Braque, la peinture et nous: propos de l'artiste recueillis," 17.

18

André Derain, letter to Henri Matisse, 15-16 March 1906, quoted in Rémi Labrusse, *Matisse: la condition de l'image* (Paris: Gallimard, 1999), 53.

19

Braque, "Notebooks 1947-1955," *Illustrated Notebooks 1917-1955,* 98.

20

Braque, in Charbonnier, "Entretien avec Georges Braque," 8, 18.

21

For some of the details of the response to Cézanne, see John Golding, "Cézanne, Braque, and Pictorial Space"; Richard Shiff, "Lucky Cézanne (*Cézanne tychique*)," in Joseph J. Rishel and Katherine Sachs, eds., *Cézanne and Beyond* (Philadelphia: Philadelphia Museum of Art, 2009), 257-69, 55-101.

22

Braque, in André Verdet, "Avec Georges Braque," unpaginated supplement to *XXe siècle* 24, no. 18 (February 1962).

23

Braque, in Liberman, *The Artist in His Studio*, 40.

24

On Cézanne's (somewhat ironic) reference to his sensations, see Octave Mirbeau, "Préface du catalogue du Salon d'automne 1909," *Combats esthétiques,* ed. Pierre Michel and Jean François Nivet, 2 vols. (Paris: Séguier, 1993), 2:485.

25

For an alternative way of describing what may have been Braque's perception of Cézanne, with the stress on Braque's turn to effects of perspective projection as opposed to a play of tactile marking, see William Rubin, "Cézannisme and the Beginnings of Cubism," in William Rubin, ed., *Cézanne: The Late Work* (New York: Museum of Modern Art, 1977), 176-80.

26

Braque, in Liberman, *The Artist in His Studio*, 39.

27

Braque, in Charbonnier, "Entretien avec Georges Braque," 10. As an example of the consistency of Braque's (well rehearsed?) statements to various interviewers, compare what Liberman (1954) and Charbonnier (1950) heard to what Richardson heard during the same period: "Objects don't exist for me, except when there is a harmonious relationship between them, and also between them and me" (John Richardson, "The Ateliers of Braque," *Burlington Magazine* 97 [June 1955]: 170).

28

Braque, in Paulhan, "Georges Braque dans ses propos," 6. In his still life paintings of the 1920s and later decades, Braque created an ambiguous play of dark and light contours; this is one of the devices that extends pictorial space both forward and back (see, for example, *Brown Still Life,* 1926, **Plate 29**). On at least one occasion, Braque seems to have assessed his work in terms of a division of the material and physical conditions that interested him. When interviewed by Alfred M. Frankfurter in late 1948, he spoke of his still life painting as intended—the words are Frankfurter's paraphrase—"to stir the tactile sense," whereas his landscapes would "create spatial volume," and his billiard table images would seek "movement, the life of the objects beyond the picture"; see Alfred M. Frankfurter, "G. Braque," *Art News* 47 (February 1949): 56.

29

Braque, "Notebooks 1917-1947," *Illustrated Notebooks 1917-1955,* 35.

30

Braque, in Charbonnier, "Entretien avec Georges Braque," 11. See also Braque, in Liberman, *The Artist in His Studio*, 40.

31

Braque, in Paulhan, "Georges Braque dans ses propos," 6; in Liberman, *The Artist in His Studio*, 39-40.

32

Braque, in Paulhan, "Georges Braque dans ses propos," 6.

33

"*C'est ce qui fait que l'art est vivant*": Braque, in Charbonnier, "Entretien avec Georges Braque," 15.

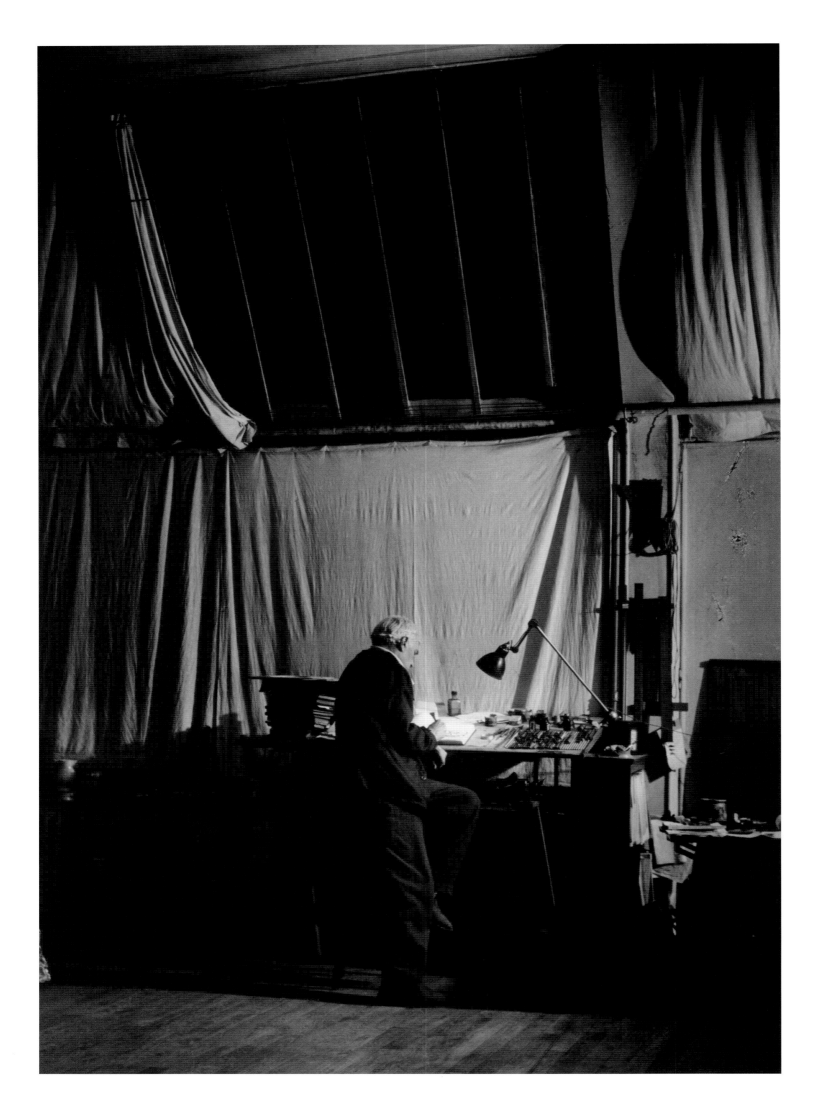

Georges Braque at his work table,
at night, in his studio on the rue
Douanier, Paris, 1946.
Photograph by Brassaï

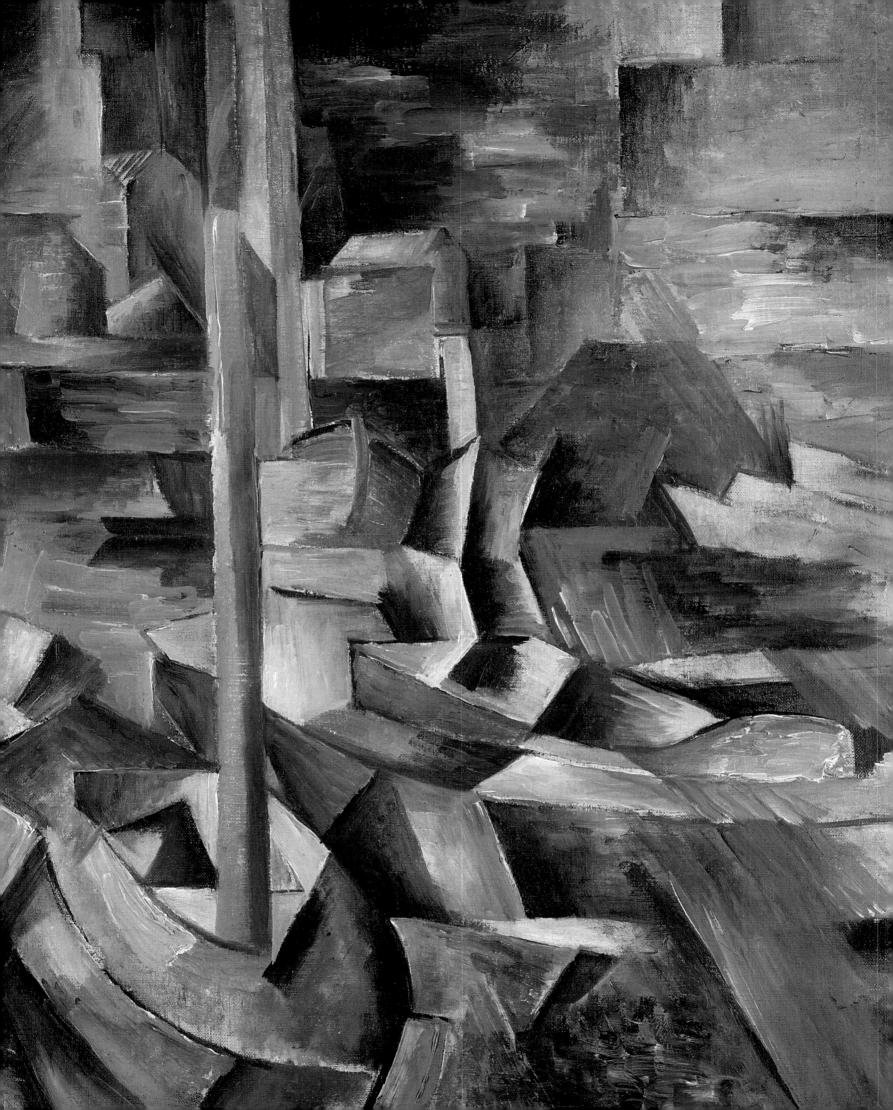

Dieter Buchhart

<div style="text-align: right">

Georges Braque:
The World as
Still Life

</div>

ALTHOUGH HE NEVER SAW HIMSELF IN THE ROLE OF THE REBEL, Georges Braque was indeed a revolutionary, in fact one of the greatest innovators in twentieth century art. For the artist saw "commitment and art" (the artist refers to l'*art engagé*) as "entirely different things. ... I can by no means force my art into certain paths; I have no idea what I will be doing tomorrow never mind in a year. Ideas conceived beforehand do not exist for me."[1] But still during the artist's lifetime, John Richardson contradicted the notion that Braque avoided making conscious artistic decisions: "Notwithstanding these words, I shall persist in regarding Braque as a rebel, for he has always been an active enemy of conventions in art as well as in life."[2] And Braque's unconventional rejection of what seem to be the greatest achievements of Western art history appears to prove Richardson right. The artist not only rejected geometrical perspective, but also a fixation on certain artistic materials in drawing and painting as well as "accepted views of reality."[3] But how did these radical departures from the classical conception of art develop in Braque's oeuvre, which he himself saw as having its origins in the art of Paul Cézanne? "All of us [modernist artists] come from Cézanne. Cézanne has overthrown centuries of painting."[4] For Cézanne marked the end of scientific perspective, as Fritz Novotny put it.[5] But how did Cézanne influence Braque's radicalness, and in what ways did Braque surpass Cézanne's innovations?

Fauvism: Symmetry as a Process of Harmonization

In the beginning, as an art student under the influence of Impressionism, Braque painted in the style of the second half of the nineteenth century (1905, **Fig. 1**). After visiting the 1905 debut exhibition of the Fauves at the Salon d'Automne at the Grand Palais, the artist, greatly impressed by the work of Henri Matisse and André Derain, began to turn to this new "physical painting."[6] But although Braque "did not value romanticism"[7] in his Fauve works such as *Landscape at L'Estaque* (1906, **Plate 1**) and *Seascape, L'Estaque* (1906, **Fig. 2**), the symmetric principle of composition and the emphasis placed on shape and the congruency of form are striking. It should be understood in the sense of Raphael Rosenberg's reference to the abstract quality of compositions, as in the

PLATE 7 [DETAIL]
Georges Braque
Harbor
1909
Oil on canvas
16 x 19 inches (40.5 x 48 cm)
National Gallery of Art,
Washington, Gift of
Victoria Nebeker Coberly
in memory of her son,
John W. Mudd
1992.3.1

"pyramidal composition" of Raphael's *The Holy Family with Saint Elizabeth and John the Baptist* from 1505-06 (**Fig. 3**): "Contemplating the composition of a painting of composition in general was always an act of abstraction whereby the abstract images emerge in part in the artist's head, in part on paper."[8] Using two trees to flank the picture, Braque creates an arch and a decided symmetry in *Seascape, L'Estaque.* The symmetry mentioned in *Seascape, L'Estaque* and the formal analogy of clouds, trees, and field in *The Great Trees, L'Estaque* (1906-07, **Plate 4**) are reminiscent of Caspar David Friedrich's (1774–1840) principles of composition, as evident in the shapes of the iceberg and the shipwreck in his *The Polar Sea* from 1823-24 (**Fig. 4**) and its striving toward symmetry. Like Friedrich, Braque also deviates from the strict topography of the motif, using symmetry as a stylistic means in works such as *Céret, Rooftops* (1911, **Plate 12**). For Braque, it is about "poetry,"[9] "the quality I value above all else in art . . . For me it is a matter of harmony, or rapports, of rhythm, and—most important for my own work—of 'metamorphosis.'"[10] In his Fauve works, metamorphosis means transforming the landscape in the sense of its dynamization and harmonization. Friedrich's formally exaggerated, clear geometry of visual structure was something that the two artists shared. With a similar stringency, Braque used symmetry and geometry and distorted his visual choreography as part of a process of abstraction and harmonization. In his Cubist works, however, Braque clearly broke with painterly tradition. In contrast to Friedrich, Braque dissolved forms and weakened the visual space in his Fauve works. The foreground with a path lined with trees in *Landscape at L'Estaque* (1906, **Plate 1**) seems to fold out slightly towards the beholder, while the fields and mountains in the middle and background largely fuse in their colors to form a yellow-red backdrop. The organic nature of the trees, stones, and meadows grant the visual event a sense of dynamism. In *The Great Trees, L'Estaque,* a condensation of shapes takes place, which are more clearly defined by the compacted areas of paint.

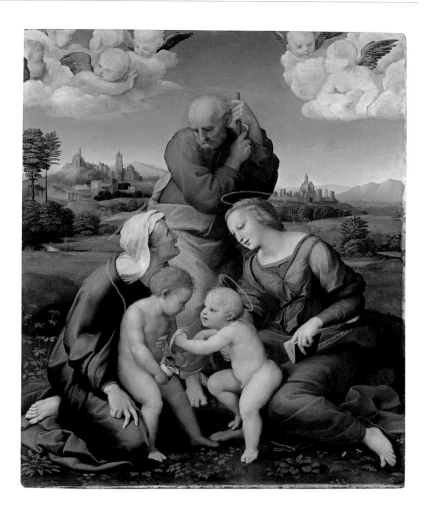

Fig. 3 [LEFT]
Raphael
The Holy Family with Saint Elizabeth and John the Baptist
1505-06
Oil on wood
51 ⅝ x 42 ⅛ inches (131 x107 cm.)
Alte Pinakothek, Bayerische Staats-gemäldesammlungen, Munich

Fig. 4 [BELOW]
Caspar David Friedrich
The Polar Sea
1823-1824
Oil on canvas
38 x 50 inches (96.5 x 127 cm.)
Hamburger Kunsthalle, Hamburg

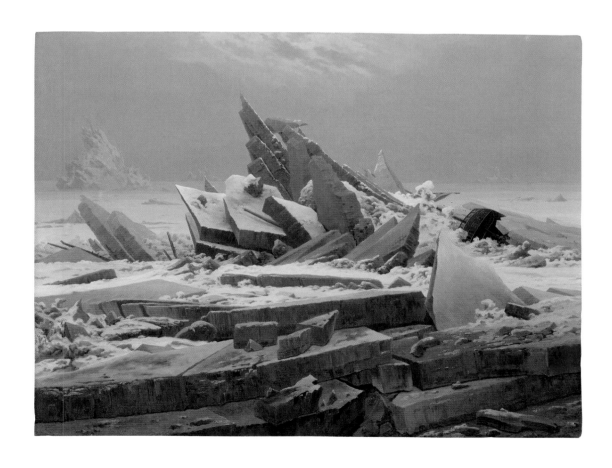

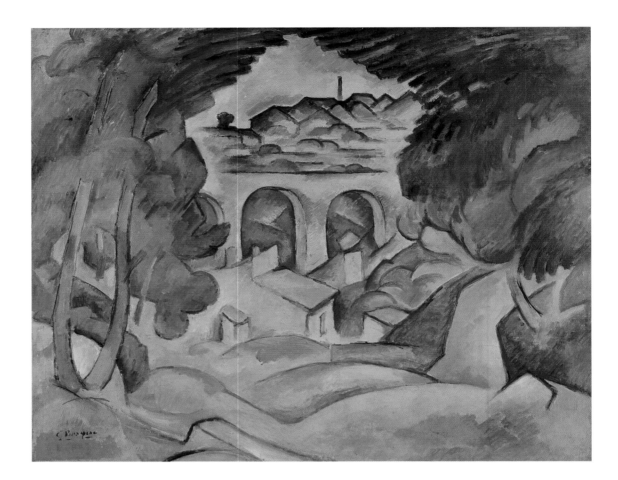

Fig. 5
Georges Braque
The Viaduct at L'Estaque
1907
Oil on canvas
25 ⅝ x 31 ¾ inches (65 x 80.5 cm)
Minneapolis Institute of Arts,
The John R. Van Derlip Fund,
the Fiduciary Fund, and Gift of
funds from Mr. and Mrs. Patrick
Butler and various donors

Early Cubism: The Break with Geometric Perspective

The work of Cézanne left a great impression on the young Braque. "Cézanne freed us from it [the Renaissance]. He opened our eyes."[11] The artist also had sufficient opportunity to see Cézanne's work: just before the turn of the century, Cézanne had achieved fame and had become something of a role model for a younger generation of artists.[12] At the start of the new century, his painting virtually dominated the Paris art world, and his large retrospective at the Salon d'Automne in 1907 led to geometric simplification in the work of Derain, Raoul Dufy, and Braque.[13] In the fall of 1907, Braque began to emphasize shapes more clearly by using contouring, and, influenced by Cézanne, he also began emphasizing the surfaces and limiting his palette of colors to just a few tones as can be seen in the painting, *Houses at L'Estaque* (1907, **Plate 6**). In the next year, he worked solely in alternating shades of ochre, brown, and gray. In this process of reduction, symmetry plays a decisive role. For example, in his two depictions of *The Viaduct at L'Estaque*, one from the fall of 1907 at the Minneapolis Institute of Arts (**Fig. 5**) the other from early 1908 in the collection of the Tel Aviv Museum of Art (**Fig. 6**), the trees and elements of the landscape are transformed into arches that embrace a pyramidal and almond-shaped composition. Jean Laude describes "the mandorla made up by foreground trees" as a "double frame" in the latter.[14] Braque almost forces natural forms into a compositional corset, a second frame by which he achieves the greatest possible harmonization of the visual events and within which he can focus

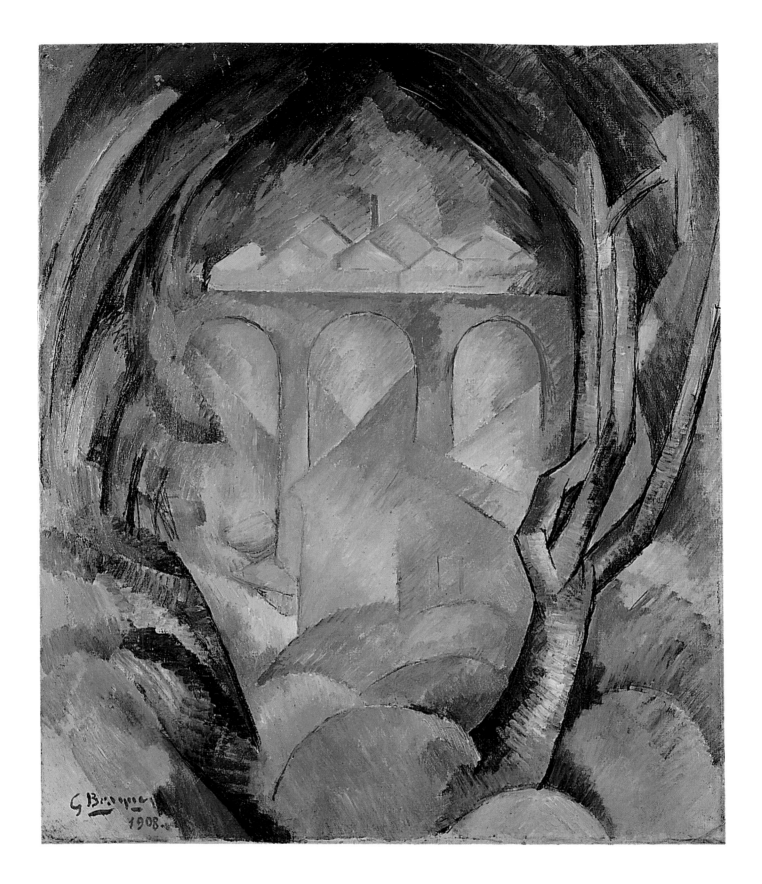

Fig. 6
Georges Braque
The Viaduct at L'Estaque, 1908
Oil on canvas
28 ¾ x 23 ⅝ inches (73 x 60 cm)
Mizne –Blumental Collection, Tel Aviv Museum of Art

on engaging with form, surface, and color. While in the work from the Minneapolis museum, a spatial differentiation of foreground, middle ground, and background is still recognizable, a few months later Braque breaks with geometrical perspective in the painting at the Tel Aviv Museum of Art: "The intermediate plane (or middle ground) tends either to be purely and simply done away with or, which comes down to the same thing, to merge indistinguishably with the background plane."[15] In so doing, he turned against the "deceptive illusionism" of the "scientific theory of perspective": "It is simply a trick—a bad trick—which makes it impossible for an artist to convey a full experience of space...It is as if someone spent his life drawing profiles and ended by believing that man was one-eyed. When we arrived at this conclusion, everything changed, you have no idea how much."[16] The critics already noted this break with tradition at Braque's first solo exhibition at Galerie Kahnweiler in November 1908 in Paris, and it was not received warmly. In his brief review of the exhibition Louis Vauxcelles described the works as "terribly simplified and reduced to geometric schemas, to cubes."[17] In so doing, Vauxcelles was referring to Matisse's comment that the landscapes are assembled of "little cubes," thus coining the term Cubism.[18]

Cubism and the Tactile Space of Movement

Braque's radical break with traditional perspective from a single point of view becomes clear in comparing two canvases painted within a two-year period: *The Port of La Ciotat* from 1907 (**Plate 5**) and *Harbor* from 1909 (**Plate 7**). The former is by and large a Fauve painting based on the topography of the harbor. Numerous boats of different sizes mark the line of the harbor in the foreground, also placing an emphasis on the diagonal. The middle ground is demarcated by diverse harbor buildings and two passenger steamers placed before the sea and the mountains in the background. In contrast, Braque developed the visual events in *Harbor* from the boat placed in the middle of the painting, whose mast divides the picture almost exactly in two. The fragmentation of the boats and buildings allows for a simultaneous observation from several points of view and "getting as close to the objects as painting allowed. Fragmentation allowed me to establish a spatial element as well as a spatial movement."[19] Braque was interested in "making the new space visible" that he was able to "feel." He wanted to develop a "tactile...manual space," which he found in the still life.[20] He thus divided the boats into "object fragments," to get "as close to the objects as painting allowed," for he was interested in the "the path we take to move toward the object that interests us."[21] Braque was referring to the constant change of the beholder's point of view on a motif that itself was moving in relationship to the object at rest. By dissecting the object into fragments, he sought to "establish the space and movement in that space,"[22] to simulate the constantly changing perspective on the object. Braque approached the paradox of the depiction of movement in the rigid visual composition, to which the American printmaker Joseph Pennell already referred in 1891:

If you photograph an object in motion, all feeling of motion is lost, and the object at once stands still. A most curious example of this occurred to a painter just after the first appearance in America of Mr. Muybridge's photographs of horses in action. This painter wished to show a drag coming along the road at a rapid trot. He drew and redrew, and photographed and rephotographed the horses until he had gotten their action apparently approximately right. Their legs had been studied and painted in the most marvellous manner. He then put on the drag. He drew every spoke in the wheels, and the whole affair looked as if it had been instantaneously petrified or arrested. There was no action in it. He then blurred the spokes, giving the drag the appearance of motion. The result was that it seemed to be on the point of running right over the horses, which were standing still.[23]

Pennell was referring to the dialectical relationship—a relationship of lack of focus[24]—between the snapshot and the time exposure that lies at the foundation of the pictorial approach to movement in photography and painting. While capturing a single moment loses the actual impression of movement, the depiction of traces of movement entails a loss of legibility. Braque chose an additional way of depicting movement, by bringing the object as close as possible and dissecting it into fragments that provide various perspectives on the object. The sum of these fragments results in a path towards and around the object, marking the movement of the beholder in visual space. All the same, movement in the actual sense of changing location cannot be expressed by means of this fragmentation: rather, it can be read as an index of movement. At the same time, the dissection of the object makes it possible to make movement palpable for the beholder in the sense of a "tactile" space of movement. Here Braque's depiction of movement differs from that in the works of the Futurists[25] or Edvard Munch[26] by means of a repeating dissection of movement, a relation of lack of focus between the snapshot and time exposure that lies at the foundation of his pictorial engagement with movement and various relationships to duration, space, and time. The failure to reconstruct movement by way of momentary fragmentation entails the impossibility of having both the spatial and temporal points of the interval within which movement takes place converge or coincide. For as Henri Bergson suggests,[27] movement always takes place within a concrete duration, and Braque's Cubist dissections of objects simulates this.

In his second work *Matière et Mémoire*,[28] Bergson claims that the past has not ceased existing to the extent that we are dealing with duration. Bergson conceives of duration as essentially related to memory. Duration as memory, like Braque's fragmentation of objects, is first of all preserving, for the moments that belong to the past are not obliterated in their existence. The past continues to live on both as a trace in our memory as well as by way of definition, so that duration for Bergson as well as Braque is seen not so much as transience, but rather as perpetuity. Secondly, duration as memory is cumulative, as the philosopher then points out, for the weight of what has passed, of what I lug along on my path, becomes ever greater with the passing of time.[29] Bergson classifies duration alongside other things as belonging to the memory of material, whereas each duration is defined by a very certain rhythm. Braque succeeds not only in reconstructing

our movement towards and around the object by way of his "object fragments", but makes them tactile, allowing us to experience them in their fullness. In so doing, he approaches the potential of simulating movement in real time of film's "cut on movement,"[30] which after the turn of the century increasingly gained importance and served as a source of inspiration.[31] In *Piano and Mandola* (1909-10, **Plate 10**) or *Violin and Palette* (1909, **Plate 9**), duration in the Bergsonian sense is not just depicted as memory-like, but becomes a tactile space of experience. The fragments of the object of the violin in *Violin and Palette* from 1909 provide the space of movement towards and around the violin within a certain duration. In so doing, Braque literally conserves time, creating a materialized space of memory.

Cubism and the Transformation of the Landscape to a Still Life

As the painter himself stated, the exploration of the tactile space of movement led Braque to the still life, for he wanted to make the relationship between the moving subject and the resting, palpable object available to experience. On first glance, this seems understandable, for in the still life it seems possible to physically overcome spatial distance in the sense of a distance in the process of creation and in the simulated space of the beholder. And yet Braque did succeed in transforming landscapes to tactile object landscapes approaching the character of still lifes. His harbor depictions from 1909 already clearly reveal this artistic intention, inviting the beholder to walk through the space of the image against the backdrop of a landscape where the scale is different, but the principle of composition for the space of movement is comparable. In *Harbor* (1909, **Plate 8**), Braque alludes to a middle ground and a background by way of two lighthouses, although it is possible that this also represents a play with proximity and distance of the same object. The fragments of the boats offer various perspectives moving towards and around these lighthouses. In this context, a series of paintings Braque made in the summer of 1909 seems decisive; these canvases depicting Château de la Roche-Guyon anticipate a clear development towards the landscape qua still life. In one canvas located at Stockholm's Moderna Museet, buildings and trees can still be distinguished from one another (1909, **Fig. 7**), while a later version, today in a private collection (1909, **Fig. 8**), not only takes a step away from geometrical perspective; the represented objects, surrounded by a green-gray mandorla, can no longer be clearly decoded as building, rock, or other objects. The sense of scale is also increasingly lost, for the objects are brought as close as possible to the beholder, whereby Braque is able "not only to see things, but to touch them" in his landscapes,[32] creating a tactile, manual space of landscape. Braque thus seems literally to transfer objects into his tactile space. The fragments of the buildings that lie at a distance in the landscape topography are equally accessible to both artist and beholder as the trees located topographically in the foreground. For the artist, at issue here is tactile sensory perception in a double sense. First, he touches the canvas with his brush, whereby the distance between his eyes and the tip of the brush is a limited distance defined by his own body and the length of the

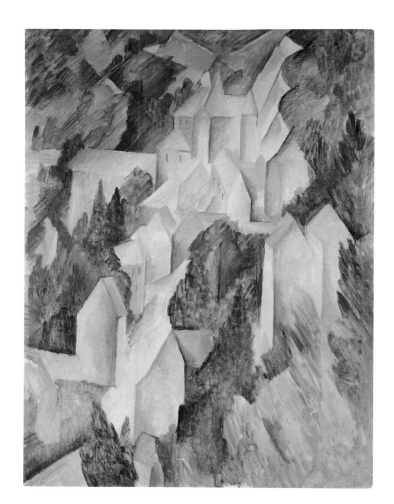

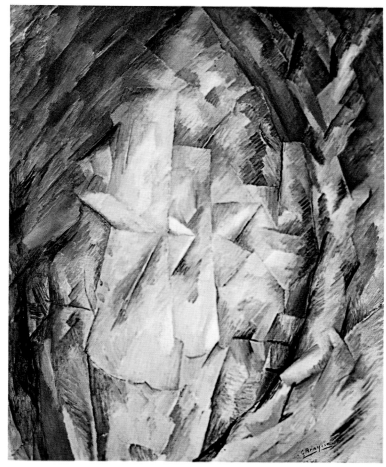

brush. Secondly, he transfers the objects to a literally tactile space, whereby the object distance becomes that of the distance of painting.

The convergence of landscape and still life is most clearly demonstrated in comparing the two still lifes, *The Mantlepiece* (1911, **Plate 14**) and *Gueridon* (1911, **Plate 13**), with *Céret, Rooftops* (1911, **Plate 12**). Whether buildings, roofs, a clarinet, bottles, or a table, Braque brings the "object fragments" in reach of the beholder. In so doing, he subordinates both the still life and the urban landscape to a symmetrical, pyramidal composition. In contrast to the harmonization and dynamization in the Fauve landscapes such as *Landscape at L'Estaque* (1906, **Plate 1**) and *Seascape, L'Estaque* (1906, **Fig. 2**), in his Cubist works Braque now simulates the dynamization of the beholder. His arresting of individual fragments reconstructs the movement towards the object and around it and the duration conserved in it. The materiality of individual "object fragments" is that of the touch of paint from the brush, which like Cézanne's *taches*,[33] is a form free of meaning. In his essay, "Cézanne's Physicality: The Politics of Touch," Richard Shiff explores the emergence of the *taches* in Cézanne's work and explains three aspects of painting and its process of emergence.[34] First, he understands a *tache* as an indexical gesture of the painter that establishes a metonymic relationship to the painter. Second, a tache represents a mark of paint that thirdly generates a tactile sensory perception and sensation that the painter actually experiences or the beholder can imagine.[35] "Touches, not vision, make a picture," Shiff argues, but he also points out the dual mean-

Fig. 7 [ABOVE, LEFT]
Georges Braque
La Roche-Guyon
1909
Oil on canvas
32 x 23 ¾ inches (81 x 60 cm)
Moderna Museet, Stockholm

Fig. 8 [ABOVE, RIGHT]
Georges Braque
La Roche-Guyon Bridge
1909
Oil on canvas
32 x 25 ¾ inches (81 x 65 cm)

ing of this statement: "The name of an action, touching a surface to leave a mark, is transferred to the mark itself as the effect of this cause; touching makes a paint mark, so a paint mark becomes a touch."[36] The brush dipped in paint touches the support that in its stability offers resistance, deforming the brush hairs and thus generating the paint mark. By way of a continuous lateral movement, a brushstroke can emerge.

The *tache* is both dependent on the material as well as the body of the artist, and thus communicates the painter's physical presence. Individual brushstrokes form a unity. These color surfaces remain in the work of both Cézanne and Braque at a distance from the eye that corresponds to the distance of the painter from the support during painting, ascertainable as individual color surfaces that constitute a shape. In so doing, Braque brings the beholder as close as possible to the object in his manual space of movement. The object fragments are formed from a sum of *taches*. However, the sequential assembly of these fragments constitutes the object in the imagination of the beholder, like a film shot. During Braque's lifetime, Richardson commented on the linking of individual fragments: "We are shown more of each object than the eye could normally see,"[37] citing Picasso: "In Cubism you paint not what you *see*, but what you *know* is there."[38]

The transformation of the landscape into a tactile landscape space with the quality of a still life refers to Braque's turn to the subject of the still life, to which he dedicates himself almost exclusively in the subsequent two decades. "After 1909, I ceased to be primarily a landscape painter."[39] But this was not so much abandoning the landscape as a genre, but rather transforming the landscape into a tactile space that is already fundamentally present in the still life. The motif *per se* loses significance by way of the *taches*, which are free of meaning, whereas the still life seems to be the subject best suited to Braque's Cubist experiments with "object fragments" and tactile space.

Papiers Collés and the Introduction of New Artistic Materials

After breaking with geometrical perspective and departing on an increasingly complex engagement with dissecting shapes and space, Braque expanded the repertoire of artistic materials in a joint effort with Pablo Picasso,[40] beginning in 1911 by introducing sand and plaster to the paint and developing the *papiers collés* in the fall of 1912 in Sorgues. Later, he and Picasso collaged fragments of newspaper, wallpaper, packing paper, colored papers, or labels, combining them with charcoal drawings or oil paintings. Braque mixed sand and plaster along with tobacco, ashes, metal, and snippets of paper in his paint. The radical nature of this break with prior tradition can be seen in how Braque anecdotally comments on contemporary reactions: "I recall the astonished face of a paint manufacturer who, after boasting about his finely milled product, learned that I wanted to add sand to it."[41]

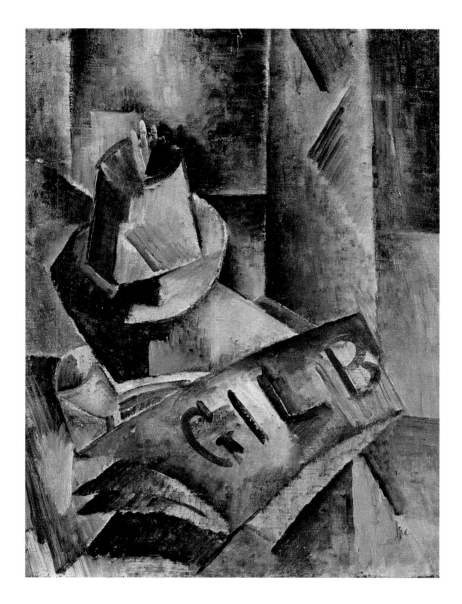

Fig. 9
Georges Braque
*The Lighter and the Daily
Paper "Gil Blas"*, 1909
Oil on canvas
13 ¾ x 10 ¾ inches
(35 x 27 cm)

The step towards transgressing the limits of classical artistic materials seems already presaged in Braque's move toward tangible space, where he wanted to "make them want to touch it."[42] In his 1912 *papier collé, Glass, Bottle and Newspaper* (**Plate 15**), Braque collaged a piece of faux-bois wallpaper. The wallpaper can evoke the wood of the table and its horizontality by way of its own horizontal orientation, but only in a limited sense can the material citation be attributed to an actually visible object. Instead, it stands for the material wood.[43] The drawing of the newspaper, the glass, and the bottle is done using charcoal. Braque uses *faux-bois* wallpaper in *Head of a Woman* (1912-13, **Plate 16**) in a comparable fashion, whereas he now takes up the verticality of the half-length portrait by way of the vertically pasted pieces of wallpaper, which now literally evoke in their own materiality the materiality of the wallpaper. The head, dissected into fragments, petrifies to become an object at rest, like the bust of a still life. The use of the faux-bois elements is like the use of the letters that Braque introduced to his paintings as early as 1909 with *The Lighter and the Daily Paper "Gil Blas"* (1909, **Fig. 9**)[44] "as an element that transcends the visual space."[45] For Braque, the letters "existed outside three-dimensional space; their inclusion in a picture allowed one to distinguish between objects which were situated in space and those which belonged outside space."[46] In *Glass, Bottle and Newspaper*, the horizontality of the table is evoked by the collaged

piece of wallpaper; a similar convergence can also be found in the oval format work, *Glass and Pipe* (1913-14, **Plate 21**), where the oval canvas itself seems to evoke the tabletop. The format of this work, 10 ⅝ x 16 ⅛ inches (27 x 41 cm), is rather small in comparison to the *Gueridon* (1913, **Plate 19**). The scale is here of special importance, for the table surface corresponds to the size of the support.

By adding newspaper and wallpapers as new materials and actually mixing various materials into the paint itself, the paint became an autonomous visual medium and itself a substance. "Color is no longer, for him, an abstract transposition of that bestowed on the object: it is *substance*, and is qualified materially, concretely, both in its difference and its relations. It is by means of unusual, adventitious materials—especially the *papiers collés*—that, without abstraction, he will get at the local tone."[47] In his subsequent synthetic paintings, Braque created *faux bois* and *faux marbre* using the techniques that he learned as a trained housepainter and limer (see *Violin and Glass*, 1913, **Plate 17**). But neither the painted imitations of wood or marble nor the *trompe l'oeil* effects generated by using a comb reveal the attempt of a perspective material imitation, but are always parallel to the image surface. Braque seems here to be imitating the *faux-boix* wallpaper itself. Accordingly, the artist by no means sought to generate the illusion of a wood board or a marble incrustation, but rather to establish "appearances as appearance,"[48] "to imitate the imitation."[49] In what Monika Wagner describes as a material based "other history of modernism," she comments, "Paint is presented as a material from which illusions are created, and in so doing the masterly use of paint takes on the task of formulating genuine statements about the role it plays in the painting."[50]

By adding sand and other fillings to the oil paint, the body of the paint becomes an "embodiment of the material,"[51] whereas Braque now completes the tactile visual space with the literally tactile. The interplay of materials representing themselves, like newspaper fragments or *faux-bois* with charcoal drawings of objects in papiers collés such as *Bottle, Glass, and Pipe* (1914, **Plate 22**) are part of Braque's attempt to explore the "potentials of the material" with increasing complexity.[52] With his *papiers collés* and the colors inherent in the collage materials, the artist began to engage more deeply with different colors and their contrasts, whereas he always took account of the materiality of the foundation. By adding various materials to the paint, he could demonstrate the dependence of the "paint on the material," as he puts it: "Dip two pieces of white fabric, each of different material, in the same dye, and their color will be different."[53] With Braque's aim to integrate the materials and things of reality itself, the artist, like Picasso, rejected "overcoming the materiality" of paint,[54] as had been proposed by pioneers of abstraction such as Adolf Hoelzel, and refused what Wassily Kandinsky declared as his new program: the "spiritual in art." Kandinsky himself commented on Picasso, "In his latest works (1911) he has arrived by way of a logical course at the destruction of the material, not, however, by its dissolution but rather by a kind of a fragmentation of its various parts and a constructive dispersion of parts across the

painting. But strikingly it seems that he wants to maintain the appearance of the material."[55] But for Braque, to whom Kandinsky's comments could also be applied, the issue was not retaining the appearance of the material, but rather bringing reality itself into the picture, by way of various materials creating a literally tactile space for the beholder. Braque replaces the illusionist window of a visual illusion with a gaze on the actual surface and its materiality.

The Metamorphosis of the Object in a Fluid Matrix of the Painting's Texture

Braque was drafted into the French army in 1914, and suffered a serious head injury on May 11, 1915, which tore him from any artistic continuity. It was only after his recuperation and subsequent discharge from the army in 1917 that he again tried to return to his artistic activity from the prewar period. In the *papier collé*, *Bottle and Musical Instruments* (1918, **Plate 24**) he returned to his prewar technique of collage, but at the same time retreated from an overly dramatic fragmentation of the objects, emphasizing the materiality of the individual objects and referring at the same time to their replaceability. The bottle is cut from corrugated cardboard, whereby he transforms the materiality of a bottle to a cardboard silhouette, signalized its exchangeability, for he could have cut it from any other random object. While in *Mandolin* (1914, **Fig. 10**), one of the last *papiers collés* before his conscription in 1914, corrugated cardboard was used as a tactile depiction of the strings of the mandolin, the corrugated cardboard used after the First World War stands for its own materiality and not that of the object represented. The *faux-bois* wallpaper also becomes a material, like the marble of a sculptor, from which all kinds of objects could be created. The subject of the still life in Bottle and Musical Instruments becomes a backdrop for the tactility and materiality of the materials themselves. Braque's great interest in the materiality is evinced by his increasing care taken in the priming of his canvases "The priming is at the basis of everything else, just like the foundations of a house."[56] In the course of the years to follow, the artist became more precise about the materiality of the painting surface. He continued to remain close to the object, yet distanced himself from the fragmentary Cubist disintegration of the objects in favor of a general engagement with materiality. In *The Compotier* from 1918 (**Plate 25**) Braque referred on the one hand to classical *trompe l'oeil* painting, yet without attempting to create a perfect illusion; on the contrary he seems to want to make the intention of "imitating imitation" visible. Neither the painted frame nor the nameplate with his signature nor the still life on the eye-shaped table is intended to suggest a perfect imitation. The still life seems to refer to the technique of collage that translates objects to two-dimensionality like cut-out, painted paper patterns. By way of several hard shadows, Braque simultaneously refers to the imitation of space, a visual illusion. In *The Black Guitar* from c. 1918-19 (**Plate 26**) and *The Pantry* from 1920 (**Plate 27**) Braque makes visible his attempt to establish appearances as appearances. In *The Black Guitar*, the guitar appears cut with a slightly crumbled newspaper like

Fig. 10
Georges Braque
Mandolin
1914
Collage with drawing,
watercolor and gouache
19 x 12 ⅝ inches
(48.5 x 32 cm)
Ulmer Museum, Ulm

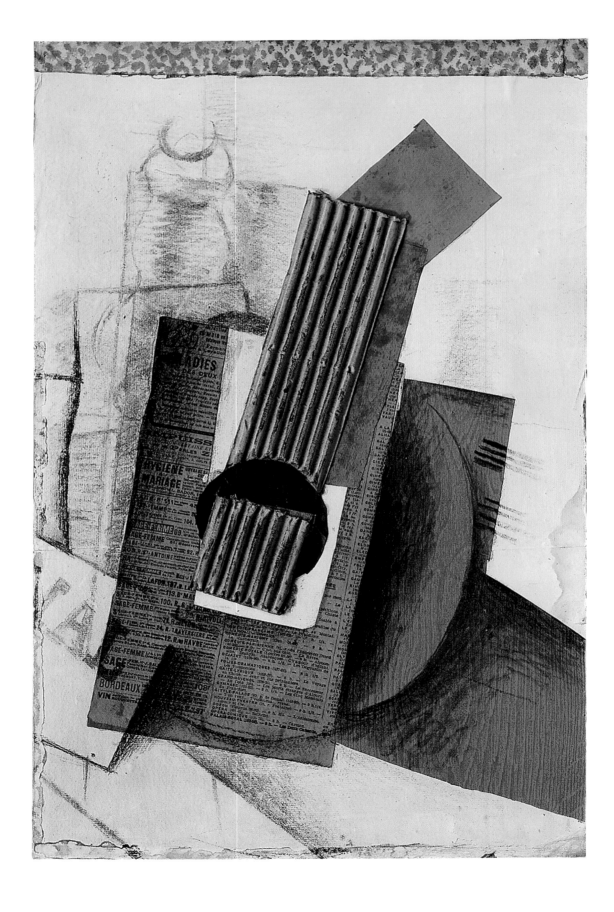

two painted paper patterns that take up the distorted shapes of the represented objects and translate them to the two-dimensionality of the visual representation. Braque not only takes up the support as a two dimensional surface, but he also refers to its flatness, whereby he makes a distinction between the materiality of the objects by way of a markedly different brushstroke. In *The Pantry*, he amplified the impression of painted collage by giving the edges of the pear and the musical instrument the corners and edges from paper patterns cut with scissors, imitating the materiality of paper. Breaking with traditional perspective and the attempt to create an illusion as a window on another reality, Braque marks the reality of the two dimensional support, covered with paint. He creates a pictorial space in which the objects are almost palpably brought closer to the surface, but without simulating simultaneous viewing from several standpoints. The dark shadows seem to result more from the materiality of the imitated collage materials than from those of the represented objects. But whereas in *The Black Guitar* the individual layers of the collaged paper are placed opaquely on the layers that seem to lie beneath, in *The Pantry* Braque develops a refined oscillation between transparency and opacity that reproduces the imitated visual superimposition of collaged elements. The term "transparency" cannot be limited exclusively to an actual optical transparency, but has to be combined with visual illusion in Clement Greenberg's sense.[57] The surface of the painting is transparent in terms of its materiality, this transparency is also presented as a visual representation of the immaterial surface of an illusionistic window. Apparently solid, opaque objects are made transparent, like a body exposed to X-rays. Lines, like the decorative line across the yellow surface in the upper left, are continued like a projection and themselves become bodies that cast shadows. The musical instrument at the center of the image is deconstructed using an imitated collage in several layers, whereby the paint of the yellow layer is marked as faux bois by the use of a comb. Metamorphosis now means deformation and transformation, as Braque was not interested in an actually rational legibility: "There are certain mysteries, certain secrets in my own work which even I do not understand, nor do I try to do so . . . Mysteries have to be respected if they are to retain their power. *L'art est fait pour troubler: la science reassure.* [Art is made to disturb: science reassures.]"[58] And Braque's works do disturb, for he deconstructs the traditional visual space and creates a new tangible space that deviates from the reality that surrounds us. He protects poetry as "the artistic quality" that he places above all else, by keeping the secret. He seems to use the conceivable material reality of a collage as a model for his space and breaks with the anchor of reason and science. With his riddle of transparency and opacity, he presents a disturbing image of uncertainty to the beholder. Braque dissolves the limits of legibility in a frame that seems legible, and declares metamorphosis to be an anarchic artistic principle. "I will try to explain what I mean by 'metamorphosis'. For me no object can be tied down to any one sort of reality. A stone may be part of a wall, a piece of sculpture, a lethal weapon, a pebble on a beach or anything else you like, just as this file in my hand can be metamorphosed into a shoe-horn or a spoon, according to the way in which I use it."[59]

The artist distances himself from the absolute of a *single* reality by referring to a plurality of realities. A single resting object has the potential of being many objects; it can transform from one to the other. Like the simulation of movement towards an object, Braque is now simulating the conceptual transformation from one entity to another. The unspecific existence of something only becomes definite through the subject and can in its richness only be recognized by way of opening new realities.

In the 1920s, Braque decisively plumbed the possibilities of the still life. He applied thick, sandy layers of paint to his works, elevating the surface of the painting and the corpus of the paint to become an object of the picture, and creates works in the interplay of painted transparency and the factual opacity of paint. In his rather small, elongated still lifes, he began painting with black. Braque understood black as "a very rich color. I lead color in all directions, and every drop depends on the whole. When treated in this manner, color becomes abstract. I use color in fixed forms to show that it acts outside of the object."[60] In *Lemon, Bananas, Plums, Glass* from 1925 (**Plate 28**), the form of the green leaves can be found as an apparent formal analogy in the bananas and in the transparent tablecloth. Just as the metamorphosis from leaf to banana and to tablecloth can be disturbing, Braque dissolves solid forms like the tabletop in *Brown Still Life* (1926, **Plate 29**) in a masterful play with transparency. The "conjuring game" with reality succeeds in the sense of Braque's dictum: "The disturbance needs to be constantly added to."[61]

In *The Yellow Tablecloth* from 1935 (**Plate 30**), Braque added to the disturbance by placing a table in room that is alluded to, but where the ceiling moldings could not possibly match the wood panels in the lower part of the image. In contrast to the still lifes from the 1920s, in the mid-1930s Braque deforms some objects to surreal, ambiguous shapes. In so doing, the organic shape in the right upper area of the image can be read as a musical instrument as well as a sculpture, whereby now only the legibility of the shape is questioned. The perfectly applied rough priming indicates the significance of the tactile surface, which in addition to the visual depiction of tangible space always includes the level of the actually tactile. An opaque application of paint has given way to the use of very thin layers, where the sandy lower level of the priming is not only palpable, but also clearly visible. The picture support is revealed like a scaffold. The support and the material sand are themselves subjected to a metamorphosis, given a new meaning comparable to Braque's depiction: "The first time the importance of this phenomenon struck me was in the trenches during the first World War when my batman turned a bucket into a brazier by poking a few holes in it and filling it with coke. For me this commonplace incident had a poetic significance: I began to see things in a new way."[62]

The next year, he created two works *The Mauve Tablecloth* (1936, **Plate 32**) and *Still Life with Guitar I (Red Tablecloth)* (1936, **Plate 33**) in approximately the same format: the two works are both similar to the larger work *The Yellow Tablecloth*, but are two fundamentally different paintings. The two still lifes not only share a comparable positioning and size of what is represented in the visual space, but they also have the same rough foundation in common. It seems as if Braque were offering the beholder two possible aggregate states of a motif: while *The Mauve Tablecloth* is in a realistically legible form and the objects are presented in muted colors, the panels in brown and the wall in *faux marbre, Still Life with Guitar I (Red Tablecloth)* is defined by an intense red, orange, and yellow in contrast to very dark realms of color. The objects seem highly de-familiarized in the sense of a distortion. While the table, panels, and guitar are still recognizable, they are turned into ornamentation. Characteristically, the background features two roughly jagged, leaf-like carpet elements which represent a wallpaper pattern, which can also be found in the *Gueridon* (1935, **Plate 31**), and in other paintings of free-standing gueridons begun in the late 1920s. Braque is already beginning to distance himself from Surrealist depictions of objects, but continues to play with the variety of representation it provides. *The Mauve Table-cloth* and *Still Life with Guitar I (Red Tablecloth)* reflect the metamorphosis of two different artistic styles and forms of representation.

Ornamentation then gains in importance as the idealizing shape of an object. Braque himself notes: "I noticed that the ornamental portion frees color from the form." [63] The roughly serrated, leaf-like ornament in the *Gueridon* is transformed back into a plant-like object, whereby there is once again no certainty about attributing a particular function to a particular element: the or-namentation could also be associated with hovering Christmas trees. The object appears to be as if in a flexible matrix. In its transformation towards ornamentation, the object dissolves and changes its aggregate state. This deceptive play with ornamentation and object can be seen in a series of female portraits that Braque worked on very intensely in 1936-37. In the monumental work *Woman at an Easel (Yellow Screen)* (1936, **Plate 34**), the upper edge of the woman's dress evokes the picture frame of the still life hanging on the wall, seemingly "framing" the woman's head. The female figure is sharply divided into two halves one dark and one light and loses all volume, becoming a resting flat object of an immense still life. But did Braque not want to depict a human being, as the title suggests? Braque's answer is vague: "When you ask me whether a particular form in one of my paintings depicts a woman's head, a fish, a vase, a bird or all four at once, I can-not give you a categorical answer, for this metamorphic confusion is fundamental to the poetry. It is all the same to me whether a form represents a different thing to different people or many things at the same time or even nothing at all." [64] The figure might be a woman or a vase, might signify a great deal or nothing, or be simply a tactile raw surface. Braque's engagement with the

human figure between being and non-existence reaches a pinnacle in the 1937 vertical painting *Woman with a Mandolin* (**Plate 35**). A silhouette of a woman with a mandolin is placed in an interior that is defined by prominent ornamentation. The shadow is echoed on the right in colorful repetitions of form. The eye, mouth, hair, and dress are alluded to with thin white lines, and yet the woman remains an object and is at the same time an area lacking color in a scene that is filled with shapes and colors in contrast to the sculptural foot of the lamp with its broad orange lampshade. A great deal here seems to violate the laws of space and order. The framed still life in the upper left thus expands across the frame in the visual space and yet remains flat. Every supposed space or volume is immediately contradicted by an element captured in two-dimensionality. Anything seems possible; nothing seems self-evident. The same is true for *Studio with Black Vase* (1938, **Fig. 11**) and the comparable painting *The Pantry* from 1920 (**Plate 27**), where everything becomes a collage, and in so doing Braque emphasizes the volume of some objects like the skull or the root of the plant, thus creating an even greater disturbance. While *faux marbre* and *faux bois* are replaced in the portraits of women by ornamentation, the false wood returns in various varnishes. In *Stool, Vase, Palette* (1939, **Plate 36**), the painted wood grain of the palette and the wood paneling encourage the beholder to touch the painting, not only due to the rough priming but also due to the way the paint is combed. Richardson finds it revealing that even when Braque turns to a vanitas still life, as in *Studio with Black Vase* as an "allegory of relationships between dream and reality of humanity," the tactile is placed at the foreground, and not the religious or the philosophical. This is supported by the artist's break with classical perspective, the traditional notion of space and use of material, and his refusal to accept generally acknowledged criteria of reality.

Braque's principles are also reflected in his extraordinary depictions of billiard tables, painted from 1944 to 1952. The billiard table itself breaks into various perspectives. In the monumental, vertical version, in the collection of the Metropolitan Museum of Art (1944-52, **Plate 38**), the table seems to push towards the beholder by way of a vertical and horizontal bending. "Not only did I give up all vanishing points, but I even wanted at a certain point in time to begin with the canvas and try to have the picture come forward toward the beholder."[65] In a drawing from 1944 (**Fig. 12**), many metamorphoses of objects are legible. The fishbowl becomes a geometrical shape, the window in the rear "has become a framed mirror or picture,"[66] as Richardson puts it. This surely shows how difficult Braque's works can be to read, for the image could also be interpreted as a scene showing a coat stand, a gueridon, and a framed painting. Strikingly, Braque tips the space toward the beholder, so that the parquet flooring seems like a wall paneling and the billiard balls seem to float in space. The cord-like white stripes are in turn reminiscent of a reflection of light in a photograph, whereby Braque ultimately questions the materiality of the painting per se, yet always keeps it physically present with its gray foundation. In turn, the background of the canvas reappears in the 1945 canvas, *The Billiard Table*, at the Tate (**Plate 39**). The light blue lines that cross

Fig. 11
Georges Braque
Studio with Black Vase
1938
Oil on canvas
38 ¼ x 51 ⅛ inches (97 x 130 cm)
The Kreeger Museum, Washington D.C.

Fig. 12
Georges Braque
Billiards
Drawing from notebook on
squared paper
© Q. Laurens Archive

the billiard table can be interpreted as the "outlines of a transparent easel,"[67] whereby the represented literally becomes the background of the canvas.

In his *Studio* series painted between 1949 and 1956, Braque again turned to working on the tactile space, achieving a new apex in his oeuvre by introducing the flying bird. The objects are more and more in the process of dissolution, and part of a fluid matrix within which nothing seems fixed, and everything is permanently in flux and metamorphosis. The transformation and deformation becomes a principle: "Nothing in these *Studios* is ever quite what it seems: sometimes shadows have substance, while things of substance turn out to be shadows: forms are flattened and flatness is given form: what is hard is painted as if it were soft: what should appear opaque appears transparent and vice versa' objects are only half indicated, or they merge with one another."[68] Richardson explains the presence of the bird as follows: "It is simply a picture within a picture, a reference to the large canvas (now destroyed) of a bird in flight which the artist had painted shortly before starting work on the series."[69] But is it at all relevant in the fluid matrix whether Braque was "impregnated"[70] with this previous subject or whether the object actually existed? It is decisive that the artist takes recourse to his engagement with the tangible space of movement in the sense of a duration that is like memory. In *Studio V* (1949-50, **Plate 40**), the bird is transparently painted onto the background, and oscillates between presence and absence. With this

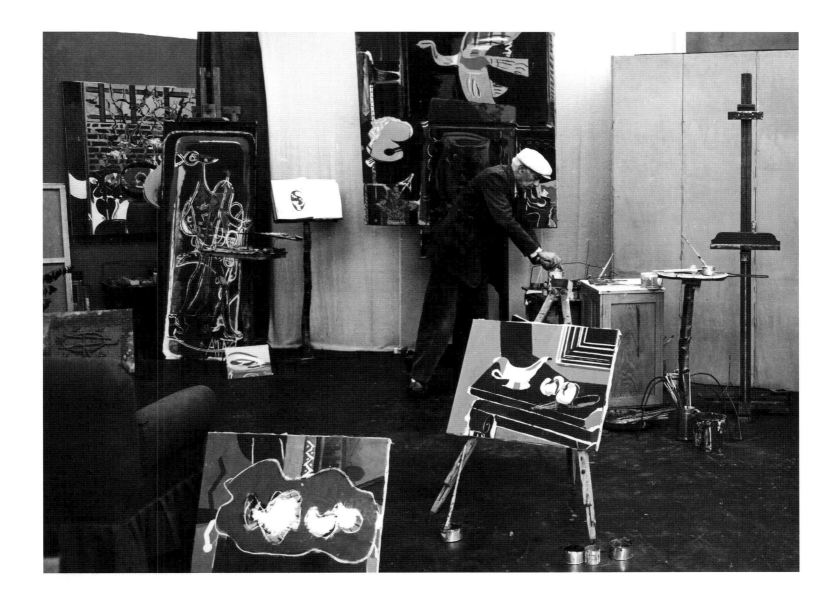

Fig. 13
Georges Braque in his studio,
Paris, 1953
**Photograph by
Robert Doisneau**

transparency, Braque created a painterly equivalent with which he succeeded in linking temporal as well as spatial events by way of their synchronic presence with one another. In these paintings, Braque marks at least two points in time or intervals, as well as the temporal horizon lying between these events, and thus always evokes the past in a sense of emergence and disappearance. In contrast, in *Studio IX* (1952-53/56, **Plate 41**) Braque first painted an opaque bird, as can be seen in a photograph from an early stage in the creation of the work (1953, **Fig. 13**). After numerous alterations, the final bird that resulted was reminiscent of the Cubist fragmentation of form, which does not so much depict the object at rest in relation to the moving object, but rather destroys its form as in an explosion. What remains are the fragments, which in turn are caught in a process of metamorphosis, forming new objects. Not only is nothing as it seems, nothing remains as it is. "I have made a great discovery. I no longer believe in anything. Objects don't exist for me except in so far as a rapport exists between them or between them and myself. When one attains this harmony, one reaches a sort of intellectual non-existence—what I can only describe as a sense of peace, which makes everything possible and right. Life then becomes a perpetual revelation. *Ça c'est de la vraie poésie.*"[71] Answers? No, it is not about answers, because in the fluid matrix of the visual texture, each answer can generate a new answer and a new thing in the very next moment, even if nothing is required in this indefinable nothingness.

Translation by Brian Currid

1

Braque (1957), quoted in "Georges Braque: Die Macht des Geheimnisses" *Georges Braque. Vom Geheimnis in der Kunst. Gesammelte Schriften und von Dora Vallier aufgezeichnete Gespräche,* (Zürich: Die Arche, 1958) 71-72. "Kunst und Engagement sind zwei völlig verschiedene Dinge [...]. Ich bin völlig außerstande, meine Kunst in ganz bestimmte Bahnen zu zwingen; ich habe keine Ahnung was ich morgen tun werde, geschweige denn, in einem Jahr. Im voraus konzipierte Ideen gibt es für mich nicht."

2

John Richardson, *Braque* (London: Oldbourne Press, 1961), 7.

3

Richardson, *Braque,* 8.

4

"Nous sommes tous partis de Cézanne. Cézanne a renversé des siècles de peinture." Braque, quoted in "Georges Braque," *Zodiaque,* January 1954, 11.

5

Fritz Novotny, *Cézanne und das Ende der wissenschaftlichen Perspektive* (Vienna: A. Schroll, 1938).

6

"peinture physique," Braque, quoted in Vallier, "Braque, la peinture et nous. Propos de l'artiste recuellis," *Cahiers d'art* 29, Nr. 1, 1954, 14.

7

"Comme je n'aimais pas le romantisme, cette peinture physique me plaisait." Braque, in Vallier, "Braque, la peinture et nous. Propos de l'artiste recueillis," *Cahiers d'art* 29, Nr. 1, 1954, 14.

8

Raphael Rosenberg, "Die Wirkungs-ästhetik," *Turner, Hugo, Moreau: Die Entdeckung der Abstraktion,* eds. Raphael Rosenberg and Max Hollein, (Munich: Hirmer Verlag, 2007), 33. See also Werner Busch, *Die notwendige Arabeske, Wirklichkeitsaneignung und Stilisierung in der deutschen Kunst des 19. Jahrhunderts* (Berlin: Mann, 1985).

9

On the concept of poetry, see Richard Shiff's comments in this volume.

10

Richardson, *Braque,* 23.

11

"Nous sommes certainement très loin de la Renaissance. Cézanne nous en a délivré. Grâce à lui, nos yeux se sont ouverts." Braque, in "Georges Braque," *Zodiaque,* January 1954, 12.

12

See "Biographie," *Cézanne: Vollendet, Unvollendet* (Ostfildern-Ruit: Hatje-Cantz, 2000), 394–395.

13

See Hajo Düchting, *Paul Cézanne (1839–1906): Natur wird Kunst* (Cologne: Taschen, 1989), 234–237.

14

Jean Laude, "The Strategy of Signs," in *Braque: Cubism. 1907–1914,* eds. Nicole Worms de Romilly and Jean Laude (Paris: Maeght, 1982), 13.

15

Laude, "The Strategy of Signs," 13.

16

Braque, in Richardson, *Braque,* 10.

17

Quoted in Laude, "The Strategy of Signs," 13.

18

Richardson, *Braque,* 12.

19

Braque, in Richardson, *Braque,* 10.

20

"C'était la matérialisation de cet espace nouveau que je sentais. Alors je commençai à faire surtout des natures mortes, parce que dans la nature il y a un espace tactile, je dirais presque manuel." Braque, in Vallier, "Braque, la peinture et nous. Propos de l'artiste recueillis," *Cahiers d'art* 29, Nr. 1, 1954, 16.

21

"C'est le chemin qu'on prend pour aller vers l'objet qui nous intéresse." Braque, in Vallier, "Braque, la peinture et nous. Propos de l'artiste recueillis," *Cahiers d'art* 29, Nr. 1, 1954, 16.

22

"La fragmentation me servait à établir l'espace et le mouvement dans l'espace..." Braque, in Vallier, "Braque, la peinture et nous. Propos de l'artiste recueillis," *Cahiers d'art* 29, Nr. 1, 1954, 16.

23

Quoted in Beaumont Newhall, *The History of Photography* (New York: The Museum of Modern Art, 1964), 86.

24

Dieter Buchhart, "Das Verschwinden im Werk Edvard Munchs. Experimente mit Materialisierung und Dematerialisierung," Ph.D. thesis, Universität Wien (2004), 238–255.

25

Ibid., 247–250.

26

Ibid., 233–255.

27

Henri Bergson, *Matter and Memory,* trans. N.M. Paul and W.S. Palmer (New York: Zone Books, 1990).

28

Bergson, *Matter and Memory.* On Bergson, see Gilles Deleuze: *Le bergsonisme,* (Paris: Presses universitaires de France, 1966). See also Erik Oger's introduction to the German translation, *Materie und Gedächtnis: Eine Abhandlung u?ber die Beziehung zwischen Körper und Geist,* (Hamburg: Meiner, 1991).

29

See Henri Bergson, *Denken und schöpferisches Werden,* (Meisenheim am Glan: Westkulturverlag, 1948), 201.

30

See Gilles Deleuze, *Cinema 1: The Movement Image,* translated by H. Tomlinson and B. Habberjam (Minneapolis: University of Minnesota Press, 1989).

31

On Braque and Picasso's Cubism and film see *Picasso, Braque, Early Film in Cubism,* The Pace Gallery, New York, 2007. See also Monika Wagner: *Das Material der Kunst: eine andere Geschichte der Moderne* (Munich: C.H. Beck, 2001), 33.

32
"Cela répondait pour moi au désir que j'ai toujours eu de toucher la chose et non seulement de la voir." Braque, in Vallier, "Braque, la peinture et nous. Propos de l'artiste recueillis," *Cahiers d'art* 29, Nr. 1, 1954, 16.

33
Richard Shiff, "Cézanne's Physicality: The Politics of Touch," *The Language of Art History,* ed. S. Kemal and I. Gaskell (Cambridge: Cambridge University Press, 1991,): 129–180; Richard Shiff, "Constructing Physicality," *Art Journal* 50 (1991), 42–47.

34
Shiff, "Cézanne's Physicality"; Shiff, "Constructing Physicality."

35
Shiff, "Cézanne's Physicality," 134.

36
Shiff, "Cézanne's Physicality," 135.

37
Richardson, *Braque,* 14.

38
Richardson, *Braque,* 14.

39
Braque, in Richardson, *Braque,* 13.

40
The shared invention of Cubism by Braque and Picasso is legendary; some works can scarcely be attributed to one artist or the other, although it remains unclear whether Braque or Picasso actually worked on the same canvas. This subject has been discussed widely, see for example William Rubin, *Picasso and Braque: Pioneering Cubism* (New York: Museum of Modern Art, 1989).

41
"Je me souviens de la figure ahurie d'un marchand de couleurs qui, après m'avoir vanté la finesse de son broyage, apprit que je voulais y ajouter du sable." Braque, in Vallier, *L'Intérieur de l'art : entretiens avec Braque, Léger, Villon, Miró, Brancusi (1954–1960),* 48.

42
Braque, in Richardson, *Braque,* 13.

43
See Rainer Lawicki, "Tableau-objet und Konstruktionsplastik im kubistischen Werk von Georges Braque und Pablo Picasso: Die Differenz von Metamorphose und Metapher," Ph.D. thesis, Universität Freiburg, 2001, 78

44
Braque himself dates his use of letters to 1911 and Richardson dates his use of letters to 1910. See Vallier, "Braque, la peinture et nous. Propos de l'artiste recueillis," *Cahiers d'art 29,* Nr. 1, 1954, 16. See also Richardson, *Braque,* 17.

45
Lawicki, 78

46
Braque, in Richardson, *Braque,* 17.

47
Laude, "The Strategy of Signs," 51–52.

48
Wagner, *Das Material der Kunst,* 35.

49
André Salmon, "Anecdote," *Cubism,* ed. Edward Fry (London: Thames & Hudson, 1966, 141.

50
Wagner, *Das Material der Kunst,* 35.

51
"J'ai voulu faire de la touche une forme de matière." Braque, in Vallier: "Braque, la peinture et nous. Propos de l'artiste recueillis," *Cahiers d'art 29,* Nr. 1, 1954, 17.

52
"Quand à moi, c'est ce goût très prononcé pour la matière elle-même qui m'a poussé à envisager les possibilités de la matière." Braque, in Vallier, "Braque, la peinture et nous. Propos de l'artiste recueillis," *Cahiers d'art 29,* Nr. 1, 1954, 17.

53
Ibid., 17.

54
Adolf Hoelzel (1853–1934) quoted in: Walter Hess: *Dokumente zum Verständnis der modernen Malerei, (*Hamburg: Rowohlt, 1956), 98.

55
Wassily Kandinsky, "Über das Geistige in der Kunst," (Bern: 1952 [1910]), 56.

56
Braque, in Richardson, *Braque,* 20.

57
Clement Greenberg, "Modernist Painting," In: *Art & Literature,* 4 (Spring 1965), 195f.

58
Braque, in Richardson, *Braque,* 23.

59
Ibid., 23.

60
"Je mène la couleur n'importe où et chaque tache dépend de l'ensemble. Traitée comme ça la couleur devient abstraite. J'emploie la couleur en formes fixes pour montrer qu'elle agit en dehors de l'objet." Braque, in Vallier, "Braque, la peinture et nous. Propos de l'artiste recueillis ," *Cahiers d'art* 29, Nr. 1, 1954, 23.

61
Braque (1957), quoted in "Georges Braque: Die Macht des Geheimnisses" *Georges Braque. Vom Geheimnis in der Kunst. Gesammelte Schriften und von Dora Vallier aufgezeichnete Gespräche,* (Zürich: Arche, 1958) 64. "Il faut toujours augmenter le trouble. (Man muss der Beunruhigung immer Vorschub leisten.)"

62
Braque, in Richardson, *Braque,* 23.

63
"Je me suis aperçu que la partie ornamentale libère la couleur de la forme." Braque, in Vallier, "Braque, la peinture et nous. Propos de l'artiste recueillis," *Cahiers d'art* 29, Nr. 1, 1954, 20.

64
Braque, in Richardson, *Braque,* 23.

65
"Georges Braque, sa vie racontée par lui-même." In: *Amis de l'Art,* Nr. 8, 1949.

66
Richardson, *Braque,* Plate 51.

67
Heike Eipeldauer, "Die großen Serien: Billardtische und Ateliers," in *Georges Braque,* ed. Ingried Brugger et al. (Ostfildern: Hatje Cantz, 2008), 195.

68
Richardson, *Braque,* 28.

69
Ibid.

70
"Il faut se laisser imprégner par les choses, il ne faut jamais couper le rapport avec elles et il faut les laisser devenir tableau quand elles voudront." Braque, in Vallier, "Braque, la peinture et nous. Propos de l'artiste recueillis," *Cahiers d'art* 29, Nr. 1, 1954, 24.

71
Braque, in Richardson, *Braque,* 24.

Georges Braque in his studio, Paris, 1953.
Photograph by Robert Doisneau

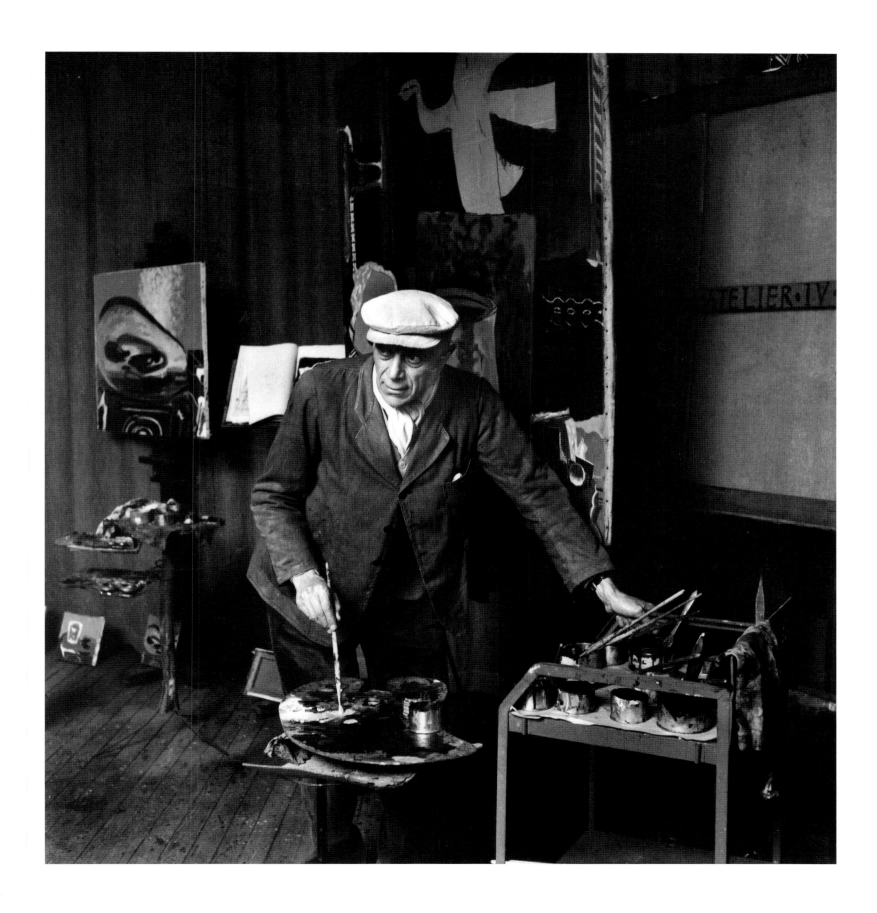

Plates

PLATE 1
Georges Braque
Landscape at L'Estaque
1906
Oil on canvas
23 5/8 x 31 7/8 inches (60 x 81 cm)
Merzbacher Kunststiftung

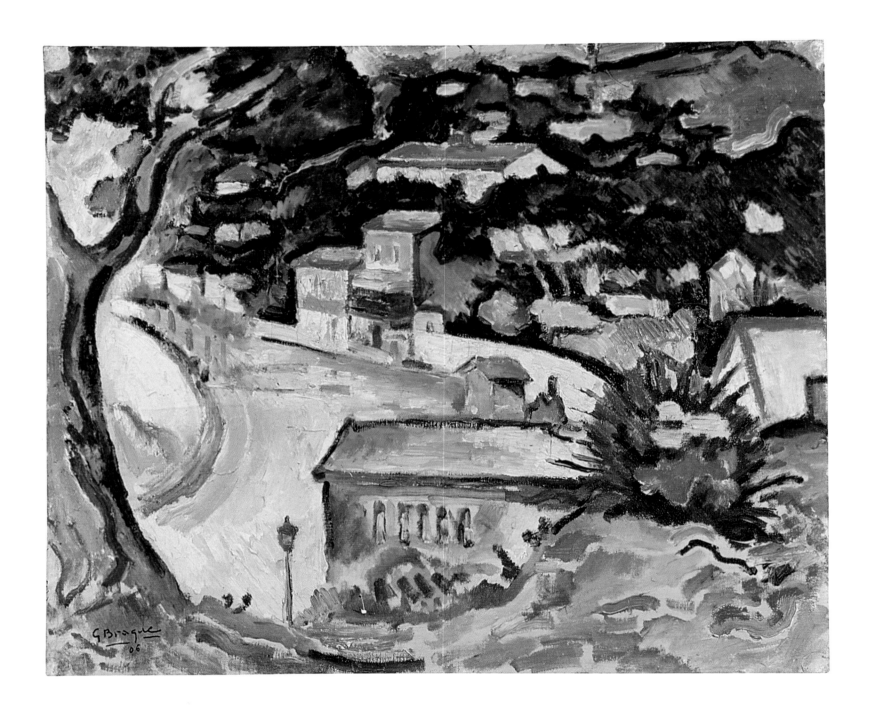

PLATE 2
Georges Braque
L'Estaque
1906
Oil on canvas
18 ⅜ x 21 ⅝ inches (46 x 55 cm)
Merzbacher Kunststiftung

PLATE 3
Georges Braque
Landscape at L'Estaque
1906
Oil on canvas
19 x 24 inches (48.5 x 61 cm)
Private European Collection

PLATE 4
Georges Braque
The Great Trees, L'Estaque
1906–07
Oil on canvas mounted on composition board
31 ½ x 27 ¾ inches (80 x 70.5 cm)
Fractional gift to The Museum of Modern Art
from a private collector

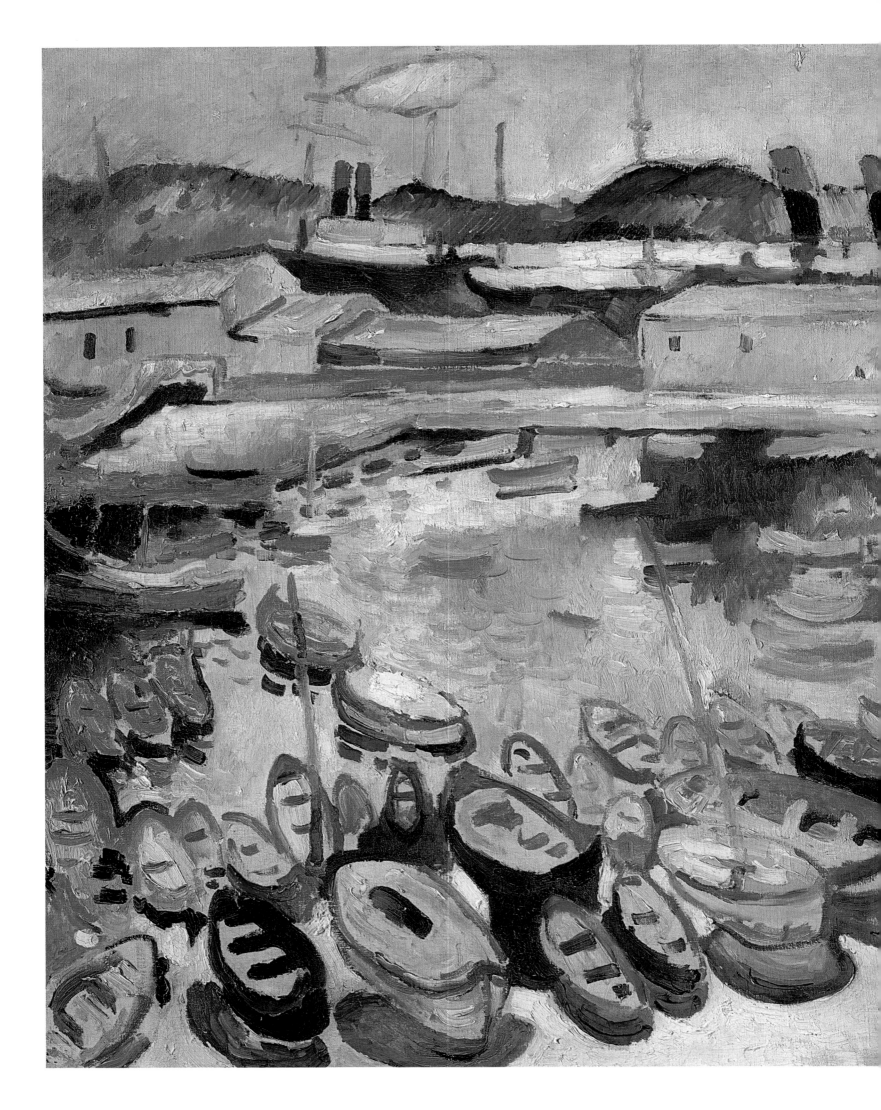

PLATE 5
Georges Braque
The Port of La Ciotat
1907
Oil on canvas
25 ½ x 31 ⅞ inches (65 x 81 cm)
National Gallery of Art, Washington,
Collection of Mr. and Mrs. John
Hay Whitney
1998.74.6

PLATE 6
Georges Braque
Houses at L'Estaque
1907
Oil on canvas
21 ½ x 18 ⅛ inches (54.5 x 46 cm)
Private International Collection

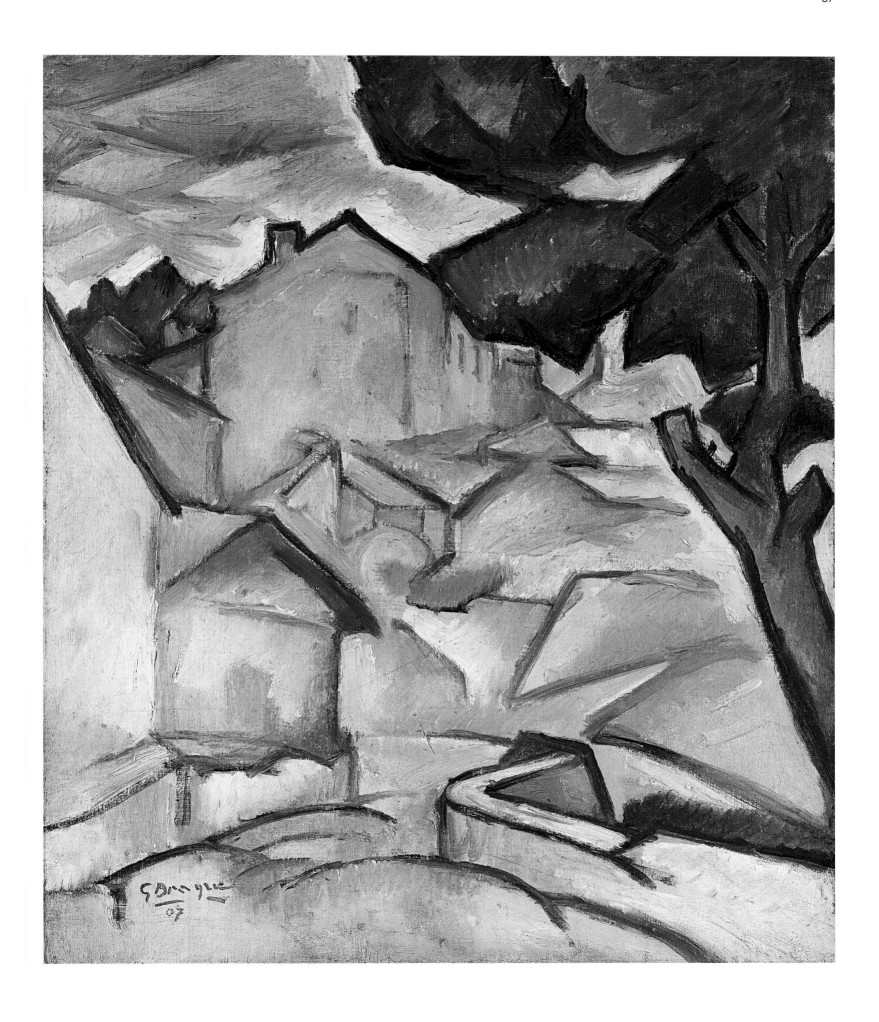

PLATE 7
Georges Braque
Harbor
1909
Oil on canvas
16 x 19 inches (40.5 x 48 cm)
National Gallery of Art, Washington,
Gift of Victoria Nebeker Coberly
in memory of her son, John W. Mudd
1992.3.1

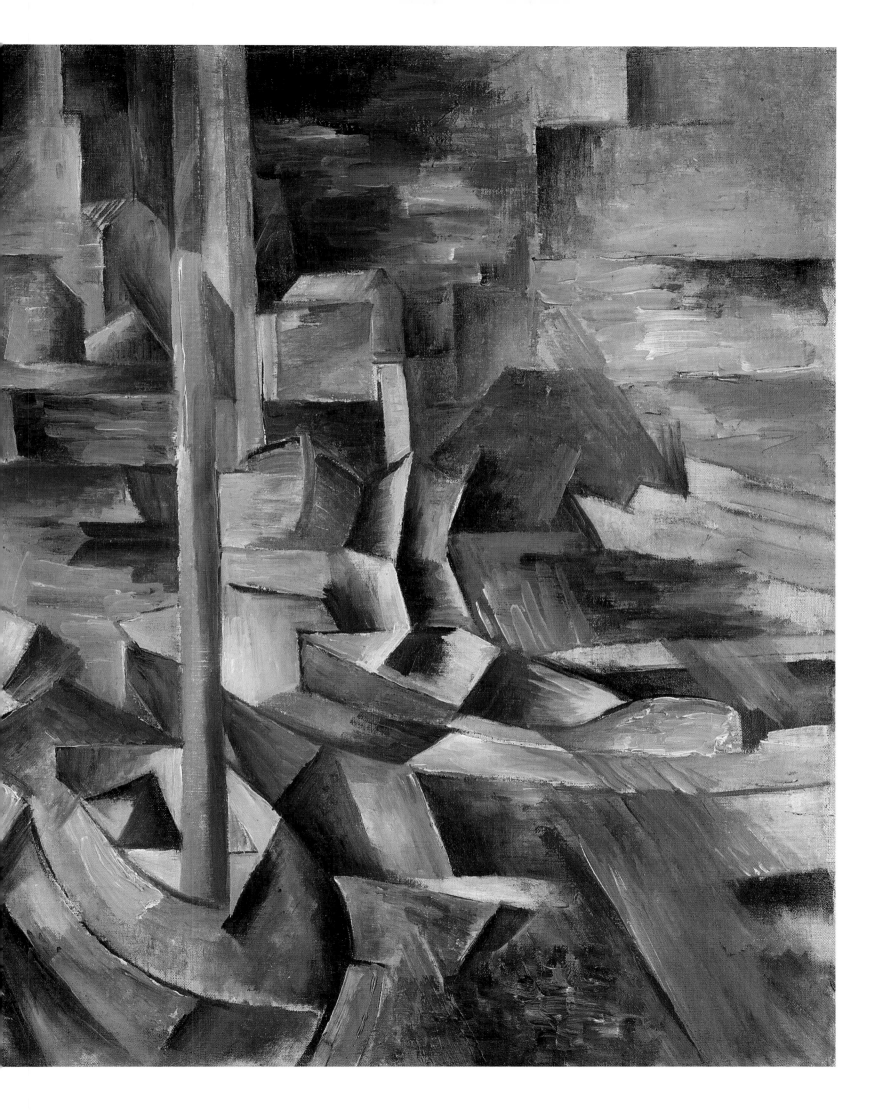

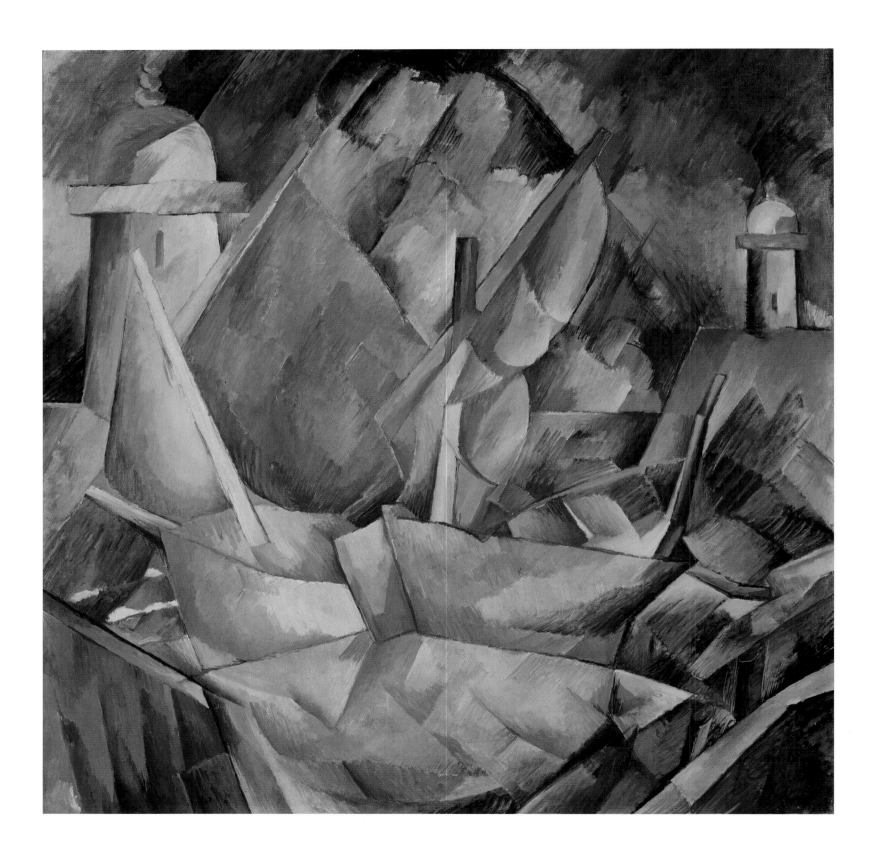

PLATE 8
Georges Braque
Harbor
1909
Oil on canvas
32 x 31 ¾ inches (81 x 80.5 cm)
Samuel A. Marx Purchase Fund, 1970.98
The Art Institute of Chicago

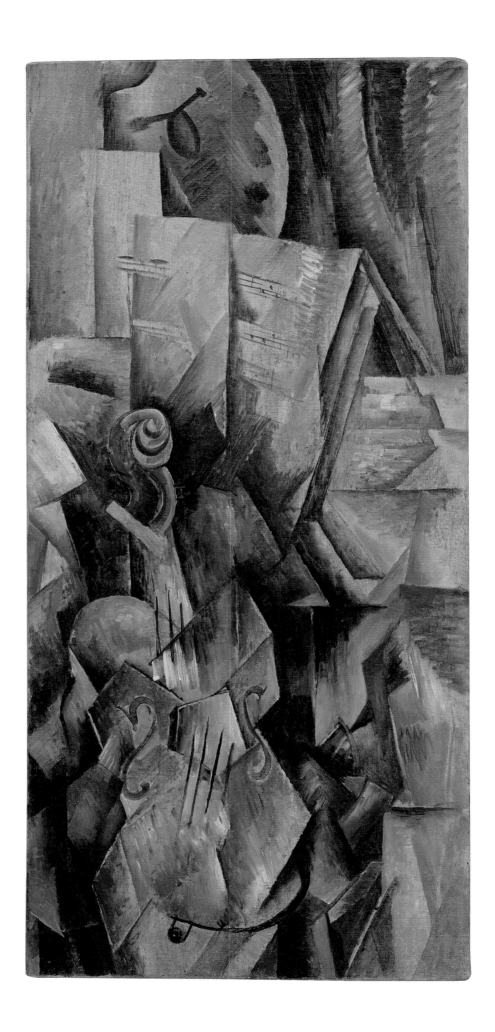

PLATE 9
Georges Braque
Violin and Palette
September 1, 1909
Oil on canvas
36 ⅛ x 16 ⅞ inches
(91.5 x 43 cm)
Solomon R. Guggenheim
Museum, New York
54.1412

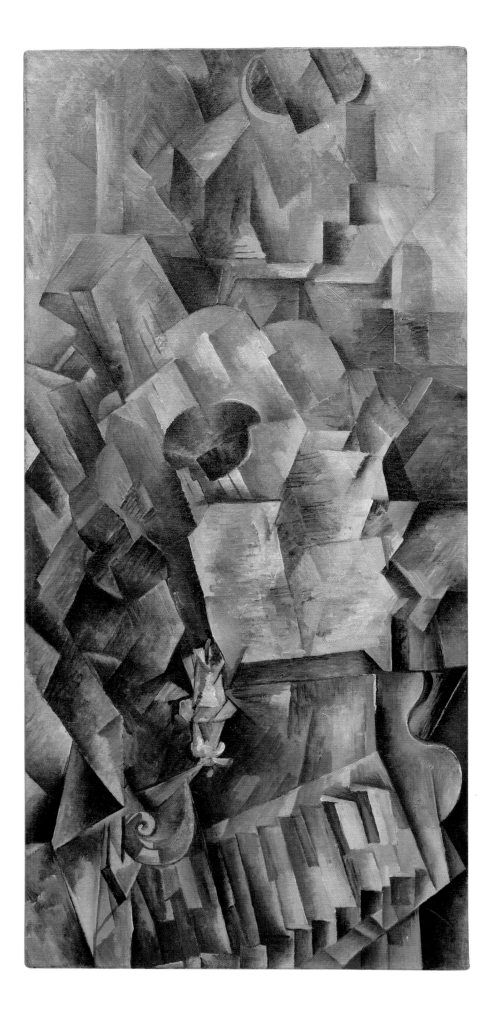

PLATE 10
Georges Braque
Piano and Mandola
Winter 1909–10
Oil on canvas
36 ⅛ x 16 ⅞ inches
(91.5 x 43 cm)
Solomon R. Guggenheim
Museum, New York
54.1411

PLATE 11
Georges Braque
Still Life with Metronome
1909–10
Oil on canvas
31 7/8 x 21 5/16 inches (81 x 54 cm)
Private Collection

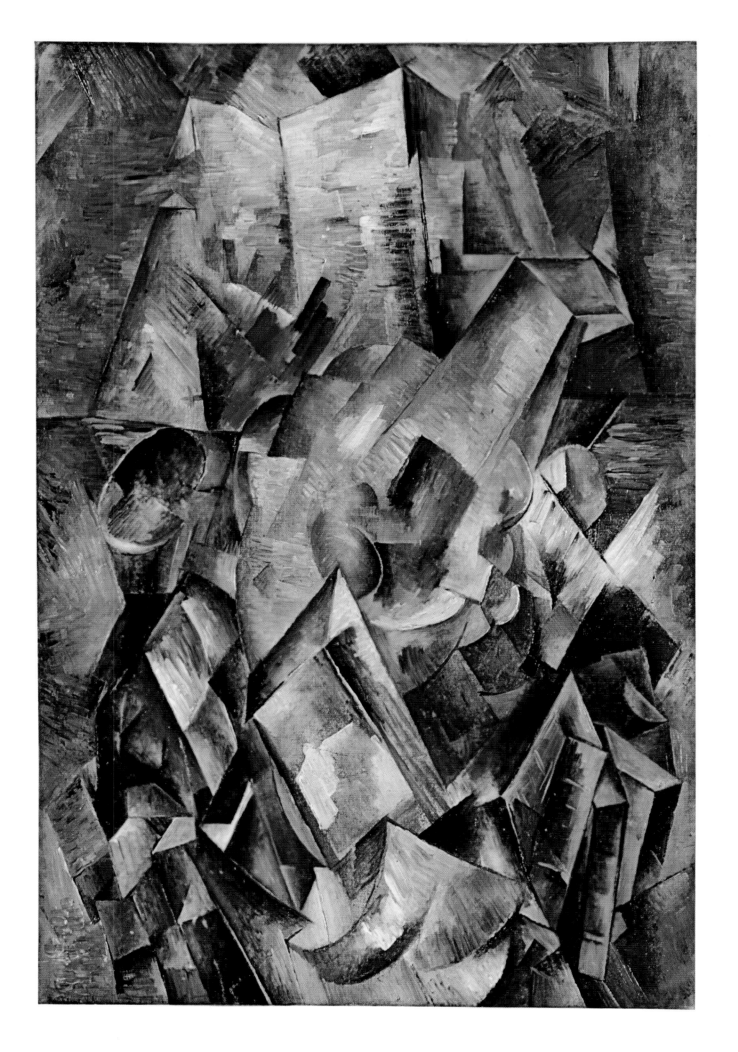

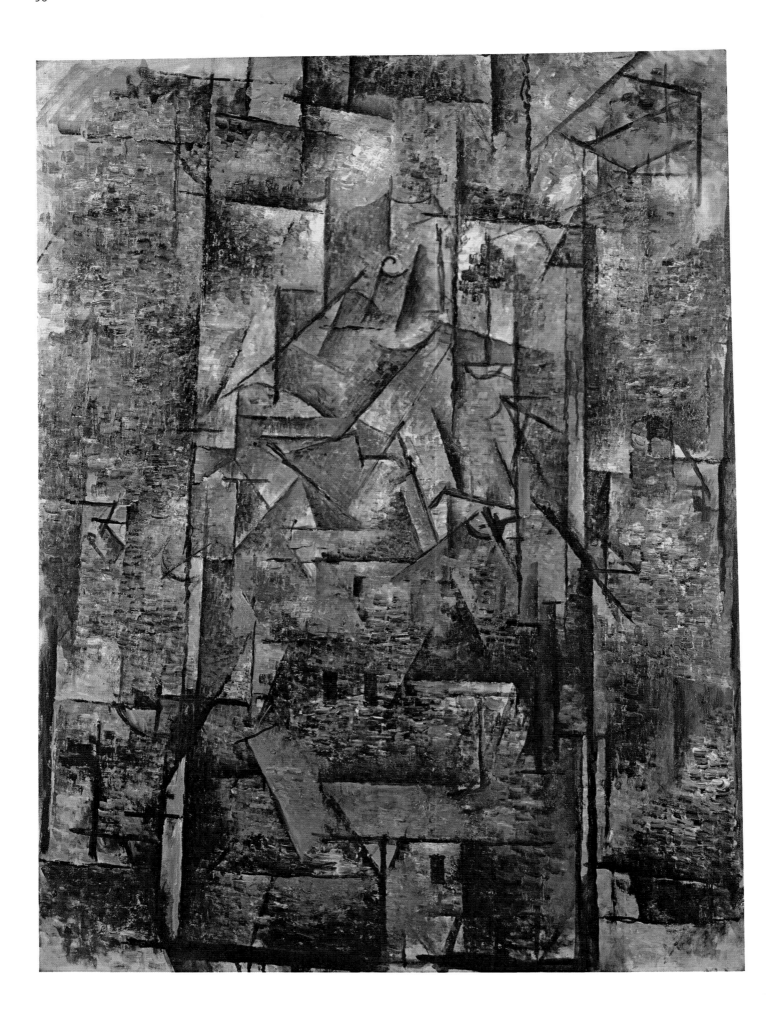

PLATE 12 [LEFT]
Georges Braque
Céret, Rooftops
1911
Oil on canvas
34 ¾ x 25 ½ inches
(88.5 x 65 cm)
Private Collection

PLATE 13 [RIGHT]
Georges Braque
Guéridon
1911
Oil on canvas
15 ¾ x 13 inches
(40 x 33 cm)
Private Collection

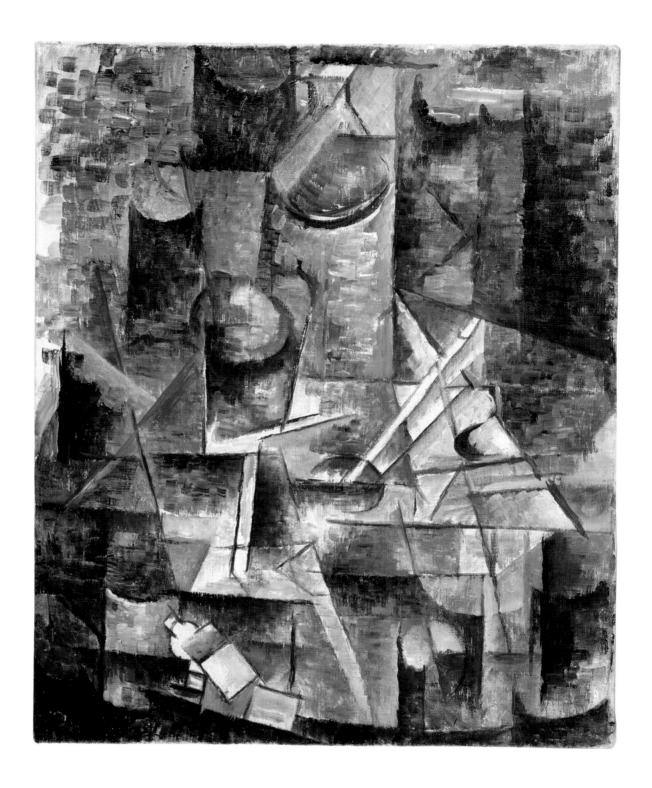

PLATE 14
Georges Braque
The Mantlepiece
1911
Oil on canvas
31 ⅞ x 23 ⅝ inches (81 x 60 cm)
Tate: Purchased with assistance from a
special government grant and with
assistance from the Art Fund 1978

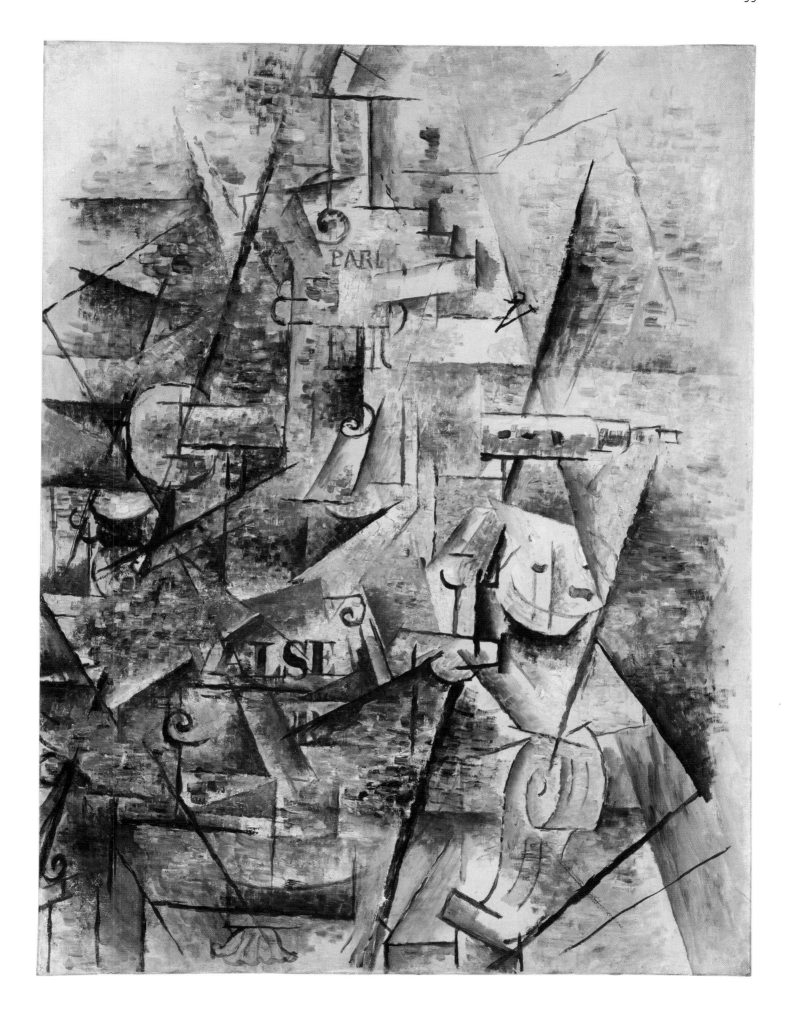

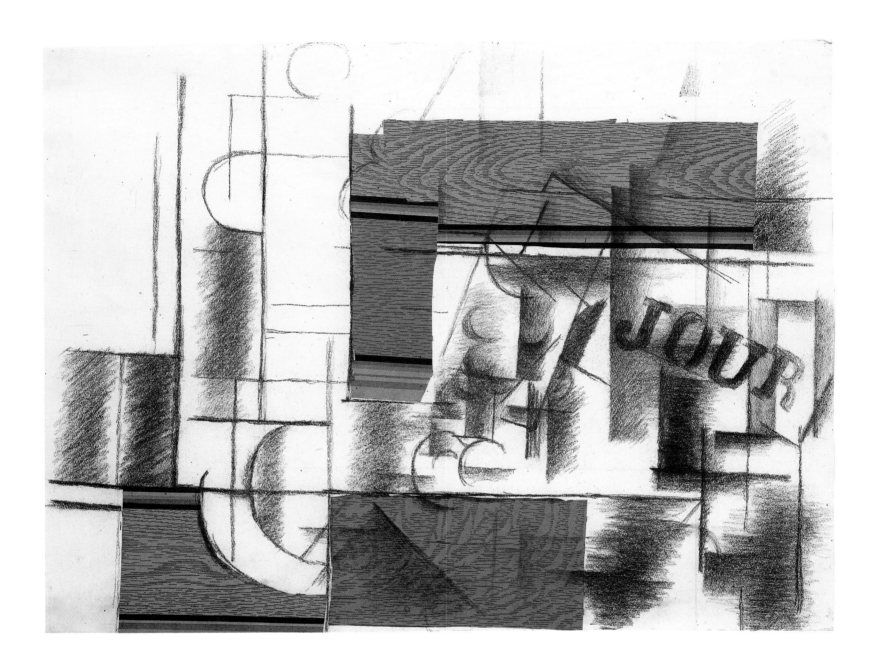

PLATE 15 [LEFT]

Georges Braque

Glass, Bottle and Newspaper

1912

Charcoal and faux-bois wallpaper on paper

18 ⅞ x 24 ⅜ inches (48 x 62 cm)

Fondation Beyeler, Riehen/Basel

PLATE 16 [RIGHT]

Georges Braque

Head of a Woman

1912–13

Charcoal and imitation wood paper pasted on paper

24 x 18 ½ inches (61 x 47 cm)

Private Collection

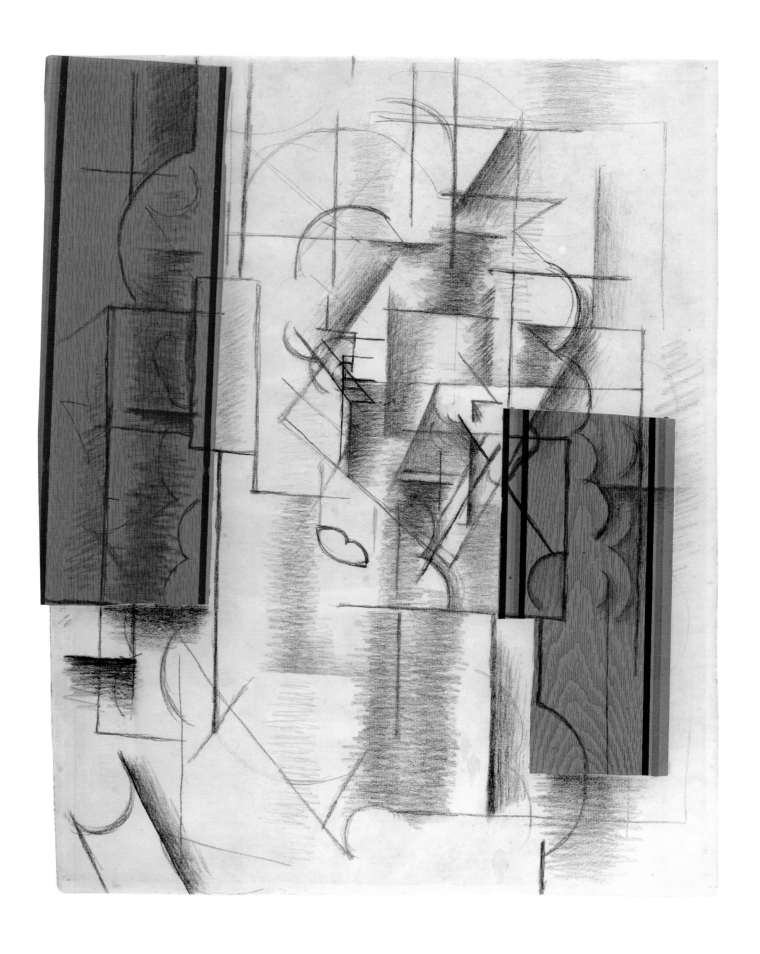

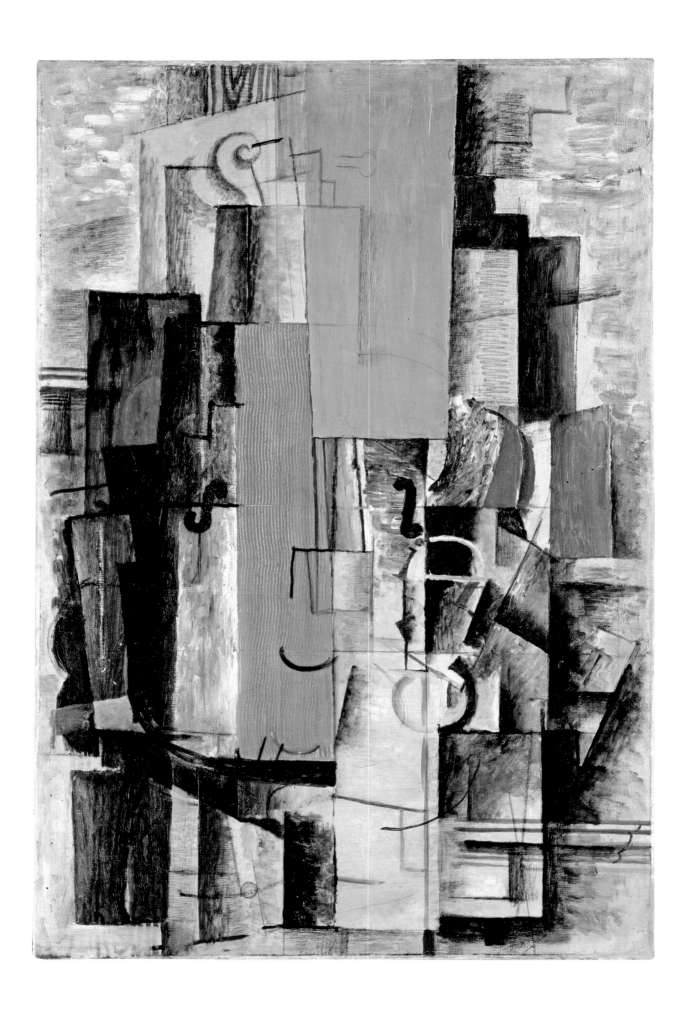

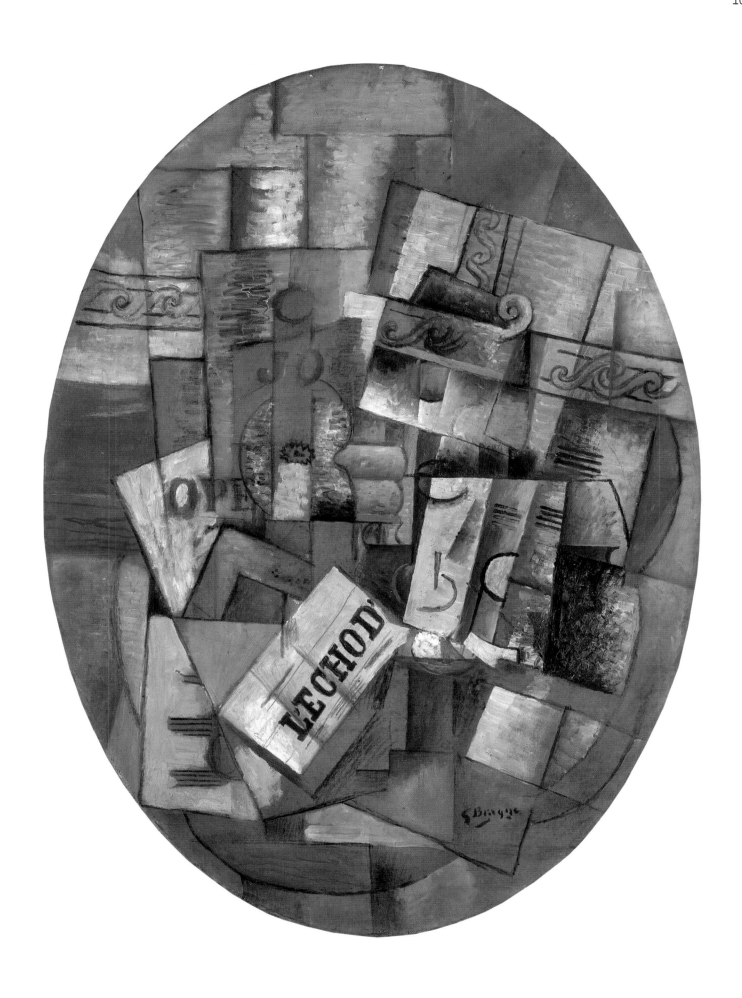

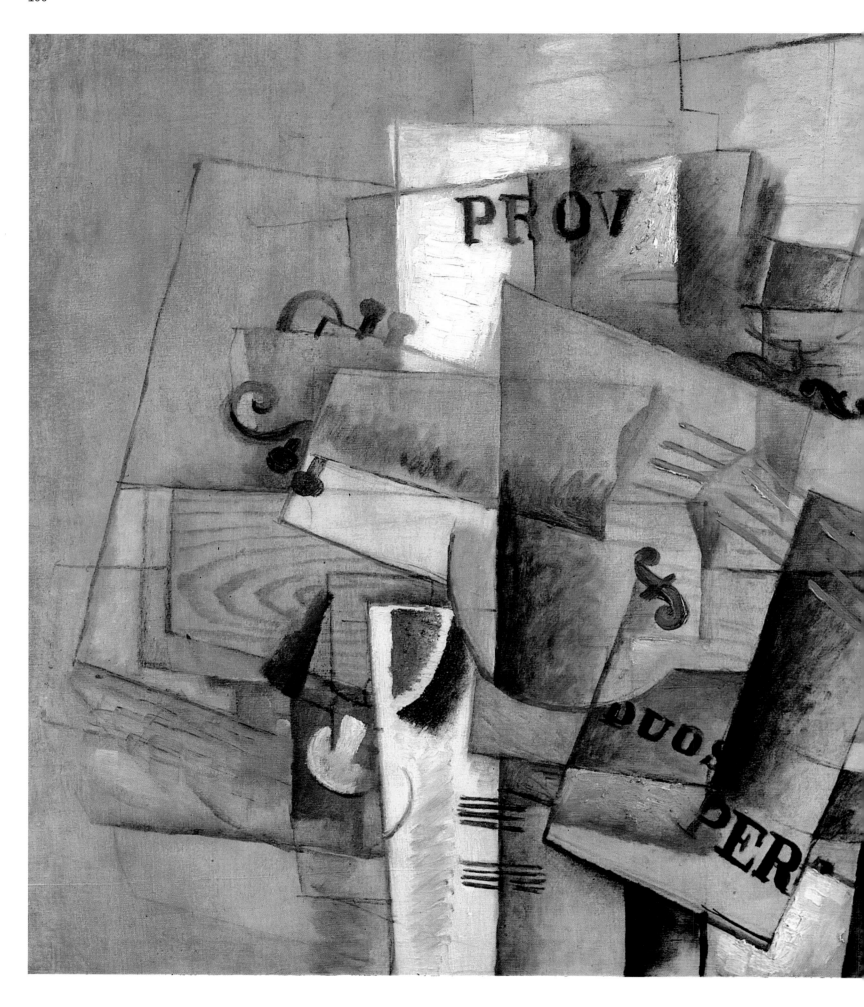

PLATE 21
Georges Braque
Glass and Pipe
1913–14
Oil on canvas
10 ⅝ x 16 ⅛ inches (27 x 41 cm)
Private Collection, New York

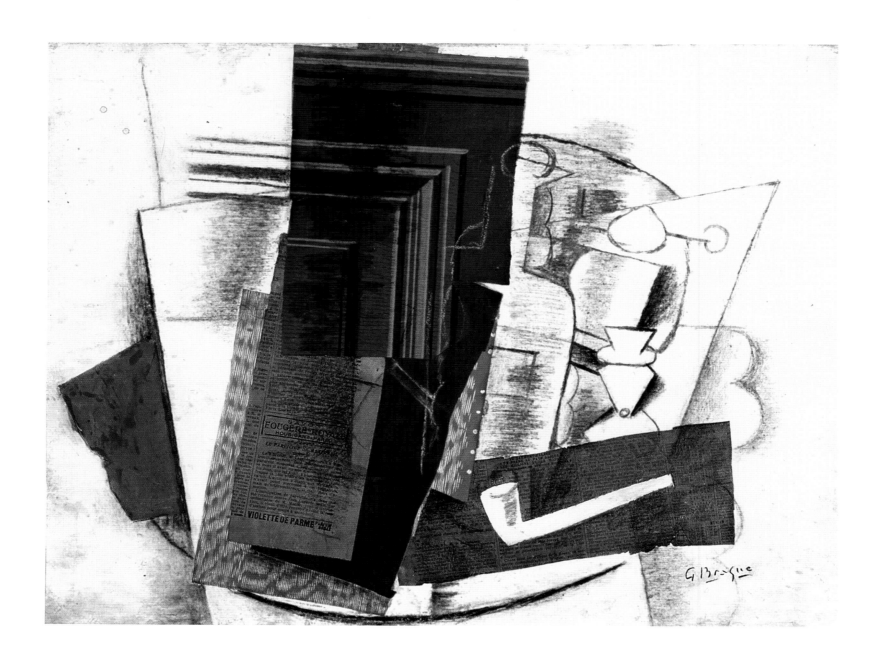

PLATE 22
Georges Braque
Bottle, Glass and Pipe
1914
Cardboard, pasted and painted
papers, newspaper, charcoal on paper
18 ⅝ x 24 ¾ inches (47.5 x 63 cm)
Private Collection

PLATE 23
Georges Braque
Guitar and Glass
1917
Oil on canvas
23 ⅝ x 36 inches (60 x 91.5 cm)
Collection Kröller-Müller Museum,
Otterlo, The Netherlands

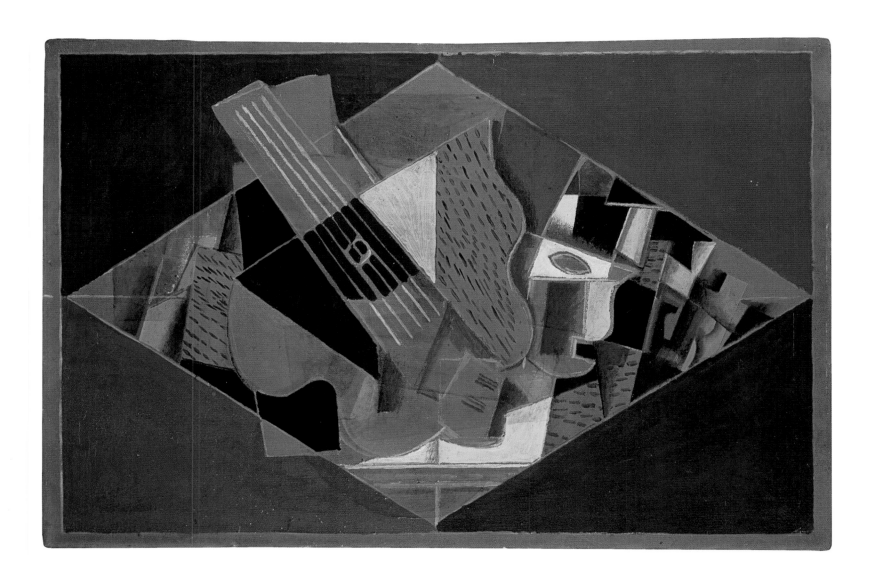

PLATE 24
Georges Braque
*Bottle and Musical
Instruments*
1918
Crayon, charcoal and
white chalk on
collaged paper and
corrugated cardboard
on primed board
20 ⅞ x 29 ¾ inches
(53 x 75.5 cm)
Private Collection

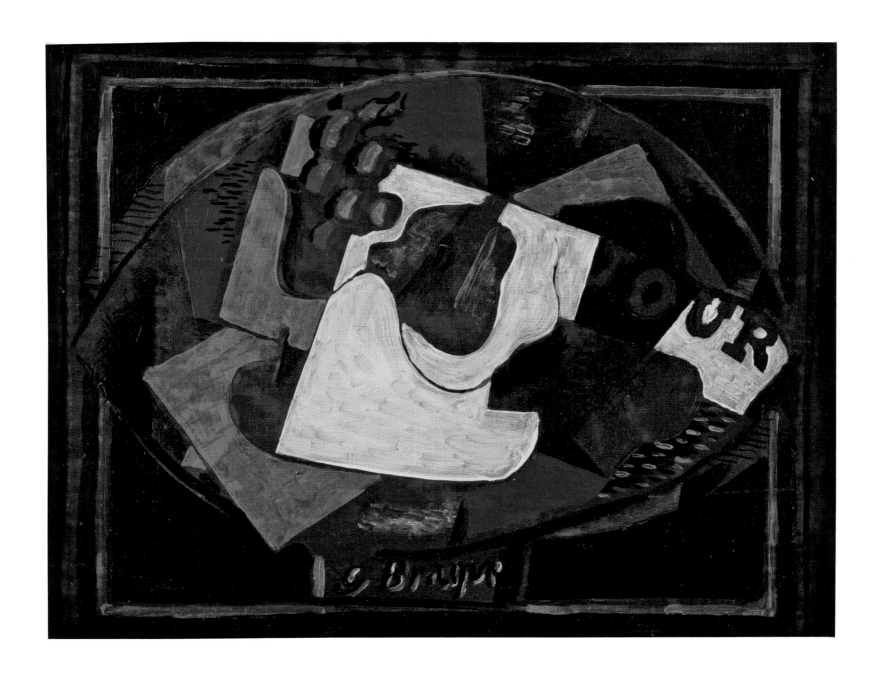

PLATE 25
Georges Braque
The Compotier
1918
Oil on canvas
16 7/8 x 21 5/8 inches (43 x 55 cm)
Bergen Art Museum, Norway

PLATE 26
Georges Braque
The Black Guitar
c. 1918–19
Oil on canvas
25 ³⁄₈ x 31 ⁷⁄₈ inches (64.5 x 81 cm)
Musée d'Art Moderne de la Ville de Paris

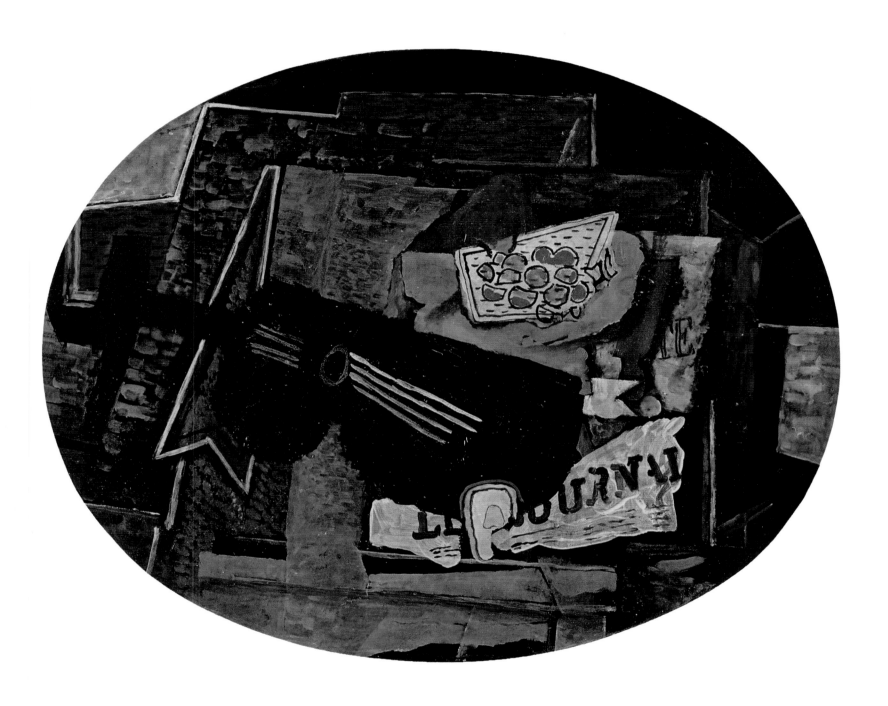

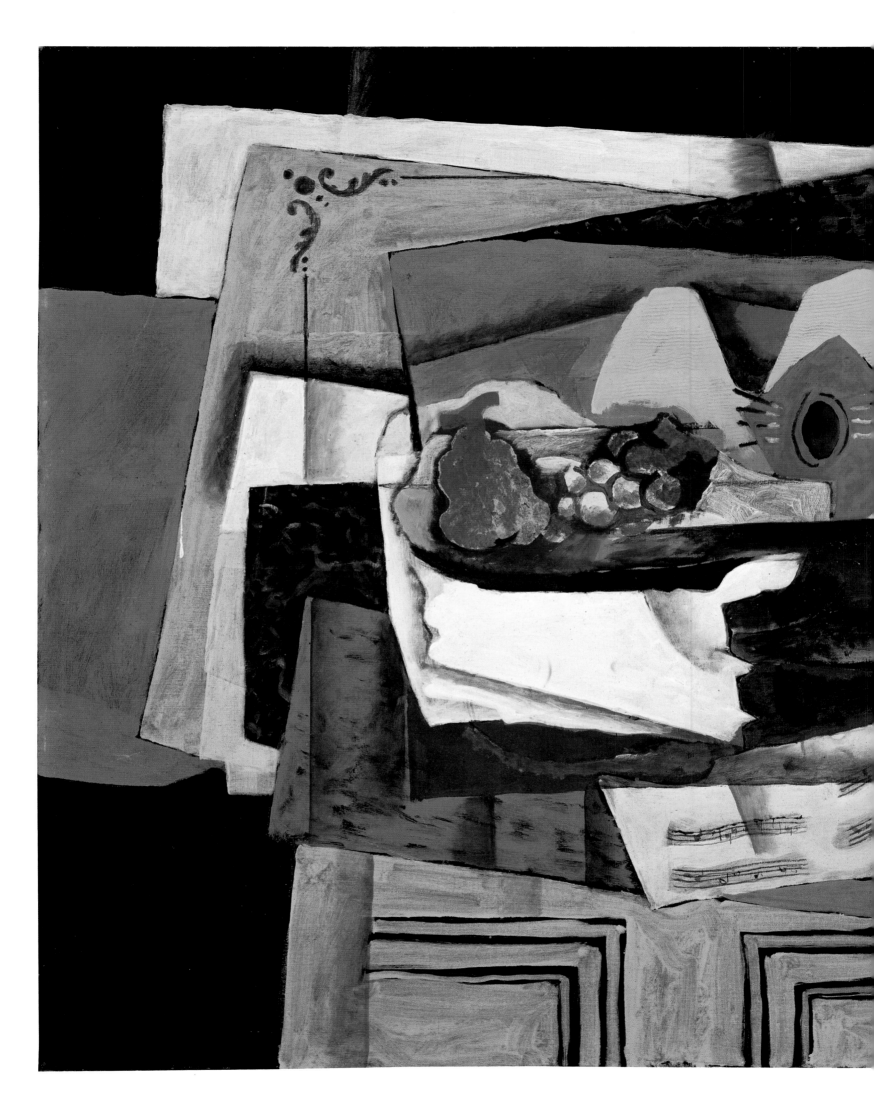

PLATE 27
Georges Braque
The Pantry
1920
Oil on canvas
31⅞ x 39⅜ inches (81 x 100 cm)
Albertina, Vienna–Batliner Collection,
Inv. GE18DL

PLATE 28
Georges Braque
Lemon, Bananas, Plums, Glass
1925
Oil on canvas
11 5/8 x 28 3/4 inches (29.5 x 73 cm)
Kunsthaus Zürich, Johanna &
Walter L. Wolf Collection

PLATE 29
Georges Braque
Brown Still Life
1926
Oil on canvas, 32 x 39 ⅜ inches (81.5 x 100 cm)
Bayerische Staatsgemäldesammlungen,
Munich – Pinakothek der Moderne
Inv. Nr. 14436

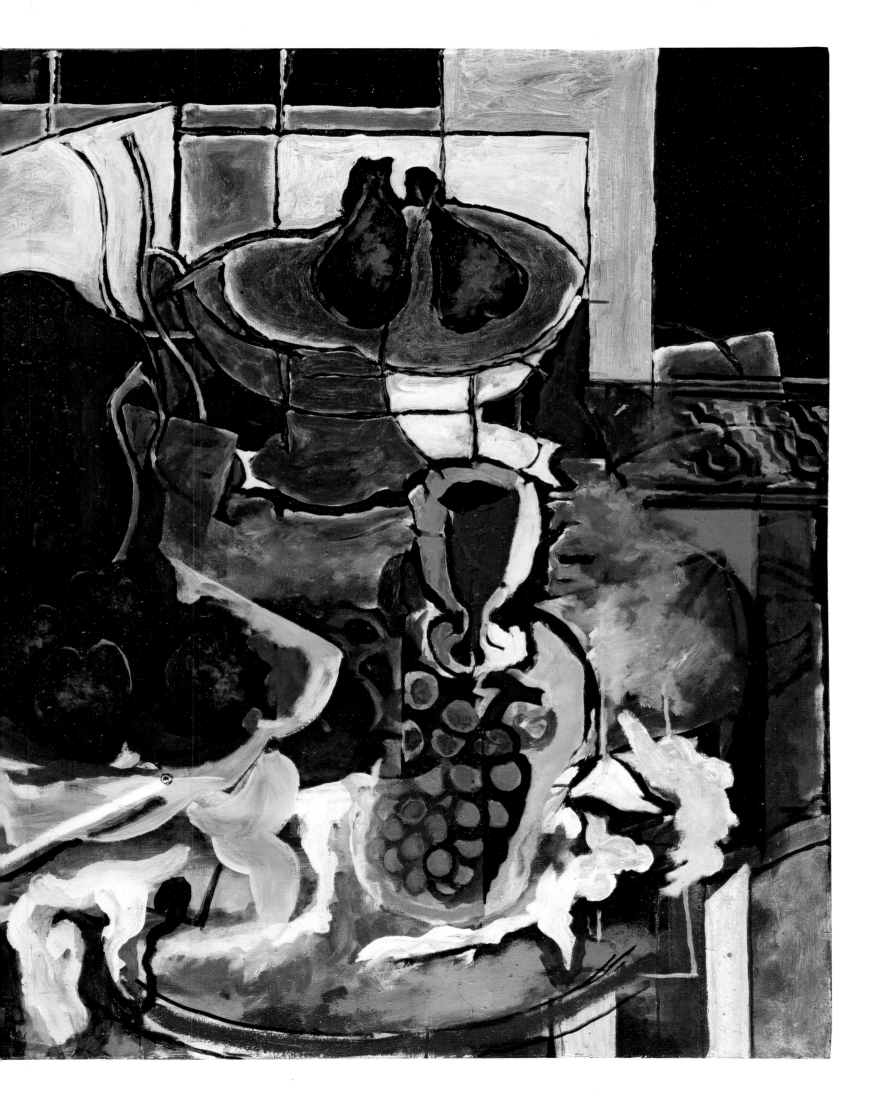

PLATE 30
Georges Braque
The Yellow Tablecloth
1935
Oil on canvas
45 x 57 inches (114.5 x 145 cm)
Private Collection

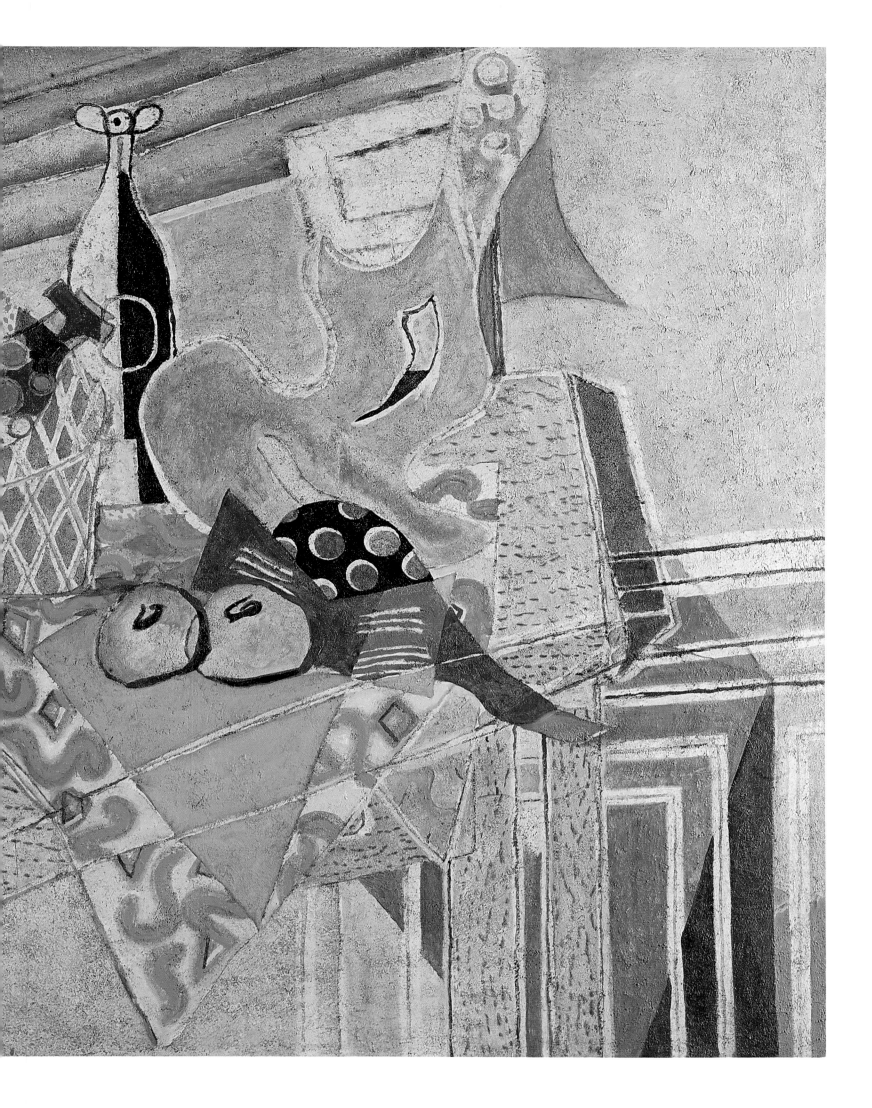

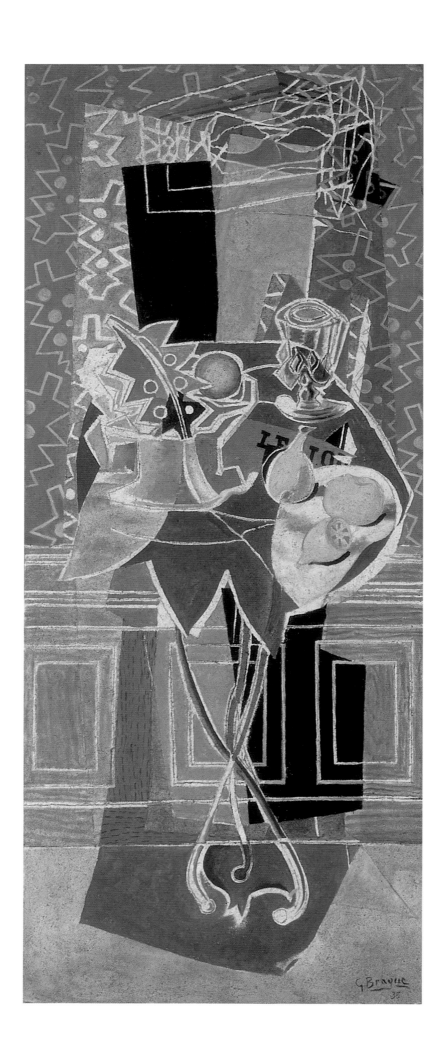

PLATE 31
Georges Braque
Gueridon
1935
Oil and sand on canvas
71 x 29 inches (180.5 cm x 73.5 cm)
San Francisco Museum of
Modern Art, Purchase with the
aid of funds from W. W. Crocker

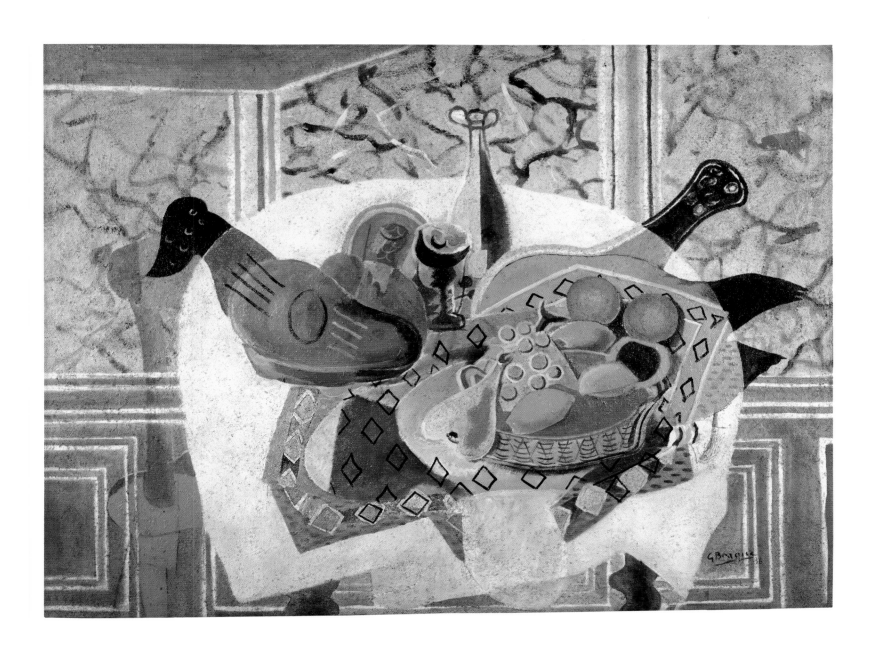

PLATE 32
Georges Braque
The Mauve Tablecloth
1936
Oil on canvas
33 ½ x 51 ½ inches (85 x 131 cm)
Private Collection

PLATE 33
Georges Braque
Still Life with Guitar I
(Red Tablecloth)
1936
Oil on canvas
38 ¼ x 51 inches (97 x 129.5 cm)
Gift of R. H. Norton, 47.46
The Norton Museum of Art,
West Palm Beach, Florida

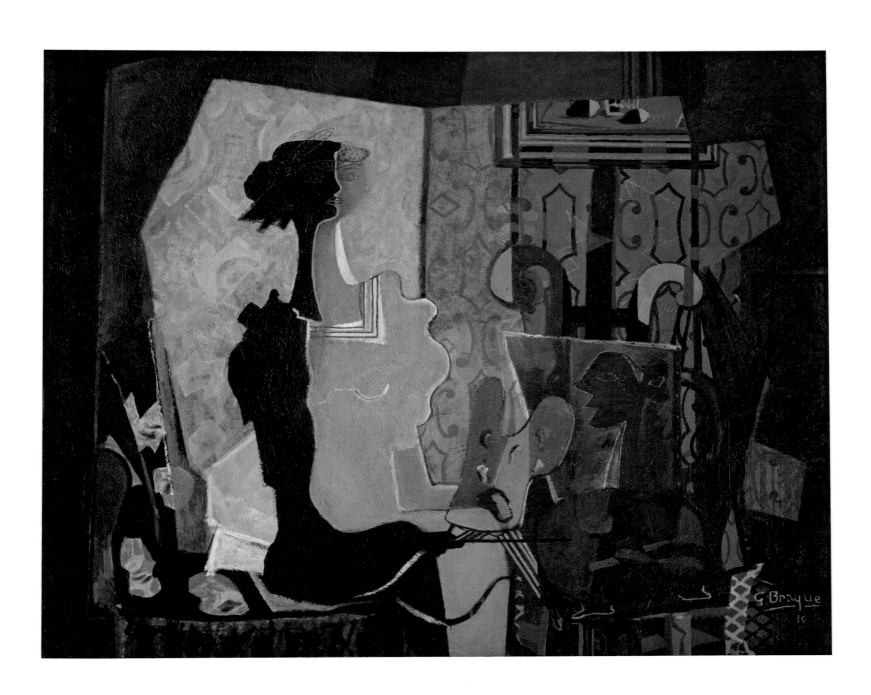

PLATE 34 [LEFT]

Georges Braque

Woman at an Easel (Yellow Screen)

1936

Oil with sand on canvas

51 ½ x 63 ⅞ inches (131 x 162 cm)

The Metropolitan Museum of Art,

Bequest of Florene M. Schoenborn, 1995

(1996.403.12)

PLATE 35 [RIGHT]

Georges Braque

Woman with a Mandolin

1937

Oil on canvas

51 ¼ x 38 ¼ inches (130 x 97 cm)

The Museum of Modern Art, New York.

Mrs. Simon Guggenheim Fund, 1948

Accession Number: 2.1948

PLATE 36
Georges Braque
Stool, Vase, Palette
1939
Oil on canvas
36 ¼ x 36 ¼ inches (92 x 92 cm)
Private Collection

PLATE 37
Georges Braque
The Washstand with Green Tiles (The Washstand)
1944
Oil on canvas
63 ⅞ x 25 ⅛ inches
(162 x 64 cm)
Acquired 1948
The Phillips Collection,
Washington, D.C.

PLATE 38
Georges Braque
The Billiard Table
1944–52
Oil with sand and charcoal on canvas
71¼ x 38½ inches (181 x 98 cm)
The Metropolitan Museum of Art,
Jacques and Natasha Gelman Collection,
1998 (1999.363.9)

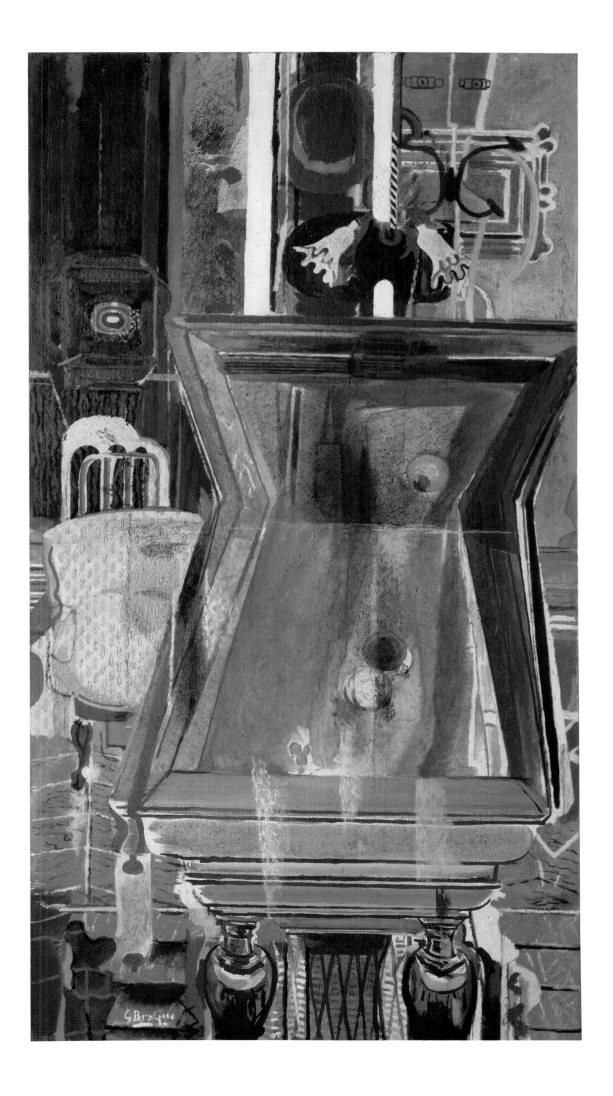

PLATE 39
Georges Braque
The Billiard Table
1945
Oil and sand on canvas
35 x 45 ¾ inches (89 x 116.5 cm)
Tate: Purchased with assistance from
the gift of Gustav and Elly Kahnweiler,
the Art Fund, Tate Members and
the Dr V.J. Daniel Bequest 2003

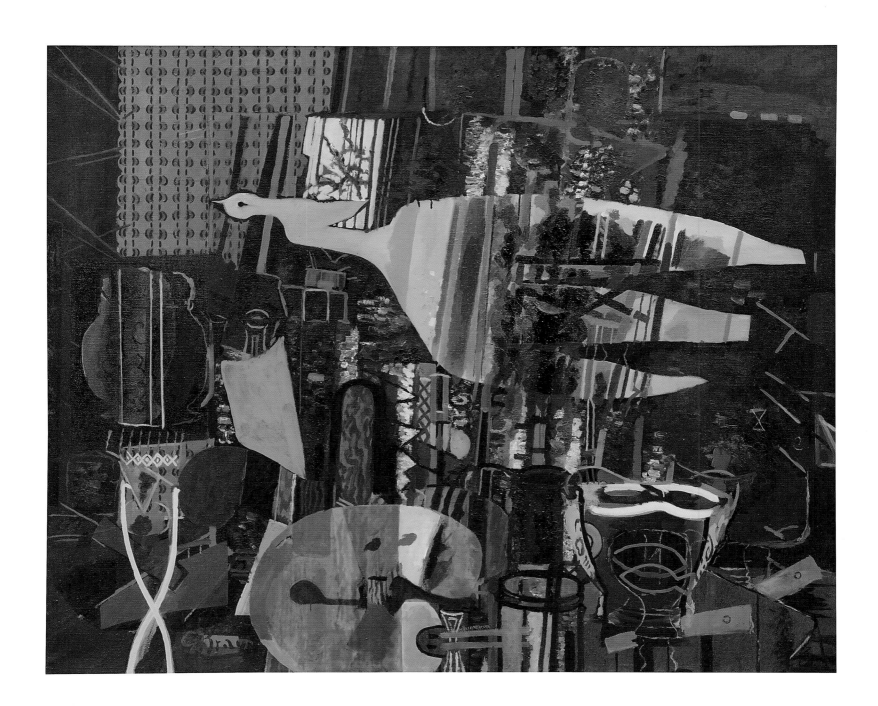

PLATE 40

Georges Braque

Studio V

1949–50

Oil on canvas

57 7/8 x 69 1/2 inches (147 x 176.5 cm)

The Museum of Modern Art, New York.

Acquired through the Lillie P. Bliss Bequest, 2000

Accession Number: 123.2000

PLATE 41
Georges Braque
Studio IX
1952–53/56
Oil on canvas
57 ½ x 57 ½ inches (146 x 146 cm)
Musée national d'art moderne – Centre de
création industrielle, Centre Pompidou, Paris
Dation, 1982
AM 1982–99

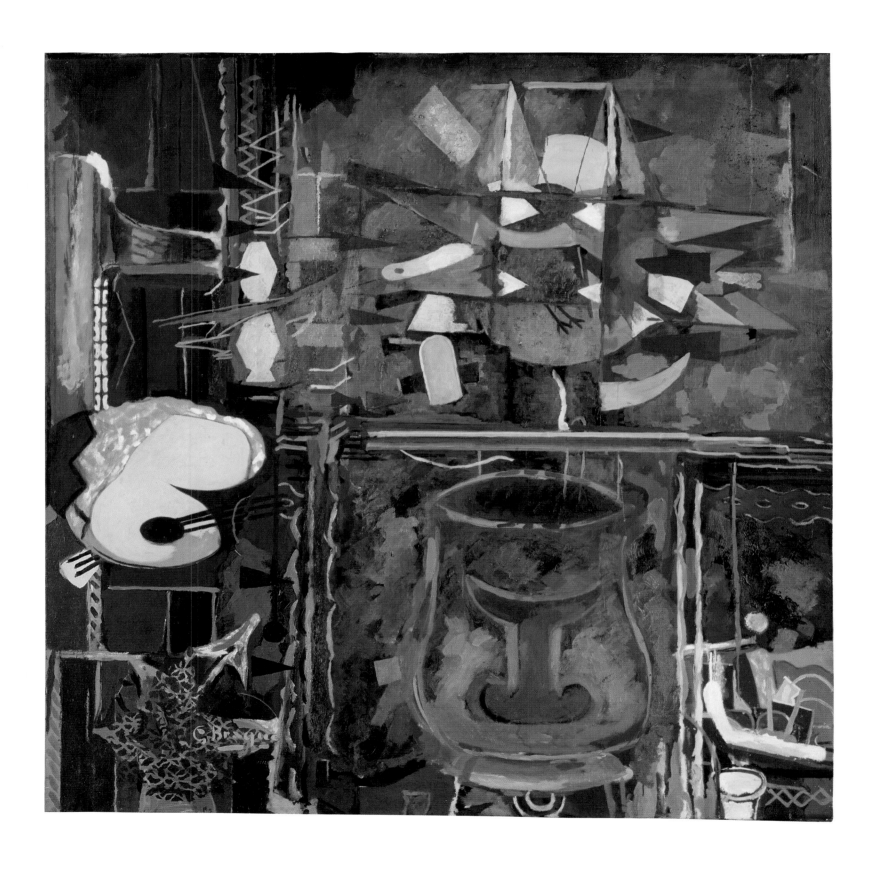

PLATE 1
Georges Braque
Landscape at L'Estaque
1906
Oil on canvas
23 ⅝ x 31 ⅞ inches (60 x 81 cm)
Merzbacher Kunststiftung

PLATE 2
Georges Braque
L'Estaque
1906
Oil on canvas
18 ⅛ x 21 ⅝ inches (46 x 55 cm)
Merzbacher Kunststiftung

PLATE 3
Georges Braque
Landscape at L'Estaque
1906
Oil on canvas
19 x 24 inches (48.5 x 61 cm)
Private European Collection

PLATE 4
Georges Braque
The Great Trees, L'Estaque
1906–07
Oil on canvas mounted on
composition board
31 ½ x 27 ¾ inches (80 x 70.5 cm)
Fractional gift to The Museum
of Modern Art from a private
collector

PLATE 5
Georges Braque
The Port of La Ciotat
1907
Oil on canvas
25 ½ x 31 ⅞ inches (65 x 81 cm)
National Gallery of Art, Washington,
Collection of Mr. and Mrs. John
Hay Whitney
1998.74.6

PLATE 6
Georges Braque
Houses at L'Estaque
1907
Oil on canvas
21 ½ x 18 ⅛ inches (54.5 x 46 cm)
Private International Collection

MAEGHT CATALOGUE RAISONNÉ VOL. I
(1907–1914): P. 60

PLATE 7
Georges Braque
Harbor
1909
Oil on canvas
16 x 19 inches (40.5 x 48 cm)
National Gallery of Art,
Washington, Gift of Victoria
Nebeker Coberly in memory
of her son, John W. Mudd
1992.3.1

MAEGHT CATALOGUE RAISONNÉ VOL. I
(1907–1914): P. 96

PLATE 8
Georges Braque
Harbor
1909
Oil on canvas
32 x 31 ¾ inches (81 x 80.5 cm)
Samuel A. Marx Purchase Fund,
1970.98, The Art Institute of
Chicago

MAEGHT CATALOGUE RAISONNÉ VOL. I
(1907–1914): P. 101

PLATE 9
Georges Braque
Violin and Palette
September 1, 1909
Oil on canvas
36 ⅛ x 16 ⅞ inches (91.5 x 43 cm)
Solomon R. Guggenheim
Museum, New York
54.1412

MAEGHT CATALOGUE RAISONNÉ VOL. I
(1907–1914): P. 111

PLATE 10
Georges Braque
Piano and Mandola
Winter 1909–10
Oil on canvas
36 ⅛ x 16 ⅞ inches (91.5 x 43 cm)
Solomon R. Guggenheim
Museum, New York
54.1411

MAEGHT CATALOGUE RAISONNÉ VOL. I
(1907–1914): P. 111

PLATE 11
Georges Braque
Still Life with Metronome
1909–10
Oil on canvas
31 ⅞ x 21 ⁵⁄₁₆ inches (81 x 54 cm)
Private Collection

MAEGHT CATALOGUE RAISONNÉ VOL. I
(1907–1914): P. 112

PLATE 12
Georges Braque
Céret, Rooftops
1911
Oil on canvas
34 ¾ x 25 ½ inches (88.5 x 65 cm)
Private Collection

MAEGHT CATALOGUE RAISONNÉ VOL. I
(1907–1914): P. 129

PLATE 13
Georges Braque
Gueridon
1911
Oil on canvas
15 ¾ x 13 inches (40 x 33 cm)
Private Collection

MAEGHT CATALOGUE RAISONNÉ VOL. I
(1907–1914): P. 140

PLATE 14
Georges Braque
The Mantlepiece
1911
Oil on canvas
31 ⅞ x 23 ⅝ inches (81 x 60 cm)
Tate: Purchased with assistance
from a special government
grant and with assistance from
the Art Fund 1978

MAEGHT CATALOGUE RAISONNÉ VOL. I
(1907–1914): P. 153

PLATE 15
Georges Braque
Glass, Bottle and Newspaper
1912
Charcoal and faux-bois
wallpaper on paper
18 ⅞ x 24 ⅜ inches (48 x 62 cm)
Fondation Beyeler, Riehen/Basel

MAEGHT CATALOGUE RAISONNÉ VOL. I
(1907–1914): P. 183

PLATE 16
Georges Braque
Head of a Woman
1912–13
Charcoal and imitation
wood paper pasted on paper
24 x 18 ½ inches (61 x 47 cm)
Private Collection

MAEGHT CATALOGUE RAISONNÉ VOL. I
(1907–1914): P. 184

PLATE 17
Georges Braque
Violin and Glass
1913
Oil on canvas
32 ¼ x 21 ½ inches (82 x 54.5 cm)
Private Collection, Courtesy
Guggenheim Asher Associates

MAEGHT CATALOGUE RAISONNÉ VOL. I
(1907–1914): P. 176

PLATE 18
Georges Braque
Glass and Tobacco
1913
Charcoal, imitation wood paper
and newspaper pasted on
Ingres paper
11 ³/₈ x 18 ⅛ inches (29 x 46 cm)
Private Collection

MAEGHT CATALOGUE RAISONNÉ VOL. I
(1907–1914): P. 189

PLATE 19
Georges Braque
Gueridon
1913
Black chalk, charcoal, and
oil on canvas
38 ⅞ x 28 ½ inches (98.5 x 72.5 cm)
Staatliche Museen zu Berlin,
Nationalgalerie, Museum
Berggruen

MAEGHT CATALOGUE RAISONNÉ VOL. I
(1907–1914): P. 197

PLATE 20
Georges Braque
Violin and Glass
1913–14
Oil and charcoal on canvas
25 ¾ x 36 ¼ inches (65.5 x 92 cm)
Private Collection

MAEGHT CATALOGUE RAISONNÉ VOL. I
(1907–1914): P. 215

PLATE 21
Georges Braque
Glass and Pipe
1913–14
Oil on canvas
10 ⅝ x 16 ⅛ inches (27 x 41 cm)
Private Collection, New York

MAEGHT CATALOGUE RAISONNÉ VOL. I
(1907–1914): P. 231

PLATE 22
Georges Braque
Bottle, Glass and Pipe
1914
Cardboard, pasted and painted
papers, newspaper, charcoal
on paper
18 ⅝ x 24 ¾ inches (47.5 x 63 cm)
Private Collection

MAEGHT CATALOGUE RAISONNÉ VOL. I
(1907–1914): P. 235

PLATE 23
Georges Braque
Guitar and Glass
1917
Oil on canvas
23 ⅝ x 36 inches (60 x 91.5 cm)
Collection Kröller-Müller Museum,
Otterlo, The Netherlands

MAEGHT CATALOGUE RAISONNÉ VOL. II
(1916–1923): P. 9

PLATE 24
Georges Braque
Bottle and Musical Instruments
1918
Crayon, charcoal and white chalk
on collaged paper and corrugated
cardboard on primed board
20 ⅞ x 29 ¾ inches (53 x 75.5 cm)
Private Collection

MAEGHT CATALOGUE RAISONNÉ VOL. II
(1916–1923): P. 36

PLATE 25
Georges Braque
The Compotier
1918
Oil on canvas
16 ⅞ x 21 ⅝ inches (43 x 55 cm)
Bergen Art Museum, Norway

MAEGHT CATALOGUE RAISONNÉ VOL. II
(1916–1923): P. 27

PLATE 26
Georges Braque
The Black Guitar
c. 1918–19
Oil on canvas
25 ³/₈ x 31 ⅞ inches (64.5 x 81 cm)
Musée d'Art Moderne de la
Ville de Paris

MAEGHT CATALOGUE RAISONNÉ VOL. II
(1916–1923): P. 51

PLATE 27
Georges Braque
The Pantry
1920
Oil on canvas
31 ⅞ x 39 ³/₈ inches (81 x 100 cm)
Albertina, Vienna – Batliner
Collection, Inv. GE18DL

MAEGHT CATALOGUE RAISONNÉ VOL. II
(1916–1923): P. 72

PLATE 28
Georges Braque
Lemon, Bananas, Plums, Glass
1925
Oil on canvas
11 ⅝ x 28 ¾ inches (29.5 x 73 cm)
Kunsthaus Zürich, Johanna &
Walter L. Wolf Collection

MAEGHT CATALOGUE RAISONNÉ VOL. III
(1924–1927): P. 58

PLATE 29
Georges Braque
Brown Still Life
1926
Oil on canvas, 32 x 39 ³/₈ inches
(81.5 x 100 cm)
Bayerische Staatsgemälde-
sammlungen, Munich –
Pinakothek der Moderne
Inv. Nr. 14436

MAEGHT CATALOGUE RAISONNÉ VOL. III
(1924–1927): P. 78

PLATE 30
Georges Braque
The Yellow Tablecloth
1935
Oil on canvas
45 x 57 inches (114.5 x 145 cm)
Private Collection

MAEGHT CATALOGUE RAISONNÉ VOL. IV
(1928–1935): P. 109

PLATE 31
Georges Braque
Gueridon
1935
Oil and sand on canvas
71 x 29 inches (180.5 cm x 73.5 cm)
San Francisco Museum of
Modern Art, Purchase with the
aid of funds from W. W. Crocker

MAEGHT CATALOGUE RAISONNÉ VOL. V
(1936–1941): P. 8

PLATE 32
Georges Braque
The Mauve Tablecloth
1936
Oil on canvas
33 ½ x 51 ½ inches (85 x 131 cm)
Private Collection

MAEGHT CATALOGUE RAISONNÉ VOL. V
(1936–1941): P. 5

PLATE 33
Georges Braque
*Still Life with Guitar I (Red
Tablecloth)*
1936
Oil on canvas
38 ¼ x 51 inches (97 x 129.5 cm)
Gift of R. H. Norton, 47.46
The Norton Museum of Art, West
Palm Beach, Florida

MAEGHT CATALOGUE RAISONNÉ VOL. V
(1936–1941): P. 6

PLATE 34

Georges Braque

Woman at an Easel (Yellow Screen)

1936

Oil with sand on canvas

51 ½ x 63 ⅞ inches (131 x 162 cm)

The Metropolitan Museum of Art, Bequest of Florene M. Schoenborn, 1995 (1996.403.12)

MAEGHT CATALOGUE RAISONNÉ VOL. V (1936–1941): P. 1

PLATE 35

Georges Braque

Woman with a Mandolin

1937

Oil on canvas

51 ¼ x 38 ¼ inches (130 x 97 cm)

The Museum of Modern Art, New York. Mrs. Simon Guggenheim Fund, 1948

Accession Number: 2.1948

MAEGHT CATALOGUE RAISONNÉ VOL. V (1936–1941): P. 16

PLATE 36

Georges Braque

Stool, Vase, Palette

1939

Oil on canvas

36 ¼ x 36 ¼ inches (92 x 92 cm)

Private Collection

MAEGHT CATALOGUE RAISONNÉ VOL. V (1936–1941): P. 62

PLATE 37

Georges Braque

The Washstand with Green Tiles (The Washstand)

1944

Oil on canvas

63 ⅞ x 25 ⅛ inches (162 x 64 cm)

Acquired 1948

The Phillips Collection, Washington, D.C.

MAEGHT CATALOGUE RAISONNÉ VOL. VI (1942–1947): P. 70

PLATE 38

Georges Braque

The Billiard Table

1944–52

Oil with sand and charcoal on canvas

71 ¼ x 38 ½ inches (181 x 98 cm)

The Metropolitan Museum of Art, Jacques and Natasha Gelman Collection, 1998 (1999.363.9)

MAEGHT CATALOGUE RAISONNÉ VOL. VII (1948–1957): P. 37

PLATE 39

Georges Braque

The Billiard Table

1945

Oil and sand on canvas

35 x 45 ¾ inches (89 x 116.5 cm)

Tate: Purchased with assistance from the gift of Gustav and Elly Kahnweiler, the Art Fund, Tate Members and the Dr V.J. Daniel Bequest 2003

PLATE 40

Georges Braque

Studio V

1949–50

Oil on canvas

57 ⅞ x 69 ½ inches (147 x 176.5 cm)

The Museum of Modern Art, New York. Acquired through the Lillie P. Bliss Bequest, 2000

Accession Number: 123.2000

MAEGHT CATALOGUE RAISONNÉ VOL. VII (1948–1957): P. 9

PLATE 41

Georges Braque

Studio IX

1952–53/56

Oil on canvas

57 ½ x 57 ½ inches (146 x 146 cm)

Musée national d'art moderne - Centre de création industrielle, Centre Pompidou, Paris

Dation, 1982

AM 1982–99

MAEGHT CATALOGUE RAISONNÉ VOL. VII (1948–1957): P. 104

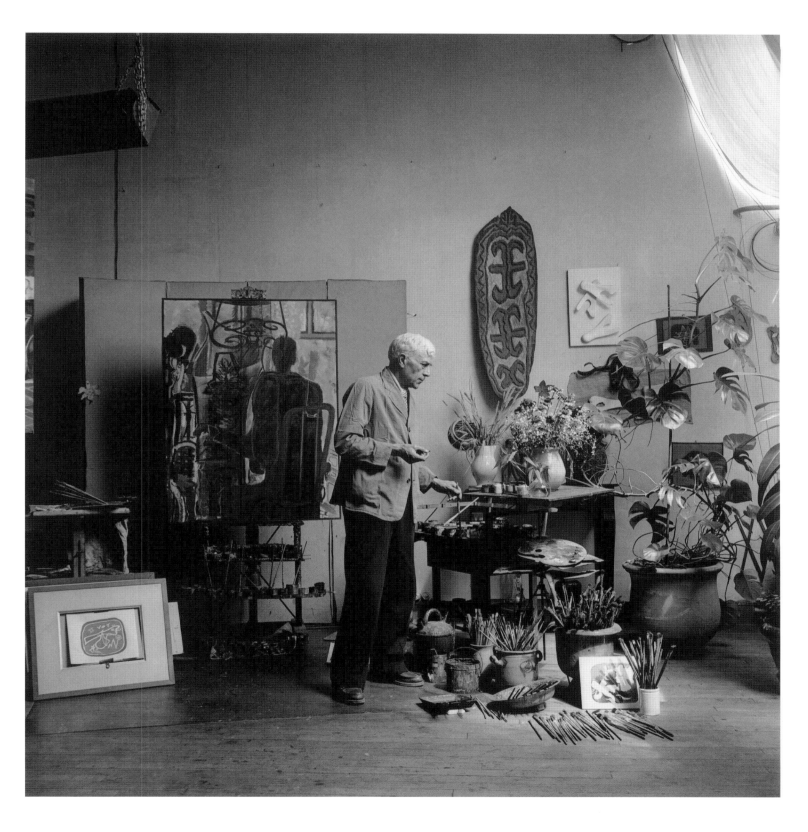

Georges Braque in his Paris studio in front of *The Man with a Guitar.*
Photograph by Willy Maywald

Portrait of Georges Braque, 1922. **Photograph by Man Ray**

Georges Braque was born on May 13, 1882 in Argenteuil-sur-Seine, a suburb outside of Paris. His family moved to Le Havre in 1890, where his father ran a house-painting and decorating business. In Le Havre, Braque took evening classes at the École des Beaux-Arts, but, following in the footsteps of his father, he dropped out of school to apprentice as a decorator and house painter. In 1900, Braque moved to Paris to study under a master decorator, but he continued to take painting classes in the evenings. Braque would draw from the technical knowledge he learned as an apprentice craftsman throughout his career.

It was not until 1902 that Braque dedicated himself to fine art full-time, enrolling at the Académie Humbert. Frequenting Parisian museums and galleries, Braque became particularly impressed by the paintings of the Impressionists. His paintings at this time reflect their influence, but by 1904 he began using brighter colors, inspired in part by the vibrant palette of Vincent van Gogh.

At the 1905 Salon d'Automne, Braque was struck by the strident colors and loose, expressive brushwork of Henri Matisse's and André Derain's first Fauve paintings. It was at this exhibition that the Fauve movement gained momentum, after art critic Louis Vauxcelles disparagingly called the artists "fauves," French for wild beasts. During his stay in Antwerp in the summer of 1906 with Othon Friesz, Braque experimented with his first paintings in the Fauve style. As Matisse and Derain had done before him, he spent the winter in the south of France in order to paint the bright sunlight and water of the Mediterranean. He settled in the picturesque harbor town of L'Estaque, which had been a favorite spot of Paul Cézanne since the 1870s. At L'Estaque, Braque painted a series of vibrant Fauve landscapes that also betray the influences of Cézanne's compositions (see **Plate 1, 2, 3, 4**). Braque exhibited six of these Fauve landscapes at the Salon des Indépendants in March of 1907.

Braque was late to join Fauvism and was early to leave the movement; by the fall of 1907 he was already abandoning the style. He looked increasingly to the example of Cézanne – whose memorial retrospective Braque visited in October – and he began painting in a more restricted, subdued palette with an emphasis on geometric forms and flattened spaces (see **Plate 6**). In the fall, Braque met the dealer Daniel-Henry Kahnweiler and also the poet Guillaume Apollinaire, who took Braque to Pablo Picasso's studio. There Braque was astounded by Picasso's monumental canvas, *Les Demoiselles d'Avignon*. In response, Braque painted his own *Large Nude* in 1908, which incorporates the rawness, shallow space, and the muted colors of Picasso's work.

In the summer of 1908, during another trip to L'Estaque, Braque completed a group of stark, largely abstract paintings that simplify the forms of the landscape into geometric forms and planes. In November, Kahnweiler organized Braque's first one-man exhibition, showing more than twenty of these paintings. Reviewing the exhibition, Vauxcelles described Braque's work as "full of little cubes"—apparently echoing a remark made by Matisse—which coined the name for the nascent Cubist movement. These paintings in turn influenced Picasso, who became very close with Braque by the winter of 1908-09. Visiting each other daily, Braque and Picasso worked together to pioneer the radical style of Cubist painting (see **Plate 7, 8, 9, 10, 11**). Their collaboration was so close that Braque famously later described them as two mountaineers, roped together.

By 1910-11, they had developed the style known as Analytic Cubism, painting compressed and shallow spaces with a reduced palette of browns and grays (see **Plate 12, 13, 14**). By representing their subjects from multiple viewpoints, they rejected illusionism and traditional perspective, radically breaking with the history of art and painting. Braque and Picasso preferred to represent the traditional subject of the still life in these radical paintings—usually including the simple elements of bottles, fruits, pipes, newspapers, and musical instruments on tables—but since the forms are abstracted into facets and planes, the subjects can only be identified in flickering glimpses.

In 1912, Braque and Picasso began incorporating collage elements and unusual materials into their works, developing the second stage of Cubism known as Synthetic Cubism. After Picasso collaged a piece of cloth in his painting, *Still Life with Chair Caning*, Braque developed the *papier collé*, or pasted paper, technique. He made his first *papiers collés* by collaging *faux-bois* paper into his Cubist compositions (see **Plate 15, 16**). Upon seeing Braque's first *papiers collés*, Picasso began working with the technique and immediately adopted a wide range of papers, including daily newspapers and other referents to popular culture. Braque adopted new materials more slowly, but by 1913 he too was incorporating cut pieces of newspaper, colored papers, and fragments of tobacco and cigarette boxes into his work (see **Plate 18, 22**). Drawing upon his painter-decorator background, Braque often contrasted his *faux-bois* papers with painted passages of imitation woodgrain, which he achieved by using a metal decorator's comb (see **Plate 17**). He also began to experiment with mixing sand into his paint to achieve different tactile and textural effects, a technique he would frequently use for the rest of his career.

Braque and Picasso's fertile artistic collaboration lasted until the outbreak of World War One in 1914, when Braque enlisted in the French army. He suffered a serious head wound in 1915 - which required a major surgery and a lengthy hospitalization - before being discharged in April of 1916. He resumed painting in late 1916, but only made three works in that year. In 1917, he returned to the Synthetic Cubist themes that had occupied him before the war, including experiments with shaped canvases and the *papiers collés* technique. He began painting with more vivid colors and richer surfaces, moving away from the muted palette and austerity of his earlier Cubist paintings (see **Plate 23**). In the winter of 1918-19, he began a series of large-scale, vertical compositions that feature still life arrangements placed on gueridon tables. Braque's fame grew in 1922 on the occasion of an exhibition of his work at the Salon d'Automne in Paris. In that year, Braque also began his *Fireplace* series, a group of paintings that feature still life compositions on mantlepieces with elaborate surfaces, bright colors, and complex patterns. In the 1920s, Braque shifted from the imitation of wood surfaces to the imitation of marble, a shift that reflects the broader change towards the luxuriant and ornamental in Braque's oeuvre (see **Plate 27**). Though he continued to explore the formal innovations of Cubism that he had pioneered before the war, Braque's still lifes became increasingly sensuous and lyrical by the end of the decade (see **Plate 28, 29**).

In 1929, Braque built a studio in Varengeville-sur-Mer, on the Normandy coast, where he had spent many summers as a youth. He began to paint small landscapes again – a subject he had largely abandoned in recent decades – but the still life remained his preferred subject. By the early 1930s, Braque was internationally acclaimed as a still life painter and he enjoyed increasing recognition with his first major retrospective in 1933 at the Kunsthalle Basel. His still lifes at this time became increasingly colorful, decorative, and rhythmical, often featuring organically curved and fantastically colored shapes against ornamental backgrounds. His *Tablecloth* series of the mid 1930s—with their vividly colored fruits, glasses and guitars placed against richly patterned tablecloths and walls—epitomize Braque's increasingly lyrical and sensuous aesthetic (see **Plate 30, 32, 33**). In 1936, Braque also began to paint wider interior views, introducing silhouetted, flattened figures into his ornately decorated rooms (see **Plate 34, 35**).

Towards the end of the 1930s—as World War II was approaching—Braque began to paint darker, more macabre subjects in his *Vanitas* series, often including skulls as elements in his still life compositions. Following the German occupation of Paris in 1940, Braque ceased painting, but he began working again in 1941, painting a series of stark interiors and somber still lifes. He remained in Paris for the remainder of the war. In 1944, after the liberation of Paris, Braque returned to his studio in Varengeville, where he began a series of spatially complex interiors that include billiard tables, for which the series is named (see **Plate 38, 39**). In 1949, he began a new series of *Studio* paintings that depict the artist's studio. He painted nine variations of the *Studio* paintings by 1956; all but the first of the series are large in scale (see **Plate 40, 41**). These paintings feature the artist's surroundings—both the real elements of his studio and often the imaginary presences of birds passing through—in a fragmented and ambiguous aesthetic. Braque became chronically ill in 1959, which prevented him from undertaking large-scale works, but he continued to work on smaller projects, including small paintings and lithographs for the last few years of his life. In 1961, he became the first living artist to have his works exhibited in the Louvre. He died on August 31, 1963, in Paris.

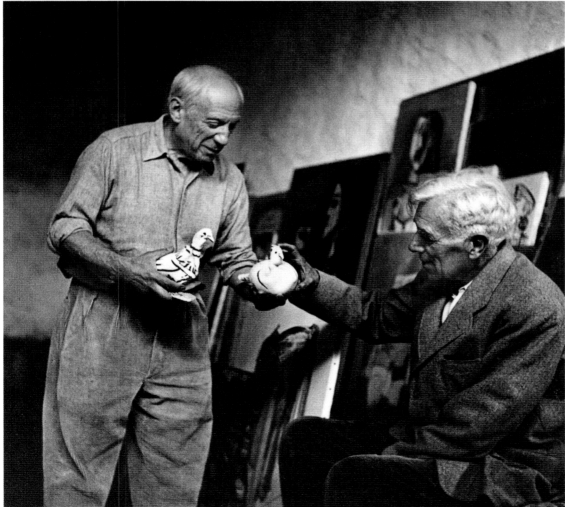

Georges Braque in his studio.
Photograph by Alexander Liberman

Pablo Picasso and Georges Braque,
Vallauris, France, 1954.
Photograph by Lee Miller

Georges Braque in Pablo Picasso's studio at 11, boulevard du Clichy, Paris, 1909.
Photograph by Pablo Picasso

Georges Braque in his studio, c. 1911
© Q. LAURENS ARCHIVE

Georges Braque in a military uniform photographed in Pablo Picasso's studio at 11, boulevard du Clichy, Paris, 1911.
Photograph by Pablo Picasso

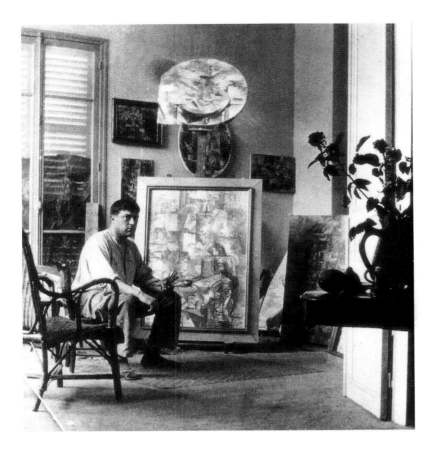

Georges Braque in his studio at 5, impasse de Guelma, Paris, c. 1912.
On bottom of easel, *The Portuguese Man (The Emigrant);* on top of
easel, *Table with Pipe;* at right, *Man with a Mandolin.*

Georges Braque in Henri Laurens' studio, 1915.
Photograph by Henri Laurens

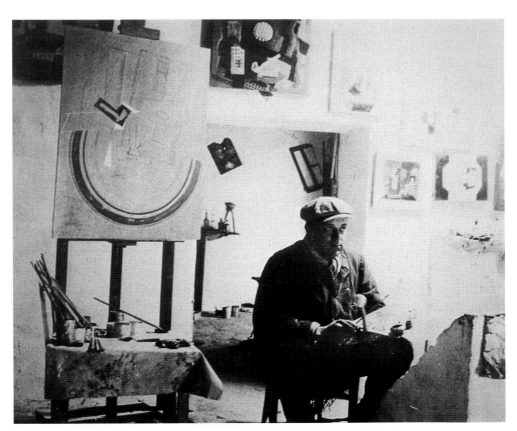

Georges Braque in his studio, 1917.

SELECTED BIBLIOGRAPHY

CATALOGUE RAISONNÉS

Georges Isarlov, *Catalogue des Oeuvres de Georges Braque: 1906–1929,* Paris 1932

Nicole S. Mangin (Worms de Romilly), *Catalogue de l'Oeuvre de Georges Braque,* ed. By Maeght Editeur, 6 vol., Paris 1959–1973
 1959: Peintures 1948–1957
 1960: Peintures 1942–1947
 1961: Peintures 1936–1941
 1962: Peintures 1928–1935
 1968: Peintures 1924–1927
 1973: Peintures 1916–1923
 1982: Peintures 1907–1914 (with a text by Jean Laude: "La Stratégie des Signes", p. 11-53)

Massimo Carrà, *L'Opera Completa di Braque.* Dalla Scomposizione Cubista al Recupero dell'Oggetto, 1908–1929, ed. By Marco Valsecchi, Milan 1971

Dora Vallier, Braque. *The Complete Graphics,* London 1982

SELECTED TEXTS AND STATEMENTS BY GEORGES BRAQUE

Gelett Burgess: "The Wild Men of Paris", in: *The Architectural Record,* May 1910

Georges Braque: "Pensées et réflexions sur la Peinture", in: *Nord-Sud, Paris* December 1917

Le Bulletin de la Vie artistique, N.21, 1924

Tériade E., "Confidences d'artistes – Georges Braque", in: *L'Intransigeant,* April 3, 1928

Tériade E., "Emancipation de la peinture", in: *Le Minotaure,* N.3-4, 1933, p. 9–20

Christian Zervos: "Réponse à une enquête (d'après des conversations avec Georges Braque)" in: *Cahiers d'Art,* N.1–4, 1935, p. 21–24

Christian Zervos: "Réponse à une enquête (d'après des conversations avec Georges Braque)" in: *Cahiers d'Art,* N.1-4, 1939, p.65f.

Jean Paulhan, "Georges Braque dans ses propos", in: *Comoedia,* September 17, 1943

Gaston Diehl: "L'Univers pictural et son destin: extrait d'une conversation avec Georges Braque", in: *Les Problèmes de la peinture,* Paris 1945

Georges Braque: *Cahiers de Georges Braque: 1917–1947,* Galerie Maeght, Paris 1947

André Warnod: "Tous les ismes conduisent au conformisme nous déclare Braque", in: *Arts,* December 5, 1947

Georges Braque: "Georges Braque, sa vie racontée par lui-même", in: *Amis de l'Art,* N.4–8, 1949

Paul Guth: "Entretien avec Georges Braque", in: *Le Figaro Littéraire,* May 1950

Georges Braque: *Le jour et la nuit,* Cahiers 1917–1952, Paris 1952

Dora Vallier: "Braque, la peinture et nous. Propos de l'artiste recueillis", in: *Cahiers d'Art,* 29, N.1, October 1954, p.13–24

John Richardson: "The Power of Mystery by Georges Braque", in: *The Observer,* London December 1, 1957

Georges Braque, Dora Vallier: *Vom Geheimnis in der Kunst. Gesammelte Schriften und von Dora Vallier aufgezeichnete Erinnerungen und Gespräche,* Zürich 1958

Georges Charbonnier: "Entretien avec Georges Braque", in: *Le Monologue du peintre,* Paris 1959, p. 7–18

Georges Braque: "Gedanken zur Kunst", in: *Das Kunstwerk,* vol. XIII; 1960, N.9

Georges Braque, *Illustrated Notebooks,* 1917–1955, New York 1971

Jacques Lassaigne: "Un entretien avec Georges Braque", in: *Les Cubistes,* exhibition catalogue Bordeaux, Galerie des Beaux-Arts, and Paris, Musée d'Art Moderne de la Ville, 1973

SELECTED MONOGRAPHS AND ESSAYS

Guillaume Apollinaire, *Georges Braque,* in: exhibition catalogue Galerie Kahnweiler, Paris 1908

Charles Morice, "Georges Braque", in: *Mercure de France,* Paris 1908, December 16, p. 736–737

Louis Vauxcelles, "Exposition Braque chez Kahnweiler, 28 rue Vignon", in: *Gil Blas,* Paris 1908, November 14

Albert Gleizes and Jean Metzinger, *Du Cubisme,* Paris 1912

André Salmon, "Histoire anecdotique du cubisme", in: *La Jeune Peinture Francaise,* Paris 1912, p. 41–61

Guillaume Apollinaire, "Die moderne Malerei", in: *Der Sturm,* N. 148–9, Berlin, February 1913

Guillaume Apollinaire, *Les Peintres Cubistes,* Paris 1913

Daniel-Henry Kahnweiler, *Der Weg zum Kubismus,* Munich 1920

Maurice Raynal, *Georges Braque,* Rome 1921

Georges Isarlov, *Georges Braque,* Paris 1932

Christian Zervos, "Georges Braque", in: *Cahiers d'Art,* 8, 1933, p.1–7

Carl Einstein, *Georges Braque,* Paris 1934

Albert E. Gallatin, *Georges Braque: Essay and Bibliography,* New York 1943

Gotthard Jedlicka, "Begegnung mit Georges Braque", in: *Begegnungen mit Künstlern der Gegenwart,* Zürich 1945, p.92–111

Jean Paulhan, *Braque le patron,* Geneva 1946

Francis Ponge, *Braque le réconciliateur,* Geneva 1946

Jean Grenier, Georges Braque, *Peintures 1909–1947,* Paris 1948

Douglas Cooper, *Braque: paintings 1909–1947,* Paris/London 1948

Henry R. Hope, *Georges Braque,* New York: The Museum of Modern Art 1949

André Lejard, *Georges Braque,* Paris 1949

Pierre Reverdy, *Georges Braque, une aventure méthodique,* Paris 1950

Francis Ponge, *Braque-Dessins,* Paris 1950

Stanislas Fumet, *Sculptures de Braque,* Paris 1951

René Char, "Peintures de Georges Braque", in: *Cahiers d'Art* 26, 1951

Fritz Laufer, *Braque,* Bern 1954

John Richardson, "The Ateliers of Braque", in: *The Burlington Magazine,* 1955, June 27, p. 164–171

Maurice Gieure, *Georges Braque,* Paris 1956

Jean Cassou, *Georges Braque,* Munich, Vienna, Basel 1956

John Golding, *Cubism: A History and an Analysis, 1907–1914,* London 1959

John Richardson, *Georges Braque,* Harmondsworth 1959

John Russell. *Georges Braque,* London 1959

André Verdet, *Braque le solitaire,* Paris 1959

Jean Leymarie, *Braque,* Geneva 1961

Werner Hofmann, *Georges Braque. His Graphic Work,* London 1962

Stanislas Fumet, *Georges Braque,* Paris 1965

Edward Fry, *Der Kubismus,* ed. By Werner Hofmann, Cologne 1966

Robert Rosenblum, *Cubism and 20th Century Art,* New York 1966

Douglas Cooper, *The Cubist Epoch,* London 1970

Pierre Descargues, André Malraux and Francis Ponge, *Georges Braque,* Paris 1971

Douglas Cooper, *Braque: The Great Years,* Chicago 1972

Francis Ponge, *L'Atelier contemporain,* Paris 1977

Raymond Cogniat, *Georges Braque,* New York 1980

Richard Shiff, *Cézanne and the End of Impressionism: A Study of the Theory, Technique, and critical Evaluation of Modern Art,* Chicago 1984

Max Raphael, *Raumgestaltungen. Der Beginn der modernen Kunst im Kubismus und im Werk von Georges Braque,* Frankfurt am Main, 1986 (original text from 1949)

Gustav Peichl, *Georges Braque, das druckgraphische Werk,* Vienna 1987

Serge Faucherau, *Georges Braque,* Recklinghausen 1988

Bernard Zurcher, *Georges Braque. Leben und Werk,* Munich 1988

Donald Kuspit, "Cubist Hypochondria. On the Case of Picasso and Braque", in: *Artforum,* September 1989, p.112–116

Karen Wilkin, "O Pioneers! Picasso and Braque: 1907–1914", in: *The New Criterion,* Vol.8, No. 4, December 1989

John Golding, "Two who made a Revolution", in: *New York Review of Books.* 5/31/90, Vol 37 issue 9, p.8

Richard Shiff, "Picasso's Touch. Collage, Papier collé, Ace of Clubs", in: *Yale University Art Gallery Bulletin,* 1990, p. 38–47

Richard Shiff, "Cézanne's Physicality: The Politics of Touch", in: *The Language of Art History,* ed. By Salim Kemal and Ivan Gaskell, Cambridge 1991

Lynn Zelevansky (ed.), *Picasso and Braque: A Symposium,* New York, 1992, with essays by Yve-Alain Bois, David Cottington, Edward F. Fry, Rosalind E. Krauss et al.

Clement Greenberg: "The Pasted Paper Revolution", in: *The Collected Essays and Criticism,* ed. By John O'Brian, Chicago 1986–1993, vol 4, p.61–66

Russell T. Clement, *Georges Braque. A Bio-Bibliography,* Westport 1994

Charles Harrison, Francis Frascina and Gill Perry, *Primitivism, Cubism, Abstraction. The Early 20th Century,* New Haven/London 1994

Norman Bryson, *Looking at the Overlooked: Four Essays on Still Life Painting,* London 1995

Jean Leymarie, *Braque: Les Ateliers,* Aix-en-Provence 1995

Francis Frascina, "Collage: Conceptual and Historical Overview", in: *Encyclopedia of Aesthetics,* ed. By Michael Kelly, New York 1998, p. 382–384

Rosalind Krauss, *The Picasso Papers,* London 1998

Neil Cox, *Cubism,* London 2000

Alex Danchev, *Georges Braque. A Life,* New York 2005

Armand Israel, *Georges Braque – Sculptures,* Paris 2008

SELECTED EXHIBITIONS

Georges Braque, Galerie Kahnweiler, Paris 1908

Georges Braque, Galerie de l'Effort Moderne (Léonce Rosenberg), Paris 1919
15e Salon d'Automne, Grand Palais des Champs-Elysées, Paris 1922

Georges Braque, Galerie Paul Rosenberg, Paris 1924

Georges Braque, Kunsthalle Basel, 1933
Exhibition od Recent Paintings by

Georges Braque, Valentine Gallery, New York, 1934

Oeuvres récentes de Georges Braque, Galerie Paul Rosenberg, Paris 1936

Georges Braque, Palais des Beaux-Arts, Bruxelles 1936

L'Epoque fauve de Braque, galerie Pierre, Paris 1938

Some Selected Paintings by Georges Braque, Buchholz Gallery, New York 1938

Georges Braque. Retrospective Exhibition. The Arts Club of Chicago, The Phillips Memorial Gallery, Washington, San Francisco Museum of Art, Chicago 1939

An Exhibition of Paintings by Georges Braque, Valentine Gallery, New York 1941

Georges Braque, Museum of Art, Baltimore, 1942

Salon d'Automne, Palais des Beaux-Arts de la Ville, Paris 1943

Georges Braque, Stedelijk Museum, Amsterdam 1945

Braque-Rouault, The Tate Gallery, London 1946

Georges Braque, Galerie Maeght, Paris 1947

XXIV Biennale di Venezia, Venice 1948: A Room for Braque

Georges Braque, ed. By Jean Cassou, The Museum of Modern Art, New York, and Cleveland Museum of Art, New York 1949

Oeuvres de Georges Braque, National Museum, Tokio 1952

Braque, Kunsthalle Bern 1953

Braque, Kunsthaus Zürich 1953

Georges Braque, ed. By Douglas Cooper, The Royal Scottish Academy, Edinburgh, and Tate Gallery, London, Edinburgh/London 1956

The Sculpture of Georges Braque, The Contemporary Art Center, Cincinnati, 1956–1957

XXIX Biennale di Venezia, Venice 1958: Rooms XLI and XLII for Braque
Georges Braque, Galerie Maeght, Paris 1959

Georges Braque, Kunsthalle, Basel 1960
L'Atelier de Braque, Musée du Louvre, Paris 1961

Homage to Georges Braque, The Contemporary Art Center Cincinnati, The Arts Club Chicago, The Walker Art Center Minneapolis, 1962–1963

Georges Braque, ed. By John Golding, Haus der Kunst, Munich 1963

Georges Braque, An American Tribute. Fauvism and Cubism. The Twenties. The Thirties. The Late Years. ed. By John Richardson, Saidenberg Gallery, Perls Galleries, Paul Rosenberg & Co., M. Knoedler & Co., New York 1964

Georges Braque, Galerie Beyeler, Basel 1968

Laurens et Braque. Les donations Laurens et Braque à l'État francais, The New York Cultural Center, New York 1971

Braque, The Great Years, The Art Institute, Chicago 1972

Georges Braque, Orangerie des Tuilleries, Paris 1973

Georges Braque, Fundación Juan March, Madrid 1979

Georges Braque, Fondation Maeght, Saint-Paul-de-Vence 1980

Oeuvres de Georges Braque (1882–1963), ed. By Nadine Pouillon, Musée National d'Art Moderne, Centre Georges Pompidou, Paris 1982

Braque. The Papiers Collés, ed. By Isabelle Monod-Fontaine, National Gallery of Art, Washington, Musée National d'Art Moderne, Centre Georges Pompidou, Paris, Washington 1982

The Essential Cubism. Braque, Picasso and Their Friends 1907–1920, ed. By Douglas Cooper and Gary Tinterow, Tate Gallery, London 1983

Georges Braque. Sculptures, Galerie Adrien Maeght, Paris 1985

Georges Braque, ed. By Jean Leymarie, Kunsthalle der Hypo-Kulturstiftung, Munich, Solomon R. Guggenheim Museum, New York, Munich 1988

Picasso and Braque. Pioneering Cubism, ed. By William Rubin, The Museum of Modern Art, New York, Kunstmuseum Basel, New York 1989

Braque. Still Lifes and Interiors, Walker Art Gallery, Liverpool, Bristol Museum and Art Gallery, London 1990

The Fauve Landscape, ed. By judy Freeman, Los Angeles County Museum of Art, The Metropolitan Museum of Art, New York, The Royal Academy of Art, London, Los Angeles, New York 1990

Georges Braque. ed. By Jean-Luis Prat, Fondation Pierre Giannada, Martigny 1992

Georges Braque. Printmaker, Tate Gallery, London 1993

Georges Braque. Rétrospective, ed. By Jean-Luis Prat, Fondation Maeght, Paris 1994

Picasso, Braque, Léger and the Cubist Spirit: 1919–1939, ed. By Wayne Kenneth, Portland Museum of Art, Portland 1996

Braque. The Late Works, ed. By John Golding, Sophie Bowness, Isabelle Monod-Fontaine, The Royal Academy of Arts, London, The Menil Collection Houston, New Haven/London 1997

Cézanne, Picasso, Braque. Der Beginn des kubistischen Stilllebens, ed. By Katharina Schmidt, Kunstmuseum Basel, Ostfildern 1998

Ein Haus für den Kubismus. Die Sammlung Raoul La Roche. Picasso, Braque, Léger, Gris, Le Corbusier und Ozenfant, ed. By Katharina Schmidt and Hartwig Fischer, Kunstmsueum Basel, Ostfildern 1998

Rétrospective Georges Braque, The Bunkura Museum of Art, Tokio 1998
Braque, Fundación Collección Thyssen-Bornemisza, Madrid 2002

Braque/Laurens: un dialogue, Musée national d'art moderne, Centre Georges Pompidou, Musée des Beaux-Arts de Lyon, Paris 2005

Georges Braque. Métamorphoses, ed. By Armand Israel, Fondazione Matalon, Milan 2005

Georges Braque. La Poétique de l'Objet, ed. By Caroline Messensee and Florence Rionnet, Ville de Dinan, Paris 2006

Georges Braque, IVAM Institut Valencia d'Art Moderne, Valencia 2006

Georges Braque et le Paysage. De l'Estaque à Varengeville 1906–1963, ed. By Véronique Serrano et al., Musée Cantini de Marseille, Paris 2006

Picasso, Braque, Early Film in Cubism, The Pace Gallery, New York, 2007

Georges Braque, The Lyricism of Geometry, ed. By Ingried Brugger, Heike Eipeldauer, Caroline Messensee, Bank Austria Kunstforum Vienna, Ostfildern 2008

Picasso and Braque: The Cubist Experiment 1910–1912, Kimbell Art Museum, Fort Worth, Texas, 2011

ACKNOWLEDGMENTS

We would like to warmly thank the museum directors and curators who made these loans possible: Richard Armstrong, Nancy Spector and Susan Davidson at the Solomon R. Guggenheim Museum, New York; Glenn Lowry, Ann Temkin and Cora Rosevear at the Museum of Modern Art, New York; Christoph Becker at the Kunsthaus Zürich; James Cuno, Stephanie D'Alessandro and Douglas Druick at The Art Institute of Chicago; Caroline Collier, Matthew Gale and Nicholas Serota at the Tate; Sam Keller, Philippe Büttner and Ulf Küster at Fondation Beyeler, Riehen/Basel; Neal Benezra and Jill Sterrett at the San Francisco Museum of Modern Art; Hope Alswang, Cheryl Brutvan and Roger Ward at the Norton Museum of Art, West Palm Beach, Florida; Christine Dixon at the National Gallery of Australia; Dorothy Kosinski at The Phillips Collection, Washington, D.C.; Alfred Pacquement and Brigitte Léal at the Musée National d'Art Moderne, Centre Georges Pompidou, Paris; Fabrice Hergott at the Musée d'Art Moderne de la Ville de Paris; Earl A. Powell III and Andrew Robison at the National Gallery of Art, Washington, D.C.; Thomas Campbell and Gary Tinterow at the Metropolitan Museum of Art, New York; Kyllikki Zacharias at the Staatliche Museen zu Berlin, Nationalgalerie, Museum Berggruen; Evert J. van Straaten at the Kröller-Müller Museum, Otterlo, The Netherlands; Knut Ormhaug and Erlend Høyersten at the Bergen Art Museum, Norway; Carla Schulz-Hoffmann and Klaus Schrenk at the Bayerische Staatsgemäldesammlungen, Munich – Pinakothek der Moderne; and Klaus Albrecht Schröder, Christine Ekelhart-Reinwetter and Rita and Herbert Batliner at the Albertina, Vienna. We would also like to acknowledge Olivier Berggruen for his invaluable assistance with the loan from the Staatliche Museen zu Berlin, Nationalgalerie, Museum Berggruen. Sincere thanks go to the private curators and advisers who helped secure loans: Abigail Asher, Emily Braun, Diana Howard, Bertha Saunders, and also to the following auction house specialists: Olivier Camu, Anika Guntrum, Phillip Hook, Sharon Kim, David Norman, Andreas Rumbler, and Elizabeth Webb. And, of course, we'd like to express our gratitude to Werner Merzbacher and the other private collectors who wish to remain anonymous for generously lending their works to the exhibition.

Special thanks go to Keith Harrington and the team at Phoenix for their work on the production of the catalogue, our graphic designer Henk van Assen, our photo editor John Long, and our translators Sara Ansari and Brian Currid. We'd also like to thank Quentin Laurens at the Braque estate for his support of the exhibition and for allowing us to reproduce photographs of Braque from his archive. Thanks also go to Milton Esterow for lending his photograph of Braque to us for the run of the exhibition.

Dieter Buchhart would like to personally thank Catherine Couturier, Heike Eipeldauer, and Katharina Schmidt, as well as Helmut Buchhart, Inge Buchhart, and Anna Karina Hofbauer for their support.

Our gratitude goes to the registrars who facilitated these loans: Carla Caputo at the Museum of Modern Art, New York; Emily Foss and Cynthia Iavarone at The Metropolitan Museum of Art, New York; Jodi Myers, Lori Mahaney and Arika Madouros at the Solomon R. Guggenheim Museum, New York; Sennen Codjo, Emilie Choffel and Camille Morando at the Musée National d'Art Moderne, Centre Georges Pompidou, Paris; Tanja Narr at the Fondation Beyeler, Riehen/Basel; Mark Van Veen at the National Gallery of Australia; Margarete Heck and Sonja Eiböck at the Albertina, Vienna; Joseph Holbach and Gretchen Martin at The Phillips Collection, Washington, D.C.; Tina Garfinkel, Donna Mauro and Kelly Parady at the San Francisco Museum of Modern Art; Darrell Green and Therese Peskowits at The Art Institute of Chicago; Astrid Holmgren at the Staatliche Museen zu Berlin, Nationalgalerie, Museum Berggruen; Nicole Simoes da Silva at the Tate; Kelli Marin and Pam Parry at the Norton Museum of Art, West Palm Beach, Florida; Simone Kober at the Bayerische Staatsgemäldesammlungen, Munich – Pinakothek der Moderne; Jean-Christophe Paolini at the Musée d'Art Moderne de la Ville de Paris; Alicia Thomas at the National Gallery of Art, Washington, D.C.; André Straatman at the Kröller-Müller Museum, Otterlo, The Netherlands; and Hank van Doornik at the Israel Museum. We would also like to thank the staff at the private collections that have helped organize their loans.

Finally, we'd like to thank the following people who provided valuable technical assistance: Anne Bast at the San Francisco MoMA; Timothy Baum; Jennifer Belt and Michael Slade at Art Resource; Kajette Bloomfield at the Bridgeman Art Library; Andrea Fisher at the Artists Rights Society (ARS); Katia Cordova, Raphaëlle Cartier and Noëlle Pourret at the Réunion des musées nationaux; Manuela Bethke at the Staatliche Museen zu Berlin, Nationalgalerie, Museum Berggruen; Cécile Brunner at the Kunsthaus Zürich; Kim Bush at the Solomon R. Guggenheim Museum, New York; Elizabeth Steele at The Phillips Collection, Washington, D.C.; Dave Epstein; Susan Charlas at the Aperture Foundation; Virginie Delcourt and Arnaud Gonzalez at the Musée d'Art Moderne André Malraux – MuMa Le Havre; Jeanne Noonan at the Chrysler Museum of Art; Bill Orcutt; Michael Fischman; Yaffa Goldfinger at the Tel Aviv Museum of Art; Laura Kandelman; Ingrid Kastel at the Albertina, Vienna; Perrine Latrive and Sophie Petit at Parisienne de Photographie; Aimee Marshall at The Art Institute of Chicago; Sara Martinez at the Museo Thyssen-Bornemisza, Madrid; Margaret Nab at the Kröller-Müller Museum, Otterlo, The Netherlands; Lucie Strnadova at the Tate; Barbara Wood at the National Gallery of Art, Washington, D.C.; Esther Siegmund-Heineke at the Ulmer Museum; John O'Halloran; Malcolm Varon; Randi Suzuki; Linda Klyve at the Bergen Art Museum, Norway; Kerry Negahban at the Lee Miller Archives; Heidi Raatz at the Minneapolis Institute of Arts; and Enrica Lipata at The Kreeger Museum, Washington, D.C.

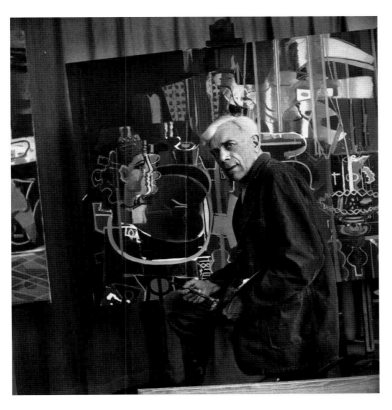

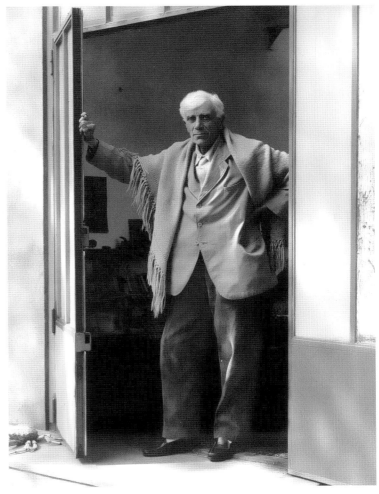

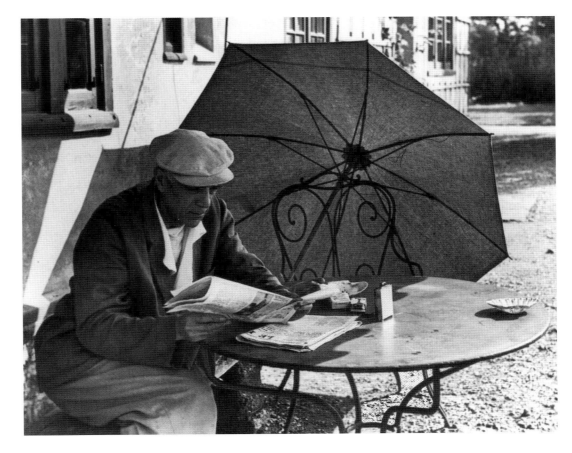

[ABOVE, LEFT]
Georges Braque, Paris, 1949.
Photograph by Boris Lipnitzki

[ABOVE, RIGHT]
Georges Braque, Varengeville,
France, 1957.
Photograph by Paul Strand

[RIGHT]
Georges Braque at Varengeville, 1955.
Photograph by Felix Man

PHOTO CREDITS

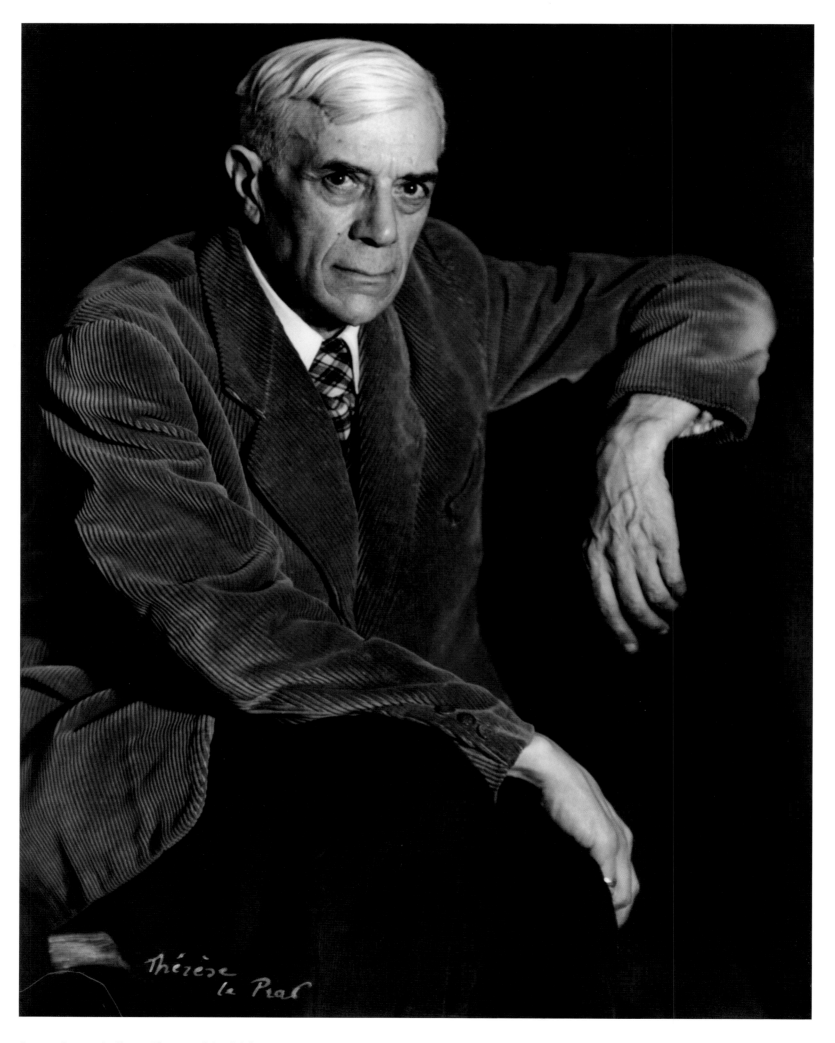

Georges Braque, April 1950. **Photograph by Thérèse Le Prat**